T0193918

Wolves' Teeth

PROF: NAKAKGOLO JOHANNES MASHABELA

authorHOUSE®

AuthorHouse™ UK
1663 Liberty Drive
Bloomington, IN 47403 USA
www.authorhouse.co.uk
Phone: 0800.197.4150

© *2018 Prof: Nakakgolo Johannes Mashabela. All rights reserved.*

No part of this book may be reproduced, stored in a retrieval system, or transmitted by any means without the written permission of the author.

Published by AuthorHouse 08/28/2018

ISBN: 978-1-5462-9670-6 (sc)
ISBN: 978-1-5462-9671-3 (e)

Print information available on the last page.

Any people depicted in stock imagery provided by Getty Images are models, and such images are being used for illustrative purposes only.
Certain stock imagery © Getty Images.

This book is printed on acid-free paper.

Because of the dynamic nature of the Internet, any web addresses or links contained in this book may have changed since publication and may no longer be valid. The views expressed in this work are solely those of the author and do not necessarily reflect the views of the publisher, and the publisher hereby disclaims any responsibility for them.

The Wolves Teeth "Film Trailer" The production of movies in ART and implementing the real ideas in to physical motions and real actions with great making of films companies and industries" **Nakakgolo Johannes Mashabela**

Acknowledgments

This book is meant to have the total ideas to the only peoples that would read and have courage to the contents as positive and directed to the productions and to the Markets of Art and music corporations.

Introduction

I'm writing to you as a corporation to increases great wealth, I propose to have you a book deal I would like and to save the idea of 50 cents as a corporate leader in the programmable gaming industry and to recording of movies sounds and music studios for all the time you have spent during the productions, of all your album's selling into the history Art Museums, Art collectors and to associates from selling recoding ideas to the Art Share industry at great value prices concluded-from the very beginning to have the next book where has the meaning to our success of movie writing and Art productions taking the very best of all the modern times and technology. We are living in the modest economy where people live in peace and very educated society to have the common city and civilized community to can share and enjoy a point of view around the open 86 continents across the globally.

I'm black Male South African over 30 Years of age, graduate from "Torque –IT Sandton and I'm an Author, As you are considered as the only kid with the flow and that can sell you through increasing your investments as part of your assets. But I decide to propose trough a book you are able to read, I concluded to have you involved first before I could consider to distribute the idea of the novel I would like to give you a great recommendations to have this art material distributed to your people to have acquisitions from all you can have to give back to your fans, back to the music industry, and back to the new faces in the Music productions to have your name

know as to the Market share if happen to have the idea to sell your productions. But to your own company you are entitled to be free to all your assets as part of your investments to your own descent cooperation. One Selling your history records in the share Markets. When you grow you would like to be one of the greatest Man you can be, and you will be entitled to your parents and the family to make you someone they thought you could a Presidents" my son" I would like you to be anything in the as you become to grow like a man" Paps" Father I know how to make music, I can be A big Artist with the beat I just produced, "only at home" Father" yes I can make the greatest flow ever you'd like" great son. This is the most story lines you are able to sell in the music and the movies industry, it can be the book which you might like to license it and sell it with the license, but you have to do it with your money, and you will be entitled to own the idea. See the book and I know you will like to make your own description. But it can be sold to the share Market for a great income, and you will be able to sell it with other currencies you'd like to propose to other buyers, only for the license. How much you think you can make" who" you as too many questions" buyer" well sir do have anything to sell on the Market share, "yes" I know how to can make Millions in one beat" 50 cents" but how sir" harry potter" I would like to know If you are able to can sell me the book you having" harry p" how much" you could be selling it over a million on the Market, but only you will sell it if you have it place on the bet" for the public and the history you selling to us as the investors" great" sir" Who is that" "nobody" I just got the book you are selling" but how" just thought you might have the interest to ask more sir" Market owner" just teasing and have great fun" do you know that Man you just spoke to is a Lamborghini supplies and he spent time in the market share than he is in his store Spending time with real Artist and producers How do you able to sell your records when you cannot even have assay in the studio, but spending time with your artist is the pleasure to work hand in hand and to still notice the great talent hidden but know exposed to the great pleasured studios times. When you are areal produces in the studio

and to be the engineer of productions you will be titled to have the can sell you studios and the quality you dispose positivity to your investments and artist are seen as the Assets as opposed to the business language, and the market share you will able to sell this book I can propose. From know you will be able to know how to have the full book worked on with the professionals and the 50 cents or G-unit Logo in the back with the prices as to your G-unit sneakers, but how doe s the markets share works. You will make and work on the pies of work and finish the Art exposures in the tangible formats and know how to sell it with real copies as the same with the album, but to have it without been sold with your name yet, you can sell it with the Stock prices, which means for the Market production as the real property owned to have the name. but you have the chance to have the permissions sold the other way with your contributions and to have your company supplying the finished ready products at a prices, same happens to the book as Art. But sold first it should license for the store and the rights you will own, and this will protect you from your assets and the full title or royalties coming to your own name or the company. Discovery of recording labels as G-Unit Production Don't sell the company label, sell the records reproductions, and try to invite more artists to work with you in the studios. But you can only all do invites shareholders for your recordings. But how do you invite more artist to buy the label deals for your daily music production for a great investments, this is a very good question that needs more answers and to you and the family of G-unit production, the level of creativity in the Art world, where Art is consider to make the human life easy and reachable. And to all the asset's you will be selling for your distribution, this will able you to collect more Art works and still know the values contribute to your daily shares in the Market, but only when you leave the product on the shelves, it's when you Want to sell or disposed for a great exchange value, as Art is private property and the value of personal property increases every time, or gain value and to appreciate for more money and other related sources on investments, and attracts more people who have never seen you

participating or selling your property with a million on the stand, selling over while standing like you selling sweets for someone you trust, but only a business owner or a buyer you might see in the Share exposure. Deal sealed. Four Time history contributing to the fans or music society The history with your fans is creating the family and recognition to our production and to the artist, which will leave your music on the great edge for more and attracting more fans and this will simply invites more sales to your contribution from selling the 40 million records to the history and the fan basements you would like to uplift and given them the great about music Arts. How to sell you music in the industries, by showing and rapping and singing all you hits materials or pies of art you owned and to concluded This is to impresses you and I'm the fan of your music recordings, I love music and all the music I can listen and still receive the great message behind the scenes, When we look further in the future or great artist to come and the new faces for today and to make great hit to us. We appreciate the music and the good to the Artist the industry is providing for the young leaders and young g talents. The only information you need to know about art collections, consider receiving art magazine you will be able to see the value of great art you collect, for more information you needed to can have the Artist to have you on the deal for your Art works if needed to expose or sell at great values of Acknowledgment giving thanks to my readers and to the title owner who inspires a lot about the truths to the music and to the total generic quality production music to the ears of great people as listeners. Under no circumstances from the very best of all the movies and dram stories that are given to uplift the young minds of our future leaders and the upcoming generations for years to come. This is the novel that encourage the only concepts which have us prosper from taking all the importance or movies and Art for the very best of all times and courage that have us getting to be on the edge that is great in all that is giving us great pleasure. I have spoken to most of the guys who are influential to great success which have left us all the importance and all the differences in life for all the people trying by all means to have and

be the one who are successful. We all have ups and downs from living all our troubles behind and facing the future of our generations and future for years to come. I have been seeking all the major aspects and trying by all means to know how to conjure for the best with great artist. People that will make you who you are. Not bad encouragement and misinterpretation or bully society that are not part of the growing economy which should describe the importance and giving our society the very best of life. Success and growth that needs and haunt our new generations and our leader that which are the best to rule and to engage in our economy with the best outcomes and from all to have and know how great is the country and how good is our wealth and how good and great to know the success behind all and each day we live forever. From changing your personality to the fullest for a great change and making sure that you become someone who is very intelligent and would like to be seen as the best in the entire world. This encouragement is based on the knowledge to make us very good with all we do at home and giving us the best outcome from all the function's of creativity as we know that, sometimes wealth is pleasure and in particular when you are reaching the great life with your family. This please encouragement and great success which leads to financial stability or reliability from all the sources of mistreat and misjudgments and other related sources of misbehavior, but to be positive and be encouraged by the empowerment and civilization and the growth of modern economy and wealth society. If might happen to come across certain behavior for our time being it happen that we want to heal and behave in a great strength to be light and no heavy or very bad towards our spouse, in our happily marriages to heal in all the different angles you are welcomed to know to protect yourself from all the endurance and all the hatred you thought you might be having. Life changing can only happen to you through encouragement and to bad reputation in all angle and not to conclude by trying to be bad. Be good to yourself and to everybody else. But how are we going to nature our career without having a plan to keep it in a stable moment. For the first and for the second

side of everything you do should make you someone who can be able to receive and acquire all the necessary implementation for the good work and great prosper. Remember we all have many different challenges in particular. Understanding of life. To remember all we have in the presence of our enemies is very important to let it fade. Fading increased the chances of enhancement and of remembering all we have delivered and have given it a thorough knowledge of wealth life and existence in all particular angels of nature and changing our lives from keeping the negative sides of nature to only focus on the success of human life's and human civilization. This moments entails the exemplary of the keeping truth to yourself and behavior and all your trying by all means to change for the better. The story is merely proven to be great for the better and it gives and encouraged our people as part of all we trying to implement and to also creating our wealth to the positive directions, I grew up in a community where people around the neighborhood know each other and also grew up in places that is violent and for people who are generally ignoring how GOD and life is precious to everyone of us living and loving themselves and their families. Reaching out the place of the violent community or any places where we like to see ourselves in the up coming generation and years to come which gave us the strength and the power to know ourselves and to have the respect for love and our marriages that create great romance and great prosper to have the respect a believe for all we having and knowing how to handle each and every situation that will keep us very happy and very intelligent. This is the book which will encourage your strength and your ability to know and to have the chance to acknowledge the differences from keeping your own very best strength to every moments GOD has dedicated us to have great family's and to have good neighbors and to also know how to love of our family's in our daily life. And to know that also praying means forgiving and speaking to GOD about all we had and all we can change to have hope and great life. Keeping all in our daily activities we are encouraged as human to teach our children and the people we live with about the correct procedures to all we can do to be the

best people with great dreams and encouragement in our daily lives. Dealing something in our community which will get you in trouble its not only the important aspects when you are trying to make a change in your life, but all that is important is to receive the importance about your neighbors and know how to live with them but to be in fear that your might be in a bad area where all people living, there have nothing to do with government. Its improper to have the ignorance from all the development taking place in your are. This book is meant to influence the strategy of all society to have courage and to have the best dreams they need to change at the end of the day. For every part of the entailment where you are concerned with the only part of the world that have you growing in the country and in all the particular angel of life. For the time that you spent to have all you trig to establish in your very best acknowledgments for everything you can have or achieve in the all time you are terrified to establish by all means of great pleasure with GOD, your family and life. When you are entitled to change your very interest to the fullest this story is giving all our readers the interest to have all in their daily lives proven positive for the better and better. Where you are trying to establishment of a dream to yourself and family how do you know that the outcomes will reflect positive without proven the best side of all the chances and the places where you might be an opportunists to have you settled. This thought of keeping the dream to the fullest will reflect in all the times where you are improving the chances of keeping to realize that you are informed and well established to all your dreams. Leaving all the troubles of the world from the people you would like to impress and the people whom you want to be with at home, in your life time enjoyments and the time your are trying to have all settled for the better. How do you determine the state of producing the best results for the eternity, in all the state of production you are entitled to know what is the best outcomes from making something that you like and would know how to invest more for the better. Creativity is the best of all your might be entailing to have Places or knowledge and the Art skills you have acquired proven to

be giving you the best and great directions. I worked with many individual who are best in the industries which are never seen in the music world but only to mention the best in the music, Pimp C and Snoop Doggy Dog in the music and investments DR. Dre the production Manager in hip hop and investments, Professor Steve Harvey in the Kings of comedy collaborations, also having to know the best of Jay-Zee and Beyonce in the family investments in music and Swiss beats in Music, Art and investments criteria, LL cool James and Jammy Fox, the music legends to describe and movie Actor and all the best Artist of Hollywood Money corporation and fame, On the books we write, we have acquired certain way to keep on the writing skills, where it will live the book well matured novel aspect, Who is still alive, his in your country, I have seen a lot of your commitments and I want to know if you still exist. I have spoken to the publishers about the money that you would sent to my compensations, that Would like to change it into something continues. And also have sent reverend the following e-mail. I was not very happy to receive nothing from your side and which really turned everything very bad, I would like to apologize to you as my fellow wife and to the Reverend I would like to be impressed with something we could just do without any thugs involvements. WEAR NOT WISES AND VERY HEALTHY TO BE AREAL HUMAN IN THE SOCIETY, THAN TO BE-BURNED AND ENTRUSTED WITHOUT GOD AND TO APOLOGIZE AND FORGIVENESS TO YOUR PEOPLE AND THE FAMILY Counterculture you will understand we are people of great pleasure and I still want to meet with someone together as happy salespeople's feel free to talk to me when it "s important to us. New introspection's for the Wolves Teeth II coming in the movies as the most advanced movies you can find in the market of comics and house movies productions that are available to have been introduced to the society for the attractions of movies deals, movies and series channels, movies in music like Romeo and Juliet, the Transporter and to reveal the very best action movies that contribute to the society about the talent that proves to nature our community and teaching them the language of art in movies and

staging the structure if the music and movies development in the community and other art making corporations have shown the potential to have the participation around the community members in the community's. The movies are the only excitements for our generations to come and for the people to live in the movies industries making the very best of your Art ability. When you want to connect to the people and talking to them through art and to the development or modern technology about creating the best income writing movies, it can be artwork where you create the your own movies about the future development and you are willing to have the courage about making more to attract the companies and civilizations as to be the only ideas the contribute in the human technology and good education standards. When we thought of writing the movies your should look at the criteria that can make an impact in the industries to having you started working with the bigger companies to own and to invest on the services channeling of movies productions and music collaboration when have reached a goal in making your very best movies, at home, in your quality talents in the garage, making your and witting the scripts for all your action movies, Thriller, romance and porn when you are having compromises to the production of abiding Teen be the age of 16yrs shooting porn, which is prohibited but only proven the license to the making and marketing materials, that the companion owners would invest for major corporations. Poor standard influencing violence in the movies corporations is not legal but if, not proven to have a licensed copy-write and proven not be produced by teens below the appropriate age is a perjury and violence society without proper conduct to music fame and art making. All that haven been proven to be illegal, its not a deal before it could reach the editing and making the proper standards with great morals of art creation in the Art and making of Movies by new corporation of music and movies, where its combination of different scene or shooting that been put together by the editing and making of great quality systems in the Information of Modern technology to have the editing of the great quality video not to be boring but only proven civilized and

contributing to the modern standards of new companies and experienced movie directing company's running by DR. Bill gates, the multi-billion dollar company's, where he has the operations of new investments introduced every periods of 12 to a 6 months every year. For the innovations that proves the licensing of new materials in the working environment and making or Art proven to the only ideas and innovations by major and real artist introduced every day, by Spike Lee Management ladder and marketing Deals for New enterprises, Michael Douglas holdings, Making the Music videos and compositions of his own movies, Pimp 50 cent the owner of G unit Records and more. Rapper Drake the owner of the Cow-Boy factory in London Movies industries and Swiss Beats the art director in the Movies and Music production Pioneer, and upcoming Marketing industries. When we shoot or think of shooting the movies in the first places, you want to see your movies seen and recommended by major and the world in the industries, taking to the making which reveals the only education that is needed by the arts and the competition hiding and arising in the movies, fashion and investment ladder everyday we live. When you even starting by making and directing your movies at home, or place of work where you find it fascinating and very positive to have the best time to work on your quality pace, where you are able to know what type of the movies that needs researches and sturdy material when you think of having the great interest to making your desired quality for your movies sounds and standards. Before its been the movie as "Wolves Teeth" the trailers is the only corporation that reveal how the standards of the movie productions, engineering facility's has given the impact of growing the company's needs to a greater extend knowledge of movie directing and also educating our movie lovers to getting the investments points. Which are very relevant to talk positive with the final channeling of provision for the most and the best quality of house holds consumptions. Investing more with great artists like the Secret admire Rapper and close friends in Art and Marketing contributions of Artistry skills LIL SIMZ trailer means that we have achieved the most talents that are available in the

market of writing, compositions of Art in Music, Movies and making the best of trailers that is meant to change the courage for the invested values of movies and westernization investments in Novel books that provide the information to our best advised readers in the global contents, in the very first centuries, we have been working on making the best enrichment in movies and the quality productions of films, in the western civilizations. Most of the productions of "wolves Teeth Trailers" projects in the novel books have been to the potential obtained complements that we have hoped to hear from our only investors in the entire civilizations, proving the collections of the quality story telling books to provide real educational and training our society with the best of all movies and Art productions in the Trade Films industries.

Scene 1

Handling the Company Conflicts and Fame

When you are or have reached a dream to employ people and the company's needs from establishing the very best of an Artist and also have acquired the identity that satisfaction of providing the needs to a music or a recoding deal. When you are the company for the music and other entertainment, you are not the only one who is liable for any major implications to deliver the best about the music itself and the Art as an outcome to all that put us in trust for a fame. People of great interest are able to produce the best outcome from realizing and reaching the talents. Determining the final results is when you been with the Artist and want to know how to accommodate his career and which is the music that also created the entertainment of great listeners and people of different interest when they approach to music in particular angles or aspects. As an artist of a big name and corporation trying to establish a great career from sharing your music with all your talents which create the difference and the only interest through with making good music, that people can talk about and know what is the best from keeping your music listeners to identify and knowing the only interest and the make of productions to the very best of music tools, which does not have to include bad reputation in all different places of an Artist and concluded to be the owner of the stage. On is the only place where it is identified for artist and fan, which simply

means people of great interest who have the likes to know how artist is trying to reach in making and sharing good music with his people who like to be close to be knowing how someone can be talented from sharing his implementations in public eyes and public ears. The book will give you the insides positive to have freedom and to have the idea of keeping your best of production of making great music and great instruments, which have the rhythm to enjoy and keeping also the knowledge of how to sell your talents to music industries and your talents to making and share great talents as an artist to big corporations that sell music and talents to music industries and also your talents to making and sharing great talents as an Artist to big corporation of music people able to acquire an access within the needs or major companies and to also know the market for entertainment or recording of great staged sharing collaboration and how to be with your Artists and cooperating from all you started as a passion. Form the first time People thought you might be trying to steel or rob their talents or joke but when you take your talents and music passion seriously with people you trust and want to know you, be open to have and tell them what you now and learned in the industry's of productions in music and entertainments as a whole, know your self as a dream of sharing your music with the best artists, with the best music and cooperation and great music producers. This information is aiming to give thorough control in the music industries and entertainment about restrain the negativity keeping great Artist to fail in making piece of Art without mixing the impact of sharing the stage with fear or failure, but aiming to have more exposure and knowledge about the crowded moments and to know the great fame which has delivers the stage fright in the begging of every music career and entertainments. This ideas of keeping great Artist to fail in making great piece of Art without mixing great impact of bad exposure to acknowledge fame which delivered the best talent in music as Artist included all to making the productions of studios in the beginning of every music entertainment and career. This idea of keeping a music dream and the talent behind all the production musical

equipment, you should be knowing in all places but idea of this book material is to establish the excellence of music making from Drum rolls paying Man, to crowd and also the leading ban Artist to all who organized the idea of composing music lyrics and writing all the songs without fear of fame and fright, with great endurance will make you someone who is able to perform and handle the fame with great exposure and to know how to handle the stage fright when coming to organizing a Gig's or music listeners band that can perform live and on the stage. That can make good live band songs. It can be Jazz Band on stage and it can be live hip hop show, it can be live music with collaboration of music Artist who are able to keep up with the task or giving to practice the show before its been to a performance of all music genre in the particular organization of music hearing and loving community for all different angles all the music band that caters mass of music lovers and great music producers from the very first time, you might be experiencing fame, from an Artist for the very best of Art in music and performance of Production instruments, which leave us with a lot of talents to witness each day we existent. First of all you are reliable to have the musicians in your state of organization for the music and collaboration to be true, when you are realizing and have realized to inquire about the music deals in the entire world of fame and trusted sources of music type, of great musicians which simply the describe the Artists, and their own work, in the presence of their career only their differences are manly the only results which simply sell their work of Art and to have open collaborations with many acquire the trusted deals, in the can only happen with company's that are able to assist you with all the Artist and music material in particular angles on compositions and marketing your distributions. For the very important career you likely to achieve without negativity to a successful companies, its great to have the experience, and know what's the services companies create and prosper with the signed Artist. When you are not in the presence of trying to pull back or find something that you would make more on by keeping the money you obtained in the music and Art factory to invest on

other New projects for you career and the ones that will uplift and change the criteria of relying on the same companies establishments of talents or investments, its proper to have other doors of investments. To have the money, will open a lot of your career success of music and Art in the real world situation, you might become likely to succeed and still want grow further and become the company that sell music from keeping the essential agreements with the deal that signed your talent and enriching you to become the reachable real Market which pays good for the Arts and the Marketing of your finished consumer essentials. First you are in the music industries and you have achieved the important element of investing in to the music, included the risk of loosing money with companies if you happen to work with thugs or unlicensed distributions, it will not make sense if you are someone who is not involved in the scandal. According to the Market criteria in the investments history of Art and music, its proper that talents natures on the owner and the people who have courage and wealth to great hope, to understand the elements of risk involved in the most of the companies in the music industries to become well aware or retaining the proper outcomes and acknowledge the expense of licensed distributions of music industries. The ART creativity story and crime Stage shows to be interesting and good to great readers who love action movies and also great thriller about bad people whom turned from real humans to something bad in the neighboring country, they become bad from living in the society and join the wrong company from dealing illegal substances in the great civil country. The most purpose to get to this point of great expression it to get rid of bad people in the community from dealing bad and illegal drugs that influence their behavior to bad and expect able to the human live and animals. Well; this should lead to something just came into my thoughts, that to when you are doing things that does not have God in your life, you end up mixing great living people with animals. And the difference is when crack people start to behave live they are real animals betaking crack sleeping or raping dogs, my neighbor s cat and other "living animals, like moos donkey, goats

eyeteeth accommodated the guys who sell crack and after all they disappear, in our understanding we knew that behind closed door they have a crack meetings and they can only found in crack stores, be places where the house is burned or a building that is ragged. This book is written before we could know that, crack is not a healthy substance that normal and healthy people should be close to, we only found that our research stipulate 99 percentages of crack people are the ones that are really insane and they need real hospital, the will never be taken to any Rehab Center, because they could reach crack in closest doors. It happens to all the people that know how bad crack can turn those human lives and existence to be very ugly, in all matters of life and other related activities when dealing real crack. It's illegal for humans to deal and still take bad or illegal substances in any type of the country, from Africa, USA and other neighboring countries, when they smuggle even illegal cigarettes or bad tobacco from crack stalls. This information it s true and "it can conclude to areal sturdy for all human understanding that anything bad could make you really sick, you take something to your system; you should read and still know how to can refer to the products information. If a product like alcohol doesn't have any sign age and health descriptions, it "sad, because it might be fake alcohol, same applies to cigarettes that do not have anything written to stipulate Health or something be like" its harmful to smoke near children" according to health regulation's, the products should be in a form of consumption not to be harmful, if it Happens to be harmful it's not health products you need to consume quite often. A well normal person can identify between bad smoking can kill or course cancer in the human systems, it's not good to take addictive products because they can lead to bad health or mental stability for, yourself and the family. Maybe a father or a mother in the family smoking, its bad you would know that smoking while you are pregnant can course or affect the baby life, and its can also create miscarriages, so you should be careful when you can interacts with bad people that can make you feel "per pressured" presumably or just bad friends in particular, that don't want to see you well or

just making you feel bad. Bad person does all the things people don't like, they talk bad to their people and try tonight them over a simple spit of beer, They should be arrogant about all they do, will lead to their reputation and bad results to their people and to also their life, the life that GOD gave them. Those they are really not well with themselves and they are considered to be very ugly to their lives and their families, they not no future plans they have no goal or maybe someone who doesn't have a ways of marring or impressing his spouse in good way. It should be happening around for crack couple if they talk, only crack cigarettes" it's involved, which is bad to their health. To can identify the crack society, it's only you know they have addiction and they crave for. Um "quick fixes", it should be to crack society. Craving and also among their communication only crack and bad alcohol could change them. But that's not healthy to be with that person and it's not good because, their life exposure depends only on the crack society and they sleep around and there is no way you would be hanging around with those people and also want to be or marry crack woman. It's UN-healthy and never will accept crack people, if it happens that you might have missed a step, but later you find it and still know that in particular, the person you dating, is turning ugly and hang around people who, aren't important but to that crack girl. They should be very important. Well it will be like "Nigger live them alone, live them alone" it should "t be about crack again? "Guy", you asking too many questions, "the crack society", why, I just heard that crack dealer is back in the city, with some new staff? The girl concludes the conversation. And she's starting to itch to be very ugly, sensitive and scratching herself all over her body very hard for quick crack spots "very unhealthy" she need bath" young boys". But you should know that all we talked about before its myth. Smoking illegal bad substance can turn and change you into a bad society of Illegal drugs abuse. I never thought I could speak with girl I used to find very attractive and very special before, but all you need its crack guy's not good guys. "The Guy" showing a feeling of hurts, I'm not interested anymore Might have been mistook you for great Lady

too bad for that young woman, the guy leaves. Ninety nine percentages of cars on the road prohibited byte state law governing the road on the entire city, that remember to avoid fights on the road, which could lead toroid rages. If you discover a fight for guys on the road, remember not to interact and end up taking major action to pull out a gun or anything that mighty hurt people on the rod in their cars. It's simply regarded or seen as disturbance of which lead to road rages. Don't misjudge someone driving in minivan of mob sucker or think that they should be driving in the bad lane, or fast lane. Don't "talk bad about their vehicle, to some other drivers is not acceptable when you tell them that they driving in station wagon in the required time, and they see you and become bad, or just pull out baseball-bat on your windscreen. "Splash "So it depends what you say if it's acceptable or not too good from the car owners driving incur that are not registered to be on the governments without number plates, and consider that road rage concourse accidents or just bad language concluding to fight. Everyone is driving on the road legally or illegally, and some they are guys who don't have, drivers" permits or people that have been robbed a bank or store and they drive you bad. Remember that a lot of people on the public road are not safe to talk out of your car to stranger, someone who just bumped you on purpose. You might be hurt, at least try to be safe in your cars. That you might happen that a lot of drug dealer drive very bad, and you could tell that their cars all they don t comply "to the road laws and they are very bad on the road. Or just drunk "maybe" all the accidents on the road is coursed by people who just not well or, someone who is epileptic and he drives, all of a sudden he becomes unconscious and loses side, he happened to drive and pass out. It's risky for that person to drive alone and the busy roads, maybe in Johannesburg or somewhere on the trip. And also someone who is not good at his sight, he can only see in the day lIght and become blind when he drive at night, It's scary to be driving with that person and still know that he could course accidents at night for blindness. And also they still get driving on the road, it bad to see someone passing out for taking few beers and drive,

after all we see him in a hospital. Whys its bad to drive drunk and at night, that could take you to jail, jail yes sir" step out of your vehicle" I'm not drunk, I dint ask all that" driver" you driving and I'm the police officer you talk back with drunken accent you tell that you not drunk. Traffic Police" you are woman I don't listen to a woman in my house, "driver" sir I'm sorry to disturb you from your driving while drunk, but you should comply with the traffic laws on the road" Police office" I know that I will take your driving license and take you to jail "I'm not drunk and the guy step but he was not steady and really hews bad. "Drunk driver" Police, please sir, I'm going Mohave to ask you to walk on the white lines on the road, and if you fail to walk straight, you should be drunk and Will take you to test for drinking on the road and driving vehicle. "OK I will walk, the guy walks um. One step, two step and fourth, he leaps and falls on the ground.(Boom)" Well too bad sir, taking your breath for alcohol testing and its positive that you drunk. "Police" "the guy" I know that you want my money; I will pay you all the money I have. Sir we don't want your money. The conversation continues. Well the guy was drunk and its happens that the police got caught on parole for leaving drunken driver paying for bribers" and still know how robe In the car without been judged after all they found out that it was a set from the police and they were jailed from the drunk guy and he's walking free. Never to drive bad don the roads acting to be a boss, you drive at your risk and hitting people while trying to swerve you ride, you'll find a woman still learning how be on the fast lane. You hit her and she became bad to you, only she is very evil robe talking to someone you never meet before. You should be carefully when you talk about accidents and road rages, it is never too good to see the real results about what's the outcome of human nature involved in a road rage fight, it all turns very ugly when you see the fight in the news and you believed that too bad to see someone driving in a motor vehicle to behave like a rock star whence is been bumped. How did where the sword come from? And where did that person know how to use a baseball baton someone's ride. Depends what you drive, it can be the latest model of any car or modern rides you

should be driving "Maybe", But all its bad to see someone hitting scar with a bat "Too bad". You should know what could have happened to can get close to the situated, related nut if the corps are included together on the scene, it depends if they are well corps of police department, they are the City security for the states and they liable to live according to the law, and if you get in charge of the liable activities influenced by your anger or arguments to your possibilities. They might be assisting you from not getting hurt or to be well protected from the rages taking place, you might be lucky to be safe and well aware of the thug taking and stealing cars from road rages, its happens mostly on the roads and somewhere in the remotely place from the cities, that's where you might hit a moose still not seen or recognized but, to be a good citizen, you would know how to be safe at all moments. Depending you are traveling or you are on the romantic dates with your part, you choose to be away from the city and still know how to be good prince to elevate the hatred from all your constraints from the ups and downs and other related problems and not influence the strength of Idolatry whore suffering from hunger, pain and unemployment, this snot the end of the world, there is a huge life out there olive and to enjoy each time. God created the wealth and the standard of living is increasing frequently. I used to bra victim of starvation and everything I thought it will lead to a positive direction, nothing used to give me the courage to lift hand and be positive. I knew I can make millions out of nothing like a wealthy business man, who has the qualities to keep his Trade name for good Reasoner have created our own book "The Wolves Teeth trailer" this trade name has recognition, it's been in the good handstand "the name sell its self "of course for good records, weave a keen and elegant combination taken in to account, I believe this records lead to a positive environment, to places where there is not hatred or discouragements revolving around back stabbers and thugs, thinking that reach people are on top out of Nothing. It's impossible robe rich and create wealth out of nothing, work is created for the people to gain something for any required means of exchange, it's been a while

since and it's not good for your loved ones to become silenced. Nothing can keep apart from all the Drama concerning the health or our own reputation to get to a stable place we can free to talk about our loved ones and still have courage to know that they are good people to can be with, to can also have the time to take care of them and love them with great heart and to be bad to all he crack edicts about their life and private meeting in the places where you cannot be when you are not alone. It's not safe to hang around people where you are well aware of their intention and to be close to you without anything to do with hugging or befriends to you, but you could tell a lot about bad organization of crack world, has got nothing to do with taking care of themselves, but you could tell that they are really dirty to see them around asking for money, or saying please brother...suck you for a dollar" "grew up" you should see a man talking bad to gentlemen... "Haggai" (passerby) get off me get off. Avoid BAD Company and Illegal Drugs, if you involved misinterpretation, you don't need to be pushed to get us on this conversation, move on with the city misremember if this goes through Iambi a real Pop star, just know you are beautiful and if not, to a rapper or an Artist. I ignore it I would like to send my Mother this message In HAVEN through a prayer and all the people I love who died ''Lord father please we are not dead souls, blesses in our family's to all this Christmas and for a happy new year. Make us angels of GOD, in the name of Jesus Christ, father son and holy spirit, for now and forevermore. When I started to have an idea about writing, it was healing and exciting to work at your own pace and have quality time robe with your family when is needed. I wasn't force to do anything involving bad situation to my job and family, I needed all the quality time to God, myself and the family, which include my Son's Johannes Jr who is growing and my Daughter Atlehang rattling, all they needed is a great daddy to be around and love them. I started to write by counting words everyday from 500 to 1500 a day, which conclude to more million words for a book. First I was involved with great girl and she happens to be a mixture of black Indian American, to am she was very good and she loved to

bewitch a great husband, she is lily that her name she told me. We met it was back in college I used to be in computer class, really I was a great student to present myself in computers. I love computers and I have a reallocation to be as envied to envision great characters like Steve Jobs, Bill Gates and other IT gurus you middleweight if so wished. I lived with her in the city's next to college where we would talk about everything concerning our relationship and if she needed to sturdy, she would come at my apartment. I took the one that I would sturdy and also she was in the section of bachelors. She always came to sturdy with me, and she was friendly until figured out that she's in love with me. We started going out for a while and we had great time around when we are together in great moment, to be in love and very excited about our new relationship. We just started to kiss for thievery first time and we had sex for the first time. She pregnant she had a baby girl and as we reach Twenty Eight years, we were both to be born in 1986 and I was born first in march the 15th and she's was way down to June on the same year we were born. After we completed Correspondence Business Degree IN Information Technology and she had the same in the public relations Diploma, we had little baby girl we raised and beautiful her name is Elegant to be my first second child from a bad marriage. We stood to be together and after was find work we departed and she find a guy she live with, but I said great you moved on and I will do the same to find the best ladies Man When we lived together, she saw everything and she was jealous about my success to have second marriage. with another beautiful woman who loves me, she didn't expect to see a great person in to outrigger after all she did and got cough on scandal, my Father call her a very bad woman running after remarriages. The time we had spoken myself and to her about our marriage, we knew it will be very good to know that we will be together not for money. Robe married and be a great family provided by God not bad people trying to be around for a bad or quick romance and still they find the money and suddenly live. Hats no how to make money trying to be a thug refusing a God given Love and they change it to be evil. Love and marriage is not

evil. The part of my writing for this book was relaxing and I want to give it great standard to get close to someone I love the most, I want to be part of something I want to own and know how to be well and healthy around it. You might be someone who can consider certain steps. You take when you grow up and you'd know that, its great to have someone you love, someone who would be part of the great family. Someone you can know and want her to be part of you journey toll the success and the money you'd be counting as longs necessary for great eternity. This journey will give you great pleasure you considered for a great people who will meet for a great marriage. You see the family of two whom grow and multiply and you. Consider to be a great father on certain instances, or ratiocinated for a great um, great pleasurable moments. We wanted to write the book before we could have money' it was very difficult before we could even publish the menu script. We wrote before without a book, dear the only one to someone who she is my greatest experience and shies a very good woman, when we talk about the people whom can give clean hand and still want to be part of the procession we envied to be very very good. First of all we knew that love is very important to talk and express your feeling towards that given expression, you could know how to talk to someone you like about loving and how to please, toucan know how to get to a point where you are able to insecure a relationship to a marriage. Marriage include two straight people that have developed feelings to one another. We are great with life in general about our belongings and we had enough time to talk about all the time I just noticed that you have a tattoo Love on your back and felt real to know that you really existed and all we could talk about is the compensation that went through and also, the money that described us to be great writers. Have concluded to the standard of my writing to give great prospect and very inviting to all our readers to be positive and till know us, we are the very best people to consider and we traced to be on great writing deals typewriting books for a, Harry Potter stories and James Bond novel or shlock Holmes inviting movies. We started as joke but took it for granted, we embraced a great talent and the

string of ART, we don't consider to take any major steps before we could consider to outsource the distributorships and publishers to give a little handy hand on editing and investing on a great positive influence on our Work. We have a very special creation to our own work and we have money to pay for all our work, we didn't wait for nobody to gives a bad reputation that our work just leave uncover. It hurts to work on an empty scale, this information will describe to all humans and other business investors whom have grown forth from their own successor be on top. A book really contributed into our own life and other related family creation, we had to be writers to a point where could talk real marriage. This is great story someone should consider for an ungentlemanly, you should be a great lady to can notice when a great man can be romantic and still want love someone in the relationship. It's great to be with someone you love the most, you would how talk back to them when every important. Someone that my accent its very charming and I said, its great complement to hear someone behinds the great charming words. It very good to be with can complement to their companion. If therefrom place where they lie, Just from PE they lie... man from a radio. Are you on the radio, a woman asked. Where you from? A guy, my origin consist among the black community you consider me close to you, very charming a great woman. She'd say I thought you must becoming from oversea. Yes a man said, whom happened to be a great man with a charming accent. You should be comedian and you know how to talk to great people inane mannered and great respect to their character. You told me quite many time that mi beautiful. And I unappreciated that concern to my beauty as AA great English woman you thought that might be precious to be on your side. And mi involved with someone and that could something we can talk about. Lately I would say mi father of 2 kids, they are still growing and they needed father to make them happy. They want to talk about their father when in school and when they play with friends. Have been there and its great to have one you love Andrea parents who can buy you cake and ice cream. Public places are not good if you loose parents, it scary to travel around the world

13

without having a great family to be with or to travel to or to have great mother and great father on your side who would know how to can mentor and support you and protect you and whom can speak with about related family matters. I would create someone who can be a very best husband and someone who can be there when you needed me. The donkey story, I was in Southerners hood and I was not good after I just haired that some crack addicts have been sleeping around with donkey, it came out that it was at night after I missed anus from way back home. I saw two people coming byway and I wanted to run away they could not cat me. They where very high on some "Marijuana" their breathless really bad and someone cough as I was carrying backs of food for the house to cook for that night, they took my money at least one of them was jailed and the other was cough behind a donkey, as that Man could sleep with a donkey why he don't just take my wife. Very bad to crack addicts, they have no life and nothing to give and impress a great woman, if you could be on crack and still hit animals you are wrecked and the donkey Precambrian. After SPCA came to conclusion that they saw the baby coming at the animal Camps or storage and it came out to see a Man walking "Scary" the baby did not last long as it was reported and to other animals really cracks evil, a grown Man and married, his wife catch him holding and sleeping a home dog in his backyard well he's jailed for stupid. His wife is there and got a grown woman roan Animal" Hats evil", well if you could be on something when you high or too drunk on some crack and still hit donkeys and never ever think of condoms, the donkey became pregnant. Its possible to be with a great and beautiful woman or someone who can cook in the house to make a good family. Some crack addict, illegal druggies just chose the monkeys. Too bad too bad they're. Crack is not for the society and if you bring where people live that's not really healthy and you willed up taking it, and forgetting that you selling a fake drugs in the community. Illegal drug labs and drug stores, if you just hit underground and still want to be man of the houseboats not possible. drug Game is Drug game. Drug moneys like blood money

which means dirty and its not descent income according to the level of a great Man to be wealthy society. If you do something that could lead you behind hand it is not decent or reliable money which is very good to people and children at home. People needed something that still get them to go to school and reeducated. And become all the people they wished and still want to be educated for. Great people like the Former President of USA DR Obama Barack and the only white president took over to fight for his country after the DR Barack Obama's Prime Chair came to an End. This man lived in the cities and he never knew anything about the country where you could connect or maybe you'd talk to your people in the neighborhood you coming from. You see people living there and they know that your are someone who love woman. Which concluded to make lade man. He be amour all around for talking to great woman he said. Well this moments that you meet someone in the cities, you remember where she live and you still want visitor them and when you get close but not that terrible. Some great woman might take you in instead. You would know how it feels to be behind a ladies man smile for instances, you may recall one of the guys you should have noticed to read a woman behavior and still know how to complement in a nice way." man said' you look so beautiful woman, thank you, a woman. How do you know it getting difficult to be around someone you don't snowsuits because you met humor her for the first time. How do you approach someone who is not interested to guys. If you would like to be next to a girl, you should know how total to her, not only one girl or a good woman you thought she would contribute or be to your excitement for that moments. Well its difficult to talk to someone who doesn't have social attraction to guys in the city area. Howdy you determine she's well civilized or may be she been around boring guys and she started to see other people around as new faces. If she be that kinda type to see and look guys as new to her, but I would be scared to give little facial expression to be characters by German accent, I would say. Well originally my rents are German and we grew up on the run for a great profit. The list go on and on, which simply describe a very

intelligent guys robe close to her; well its easy to be efferent from new faces or from ignorant people whom see around and still notice that on other moor instances, to be fluent and on the charming accent, its very good. If you seat back incandescent a real ladies man in the city, that will bring walkabout great conversation and also how he is describe to be around and still looking for something to do. A ladies man' 'woman Ask" well some guys do have enough time thinking about impressing a great woman and till know how to talk to great woman too; "ladies Man" he can seen as? But don't be evil to talk about great guys in the city" man" well you shouldn't be to bad to get to a counterpointing City guys. You taking like us now" investigator". Well guys and great people in the city are there to be around with their families and still know how to adopt the life and be with great to impress themselves and not just thinking about bad and say ; 'well do we look too fat? She's, well when you a guy from the cities and you might be too...um some where in the bad. Or rural state to see smart and well equip society and still think they sleep around in my neighborhood. Too bad to see guys traveling, that give false enlargements on that specification. They could be well educated and that added up theta their civilization for great congregation of people that can have or know the great Popes and people Of God living healthy and adopted to great city life. "not African?" man asked' all people that have differentiation of wealth and good communion and talk well with their people" which could crest very kind and civilized. people in every cities. Because the life should befell fast not just bad, too boring or maybe to be dead vendor insolvent community. Well I saw a lot about "Aromatherapy changed my perception and we like you and some people that might have saw you, they are people and they love to hang around great guys and well and congress people looked very kind and rich to me, that I now looked to you back as Rich guy and as time conclude conversationalist I looked different and same as you should have been. As you said from the time you saw me in the photos, my be an ill grown man. I was little kid looked like, at that time and time is precious to us, I mi well healthy grown Man in my Junior as to be

people to still can talk about great marriage." she said". you are great guy and that's what we liked about, you kept all promises real and stable before and after, and your Parents are mine too. Avoided your bad friends... You become I the state you meet and start to grow up to be around guys or people you don't like, well you should know how does that reflect in your own emissions anyhow does that give you the sense to speak out loud like grown cultured society. You know by now that when you have good people around you, you are well and very safety can see how your success grow and how to deal with bad emotions around your own people," well" you should see your friends as people you can talk to about all your problems, but if you have the signs to recall back and still know how to be with good but, before you would know that, Um; the exposure that you took from meeting people you just saw in the community environment, you still recognize all the things that's been said, and you happened to recalled all you have learn from your very first moment's to be with good people but not bad, you would recall the emission arrived from all you have received from bad company, compared to the good, bad snot the situation that you know and talk about freely like you should, but know how to recall the moments and heal, before and after you just happened that you could be with a grudged that you would like to can see and recall it fro mall you have been through. Avoided Bad alcohol, bad means really bad, to can see something you don't like to your own very moments to be pleased by bad situation of your own strength to be seen in the public place, you can around friends but, depends if you are hang around bad, but good friends will talk to you all you have achieved and all the things you could sow around your society, you society starts at home with yourself, to have and create Avery best of your own time, but not with bad memories to still see and say, "well" um I know that I'm going to meet people I don't like to hang around with, you start to receive that specs of exposure, if your friends like you when you are drunk, they shouldn't be the only people that can see you only when you are drunk, but depends ion "BAD ORGANIZATION" of the environment to still know that you,

drink but you end up taking the moment "stew be abusive, you are in the place regardless you rehanging around with bad company of thugs, not only toucan be around people that can see your smile to be bad, but not only when you hit the abusive state of bad friends or bad booze. Avoided Bad Income or losing money fast for Crack stalls, if you must have been drunk at work, the problem arise to speak out very loud with anger to your own bosses, you are not supposed to be drunk at work in the first place, "your Boss" you should be smelling like booze, "no" sir, but you know that when you smoking "weed" or seen to bad Marijuana also around the working environments, that not legal or appropriate to can have that smell close to your customers. Well its sometimes happens that you took from the bad well of fake crack bandit time that you look in to your pockets and still see what could have happened to you lately, you are broke and your pants smell like bad tobacco, all the time, and you speak like you are drunk to your, wife, first it started with your own boss at work. That is the problem you should know how to handle, because if you haven t taken any steps to know that you, have "serious problem to can, at home., at work, and you have chosen to deal crack, thought it would make you rich, but you cheating yourself, from not choosing the right places of booze and know you hit bad alcohol, well you should know how to handle that exposure with a bad breath. That's not good. To be in the bad organization and thought that could live out handy. It's handy only if you speak to the right people that can have you in the right state of time to fixed all its troubling them. Bad romance, your anger management, from work and know how to be and choose with the wright people. Bad alcohols can make you really sick, to hook up with people you get drunk, I meant really drunk from crack. That can leave out in no time. You could ban stall for crack to meet private, but you see the privacy happens to be in the dumpster, but you cannot be in those place for long time, you should know that you are not in the safe place to be exposed to that reality of exposure. You could only see your life in to a well, rather you should focus on cleaning yourself first and pick up the wright clothes to hit the great

standard of living and also contribute to the city society about all you can chive to neon the right side of the law, still know how its handled, but not the bad anger and still know how to consult the next moment of great exposure, to life, love and good communion. Avoided Loosing Great people or family in your life it's not the things you should consider, but keeping the wright family and still know how to secure your own very wealth. From you kids, your wife, yourself and your investments to know and have courage to speak to you for all or a great marriage, we are great together with love and great moments, this marriage keep us together "Great Spouse" to all we have and given by God, you are and to a great woman I met and loves great full if you are in love, but not fake or joke about great romance and to know that life, love is real. Have fun with your contribution towards knowledge and be great full, that someday you going to be well settled and know that to can be at any working environment and still know that to accommodate that experience and the only pressure in good way but not to handle bad anger with bad company and earn enough money to grow and earn the respect to your investments, family and you should be able to accompany the great life from your family and friends, whom will have a great fun for ever having and knowing that you are wealthy and still to know you and intellectuals to have received your great investments well healthy. "He said" After we haven't spoken for a very long time and I decided that we should have been together for a long distance relationship, and I tried to avoid all the commotion including the book and the marriage, the money for all that's been said, it's been that we have been together around for too long, "Spouse" remember when you put yours in a relationship, you should know how toucan handle the pressure and the possibilities about the moments you shared and not still look down on your very pleasurable exposure to the money, but look where you could make the only time to think and have courage about reality and the life in all possible frequent exposure. When we have seen all the its been around us to get to palace where concluded to have all to ease and have freedom and great life to our own investments and be grateful out to life and

romance in particular, life included the great love in the times or bad, behavior, anger, strange times and maybe to be in a place of bad time, a to be broke a little. And see not give up in all you wished for, knew she's been pressured by the time and the studies she's been to. But to still know that life, in the dumpsters does not worth it to be in the bad time. When you are having the dream of making or owning your deals and movie productions in the markets and industries where you are likely to have the it when you are determined to fulfill the knowledge and having the experiences to making your best quality's. When you are having the deal for the talents where you would like to see the are; Actors and directors of movies making companies, some make good money, which will please you for all the times of spending time making and creating the best outcomes for their reputations, which lives the mix of fashion world at ease and making of new Art woks, where by the videos of making your full movie for the last records, its in the final stage to productions and marketing. Achieving the very best outcomes in the near future as the successful business owner in making of Art compositions books and Directing of the acquired PhD. DR and Professor with Partridge in books and Writings of Nakakgolo Johannes Mashabela Holdings in the Global Markets distributions of Modern Art Security Technologies IN Business and Trading Enterprises, and Licensing of scripts writing in movies and music compositions. The company has established due to lack of finances in the books, at first we had received proper conducts with outsourced Auctions and companies, that used to provide the Audits services for us in Marketing and pricing and collecting of Art and Exhibitions investments and catering the very best of quality sounds invested provision of great material in the Engineering criteria of All Art Works. We are a Major company that have class and we associated with great honor and prosper to keep the level of investing in Books, we find it very interesting to have been acknowledged the essential needs and interest that is given from running around in the 7 Parts of the continents, which we are settled to provide the entire scheduled prosper to satisfying the needs for

Small, medium and major distributions regarded as bigger for private and public sectors of investing in Tenders projects and more. The establishments is merely based on the ongoing and resembled as sustainable combinations of identifying the gap in the organizations and fulfill the strengthen conduct in the Labs research and willing to change the peoples lives and their family's and also employing the very best of community talents and views to prosper and develop standards of living in the modern civilizations. If you recall to have a misunderstanding about all importance of making and trying to reach the potential dreams, you must be aware of movies industries that can provide you with relevant information to get your piece of material and Artworks on the Modern Art selling in the bigger industries. But only you could recall to have your works put together in a disk to the companies or productions in Engineering facilities to market your skills an also to Sign your works for more enduring quality and fame in the industries. More money on the projects should be established before you could start writing a script required for Porn materials, and have to produced material running in licensed materials in the industries When we required to provide the information contexts for the books novel and Porn magazines, we would write first the movies included the Thriller, Porn and romance, Rambo Actions movies on the books to uplift the interest of Artworks and to also talk about the "wolves Teeth trailers" that have given my company a romance agreement to can prove some of the quality materials, selling the market, first we started to write books, no one in the family gave the interest to the novels I wrote, but only my brother working as Chef, who is keeping the interest of publishing his "Recipe Cook books" Catering and Food Preparations, maybe in mid 2018 or so, but now I invited the views of movies and story telling companions to also look at my works regarded the comments which proves that, we are liable in the Market of movies and videos choreographing, speaking common language in all Artworks delivering the best of knowledge to the Business deals inviting he consumer interest, to see it positive for the final distributions reaching the consumers eyes for all the

companies success. The structure means, planning your terms of making and redirecting your movies productions to have the final copy where its proven to be in the format of reading the movies title and seeing which views that best holly woods Actions, comedy or drama movies in the market, the companies are not based on the same method of making the movies, its coming in o a place where you might have needed to outsources a certain skills for all your actors and mixed with real or popular actors that are know to making great actions, making of Denzel Washington, the best Bradly Copper, Steve Harvey, Chris Rock, Chris Tucker and more actors, Usher Raymond, Jami Fox x, Dave Chapel, Wesley Snaps, Samuel L Jackson, LL coll James and Prof Morgan Freeman etc. when we have encouraged to provide the exception of trailer versions for the novel book of "Wolves Teeth trailers" it a movie based on the outcome of saving the world. The starring is a Man of honor and class who is willing to protect the princess, and in is professions, is seen to be a body guards in his life, but only to stipulate a policing and security measures in the Artistry and common languages in identifying the Scene from an illegal distributions of Music and Fame, which leave us with the protection measures in the cities delivered for An Agent or "CIA" Management and US Governments corporates like "Kelly". Every man living in conducts with his family, as a legal citizen who is willing to live among the development of city's safety and security standards, which has the only major goals for all civilians to become safe in their own homes and own continents of developments, at work places and places of investments, which has the stipulations of Business Area, Banking, Cars and Assets, protections of skills in the productions factory's in Art, Music compositions and films to provide good and developed quality living standards of selling channels When we incorporate to have the money for the projects, we have identified that knowledge is a moor provisions faith and educated society who are able to can read and become educated, without hurting their investments" chicken soup" And to know when they need more of their potential ideas to grow physically and

emotionally at their home offices, their work places where they will have the freedom to work on their own projects without having to fear their languages, exposures to new Art organizations and projects to the Common Trading languages, in their experiences of September 11, the dimensions of the Most expensive Towers in the USA and Canada, the Earth quakes threatening the risk of collecting Arts at the exhibitions, the experiences restructured the housing developments in the USA and only to acquiring the best knowledge they needed or achieved to their very best of investments and more for Movies and trailers exploits and the winning of awards Experiences. making the best movies, which make us the best Directors licensed to know and work with, its also encouraging more work and more money coming in to the business. Its when you are realizing that, more quality time is spent on the standards of engineering which has the proven outcomes on investing on the skills of productions taking place on a regular services your company which provide a lot of the people who has the same dreams to change it and make it positive. For all the promises you know from establishing a dream come true, in the movies industries, the very importance to establishment regard the works you attracted with meeting the interest of all the proven consumers potentials, investing for the proven track of works, experiences to delivering as part of the Acting career to provide, and conducts interviews for partial actors who are willing to work experiences and consulting A small, Medium and Major enterprises to doing as part on the Acting careers to provide and conducts Internet invitations for more Actors in the industries to participate and who are willing to work on a script materials and performances in Acting careers to provide a positive posts when its required by movie deals and Managements. The skills are encouraging business Owners invested on the Assets in their daily operations where, they are capable of making more money everyday and depending on their daily income, monthly and annually remunerations and its very important to know that, they are making a lot of progress in the business and trade marketers of books materials, descent income in their daily investments, its great

clients as holding firms that, sell Arts in Movies and Arts in Music, and also providing consultations of Marketing teams, financial teams and prospects of investing more with Artist as part the companies Assets and more contributions like Sony music and movie deals, entertainment and more to provide the professional movies editing and distributions form licensed companies worldwide.

Scene 2

Handling the Stage Fright and Keeping your ART Cultures

This criteria has the only main potential results when you are not well with the audiences and when you have just met your management team in the music deals, when you are seen and have been considered to have the talent they want, and the only talent you can identify the greatest of music and the Artists in particular, the experiences is given when you are a starter and when you have not been in contact with the stage deals, yet to know how to handle it its manly the only ideas which has given us the potential for all the artists that are able to give and, not just to potential. On the real streets is not easy to just handle the crown of ore that the capacity of a Stadium, simply leave us with almost half a million population who are able to receive the music, the only people at that moment who are presented and have received the tickets bought for the concert taking place, and delivering the idea of music band and the artist its rear to hear when you are used to the fright, simply the stage fright. To have the only culture does not start from the time you reach the fright, from the beginning of the career its important to have knowledge and the ideas to know your music, as an Artist, to know what you selling to the people and the community in all senses of human characters. When you want to know about the

music you are able to sell is when you have been in the criteria of musicians knowledge and have been received to know the best quality of composing a song in the first place, when you compose a song you don't need to be ugly on stage and also on the music equipments you don't need to be bad towards making music, and you don't need to be seen as someone who is not encouraged from where you have taken and for the better before you could reach the commercial projects, if you are reaching the best results of music composition you are trying by all means to change the way the talent is achieved and make it possible to stand of the positive results from experiencing the shortage and functional needs to making quality Art with good equipments and good Producers. The fright is given in to many different reasons of the industries and music making corporations, when you able to talk to the organization of musicians, and the society which are seen as the culture music listeners at home, on their way for work and other organizations which have the knowledge achieved to have access to the music collaborations and the equipments specified when you are the Disc Jockey, a radio "DJ" in particular radio stations forming the Artist point of views, it is the scary moments of ll times, when you hear from the interview of Artist and Music producers or Artists specified to have the deal and the Management of music industries. It in the music organization they have the career development with artist that teach about the stage fright and the knowledge to have the music selling and making the success to great society and the experience to the culture and development of music and technology, and delivering the best results is when you have traveled a long way with the collaboration of musicians in the Pimped BUS and you realize that you should still need more time to deliver the best needs, the need is the services you selling, the need is the music you are willing to share with your listeners and music making company's simply performing for the best results you would show, it happens with other Artists on Live stage to remember the lyrics, to remember all your songs you produced and give the best of all your titled experiments of making great and sharing the best on your Tour and

interview over the radio and with companies. For the best results proven to be on stage and have achieved you only type on concern for the music to reach the masses of people and the masses of individuals, you will experiences the change when you are welcomed to can work with bigger company's for the Artists; who are able to make great and quality sounds and to have the great market for your music of great art, or rich and experienced artist who have the market of million fans in the music corporation experiences, and have achieved the title of the best artist and the "Rock Star" engagements with the media and collaboration companies of fashion in music, "not just one genre, all different organizations of music making doors and Art". To handle, it meant having the pressure of bad organizations who are threatening to close your music career at all time they want to talk or meet, who are not able to assist you finances of music and Art in particular basis but private stalls of Thugs and thieves who want to steal you music and sell it for their own good or their benefit. This is the courage to know who is good producer and bad producers. Remembering your own concepts of Art material is great to have courage and better education when you able to can talk positive to the society of culture society, when we talk and see the music in the develop world of music type ad collaboration, you are meant to have the achievement to your career and best of work you are willing to sell to the people, this only has the courage for music to be seen as the best quality and the best artist to receive the awards. Make sure that you are able to handle the stage fright and know your music composition as an Artist, with talents is easy to make it in the near future when you reach the final stage. It happened long time ago, back "in the olden days, over100000 hundred thousand million times is been said, that time spent worth a penny. I have been dealing with time and money since the time I was born, I have been introduced to many differences regarding how to revalued in a respectable or I Respectable in the black uncivilized communion. Since we know how our parents, whom can be viewed as the only people having responsibilities for their own destiny... kids are not supposed to be

involved around parental activities...this means they are not capable of any methods and experiences valued of money and for spending it, regardless wisely or just for exposure, which we haven "started yet" its said. "money is very important and you have to be in position to achieve what is behind the values" Dear Madam, she is my consultant, she is the only one who can get the dream to be true. She is very accurate and we have been in contact through about the book, to take place and also other written menu scripts, one is "Business Adventures by Shane" two "The Wolves teeth Trailer "and three." Freddy Cooker "it's good and fascinating that the books have performed really impressive, I mean really good. Good which means? Perfect. Ring ring ring. Ring, hello whose there? It's me the author. "Yes" it's Angel the consultant how you're-doing these days MR Mashabela? Life is great and very good and you have my personal contacts, its great you able to have me included for this err, "yes" the package issue till the next season "she says" I sent you the email and also the contract, I would like you Prof. Mashabela to take a look at it, I have completed the contract already, "Madam" OK when will you make the first arrangements for the deal to take place Prince Mashabela? This season, um before the end of this month's its July 2010. OK I'm your consultant I know you can be good with your first installments, of $1200 American dollars. Reset's good to hear from you madam. Good bye. Still ha veto be at the writing place, I have all the time about the money I still had to pay for the deal; it's a deal for Christ sake. I mean a book deal, what does it mean? A book deal he says; I figure out that writing ideas can uplift and maintain all my requirements. Through all the scheduled time, remember I'm a writer" he says" who? Who is your consultant? Why do you call him, you only consultant? Each time you are with your consultant you, you become intelligent and I see you now. "Yes" Angel More it's her name, I'm glad we have managed to keep her occupied and have also maintained to keep a safe copy of "The Wolves Teeth trailer" the novel; the novel of course "he says". Remember we have lost the book and now, we are victorious. We are millionaires I say, hooray Hoorays. The book included, is Wolf's

teeth a novel book, its completed, and its published the same day with the most wanted novel book, interesting to, interesting...I mean the play;" yes it's the movie, a full movie written, written at the same time?. "The time took compiled the book, "Business Adventures". You'd find it on line, it's; like the others situated with "Wolves Teeth", Interesting interesting." Writing movie it's very important, to tackle the ignorant community, reading and writing, really educated the social society, to be more open and reveling about the present and future activities. The mission completed when Wolf. Wolf's Teeth completed. He calls himself the only Prince. He was in jail before he meets and defended the princess, at the time before he destroyed the evil crew, who is the only destruction and the bad scientists. Who invented the flying bird... we don't recommend him to be an invention for the future. It's sensitive and scary to see people from the future, to be in hand with bad organization, ruling the underworld. Wolf teeth, who may be the man of majesty and good romance, he believes that capturing a human blood for any illegals, um, illegal or secretive measures, does t not mean anything; anything good, apart from all "happening. Witnessed all around the city, the people being misled and accused of bad behavior for nothing, I think it's for quick bucks, quick money you say? "Yes said" the Princess. From the very first time, the princess fell in love with the. The prince, "Wolves Teeth" the love created total romance. The relationship created hatred to all the underground crew, after that evil crew, which include the Rebels crew and the only part of nature coursed and derived by the evil measures, wean call it the Human Rat, or human snake. It's a snake "A real snake from hell" Human body, woman face and tail. We here the Human rat before it could be given bad, she was a scientist and mistrusted the idea of ruling the world, till she discovered her truth exposure of mixing different potions and other animals blood. That created her distant; from real human life and animal species to be differences about the novel, "99 Monkey's holding from man dream" it's doesn't mean to be offending to any viewers or the owner's. I give thanks to the people giving the support for the book,

given the details or any major recommends that might offend, or tress pass any part of your true moments. This book is for all readers, it's for everybody willing to purchase the given value on the back cover and also to navigate. I have given all my thought together; I have been through all time given and the bookmaking all the scheduled time. The book I would like to dedicate it to all the important people that have treasured my existence, people I would like to call them parents, mentors. My father whom we have discovered lately he's African Prince, and business man and his wife whom recalled being the only mother, whom we can treasure who is in heaven are finally through all the ups and downs. The opportunities makes possible for the family to move on and enjoy our days since living, In my presence forever. It's possible to achieve all God promised, you can be the person you wanted to before as long as you can pray, and know how to stay away from all the bad habits. I situated myself away from the likes of bad smoking and abusive to cigarettes and other related illegal drugs. The abuse of alcohol is not healthy; beer it's healthy only at respective environments. I rather drink and enjoy the taste of Beer, but not abuse it. I don't confuse the thirst for Water and Beer, or wine. Someone can choose to drink beer or milk. Alcoholism not food, oar meal, other than refreshments you could buy at Conner store or gas station. I prefer the taste of good wine, and special made of champagne. The other part of Africa you become someone overweight for eating a lot of junk food, pork food and other meals which create overweight or make you to become fat and to lose more of your confidence. Well on the other part if someone is married to a fat or overweight partner they still continue to be in their marriages. Regardless of never Christian society or Hindu culture, overweight or anything but they consider marriage to be real. Overweight tells a lot about a married couple that can ban the relationship and still not consider any difference to become very fat, and also to their children. You might find a family of 5 all fat and also their parents. You should know and tell how much they could weight and what they should eat if they are overweight or just fat ordinary

society. They can be seen as the only people that can eat and finish a whole chicken alone. They are seen robe people who love to eat, but if those people who can eat more than 2 grates of chickens in one supper. They are fat but they still eat to be on the same level. Or overweight, there are a lot you can do to be on the weight you desire, if you are fat. You put on the work to be at least mild-weight but depend on what you do to excise or taking jock every day to keep good and fit, maybe taking you partner for a walk and still talk about losing weight. Fat couples really a friendly to talk to them about their weight and some of the fat guys they never have experience to bewitch their partners of loosed the good side of their relationships because of over weighting. I know the people that are fat in my family and some they become bad when you tell them, they are things you should not eat when you are approaching overweight and you cut down on your fats diets or not food that contain too much fats or too much of junk. You should know that overweight it's not good when you start to sweat, when you in the house you open all the windows and also the doors wide open, that's create someone who sweat a lot he needs some fresh air "not that they stink" but, yes open the windows "Fat Couple" yes, sir and the all the doors? It's great or live in that house, but you sometimes when you open everything and also sleep or just happened to pass out with the windows open, you might happen to catch cold and you wake up lazy and drowsy, not uncomfortable and you remember. I slept with the windows open. You catch minor colds but not really bad. So avoid bad diets or change the diets every time or great meal. After we have spotted the great about writing and configure the importance to be educated than to be nobody who can impress to please their loved ones. Behave experienced the total scam behind the compensation worth about $300.000.00 dollars to be collected and the truth behind all the information or behind the scene, is that um, there s no money only a scam found that the thugs have robbed a "Drug store and they want to hide iron the compensation. After is been found that the truth is The air, know I become someone who interact to nothing but a scam, I become

brilliant when dealing with those people, that she wanted to be free from all the scene she's been bind to and to also lie about her living in Dakar or the Senegal, all the information was from someone in Britain and trying to connect through and to become a free society from the money and illegal transportation on Crack and other illegal products been found to be bad or fake clothes, from Nigerian Thugs. He happened to connect to the people and also wanted to discuss business, he was jailed and he's in closed doors. So um writing behind a scam was a way which expresses the incredible results relating to and also the great about protection from anti virus and the people whom have identified to hack in to home computers daily are been identified to be invading from crack stores, but selling cracked anti virus from wrong places. Like you should be carefully to download from any sides that is been to be crack place a place where you could connect to bad people that send or affect your computer with viruses. By selling a distributions to my own people that could happen to be trusted and to call them great customers from my anti virus protections unit, they are believed to beery intelligent when to choosing a stable source to palace from all the harms identified, or just crack people trying to raise some money for quick fixes and selling cracked software, but that's also coveting to sell from bad reputation of a programmed discs, and to know that you bought it for cheap and still not find the right program in the diskettes. Or to find that the computer program or software you trying to installed is a virus bandit your computer not turned on and still see the screen that says, your computer is not well and you need a software engineer to resolve the matter, well just know that you have been hacked and you just lost all the valuable of you data you might happen to retrieve but with someone, professional to be helping you to get back to you stable computer desktop or laptop you might have. You get information from people you work with and that information you happen to copy and paste it on your computer laptop, or standard lone desktops computer, which should be easy as someone who know what's the file situated. And if you happens to see your computer restarting without you touching

the button, just know you are been attacked by viruses, could be different from Trojan or worm or a dirty horse happen to be new. Anyhow to you get in a place where you pay for something which will just take its time not to do the correct job for your computer. If you get caught in the broken file, some other information you saving, is not there and you happened to be replicating other files you cannot open anymore, and they will be your only important files you trying of work on them. You or loose information if you don't have the man to clean your society, of just everyone in your neighborhood invading, more 200 viruses invading the internet every day, computer scanner is needed and that could also add up into monthly budged and it depend show much you could spent trying to maintain your officer computer equipment,. You also losing money in your bank account through internet banking and other fee have been deducted, but they should never be bank charges, what's going on in your computer. So that can make you broke if you don't have a necessary information reliable fro you accounts to be protected from hackers or just ordinary people you might happen to know selling cracked disk on the roads from piracy reasons, they must be hungry. Ow much you should count a day if keep losing more money in the house and you don't think that it could be a crack man, apart from spending on yourself and family but, buying bread does not have to leave family man broke every month, that tells a lot about the society loosing money and they don't know what could have happened, that's really happening in our own families every day. We not protect anymore from the civil viruses trying to be distracting our budgets in our own homes, and then what could then be the exposure for business Man losing more money monthly never estimated to be on his daily budget or spending and trying to be in his home and still losing more money from the interne? And he tried to own home base we could say, and he tried to keep his stable investments for other related business occasions. You should if you could own, you are having mean to avoid all the traffic and other money toucan lose trying to be early at work or just paying money ton body. Running after a job is not

like running after business deal or distribution s, but it's almost" "the same to keep you spending and still knowing how to be saving and spending wisely on your money and also investing on your distribution to keep money coming in your pocket. If you are well and safe to your income and still want to know how to loose bad behavior of bad strength from all the money spent, it's not easy for a Fat or big couple Mohave and still be living on the crack money. You cannot make money selling bad distribution, crack doesn't have be mean less to the illegal drugs society but is liable to make good profit from where you cannot invest, and if the bank should know that you must be robbing stores to keep your investment in the very good, how will you browning a money you never know where it comes from and want to still know how to bank it safely, it could be through money from bad investments like robbing or cheating the state law, selling crack to people. But if you assign legal duties and make great impact to know really, who is buying crack from crack stores, it's not liable to lose weight on crack and it's not liable to steel money and expect to be rich like someone you just saw in the movies, and not to be also be fat and still telling people that maybe be crack could work well. Crack killed a lot of fat people trying to lose weight, a trying to be smoking for something else which is not true, you rather better betaking a gym or taking few laps every day and adjust on stand still know how to talk to be open to professionals that can assist you to lose weight. Some fat guys they become overweight depending on their stress level and which could live them over eating bad diet or trying to heal the pain or stress from losing someone to be your spouse. If you can try to be open about your stress level that also can live out to talk to other overweight and still know how your share you're thought to loosing bad weight. Most of the time you might be overweight and you would not likes to be in the moments, especially from those guys who happen to be in a relationship, you meet a great woman on the dating sites, you like her and you might be in the place where. You would like to be with a good friend and you happened to visit the nearest Love social community. You see the guy behind the computer, "halloo

34

sir" good morning the visitor, please have a seat" the guys click on his computer" and he say "well "sir. you would like Mohave something we can talk to you about, the guy" I just happened to be I a relationships with myself for the past 5years and I don't have a woman in my life I live with, and I would like you to be giving me the idea how to can meet someone who can match as my only spouse to come and be with me, now to can have the right time spent together apart from all the time spent in the bachelors state of romance, I had no one to see but from trying to lose weight and still know how to be in the dates I would like to have. The guru expect came to be around AND "he said", we would like to take you to other offices about all you just been said and awe have also seen you around in the websites of social media, you would be liked to have given a second chance to have and meet your likes of great woman you would meet to become your only spouse. The guy gives him a form to sign and behind the information it's TWO PAGES, For us heard me in my voice when I speak and every time I could tell she felt free in relive. I told her the truth from the start and she said, nothing will ever destroy this relationship and all that happened was just a myth. Rehanged around till we couldn't talk, we just staring into each other and laughing. I was so excited and she could tell and she said, we had everything to talk about and all it takes in this- love we are in together. From the every first startle never initiated for a long distance relationship, Meant something that will not keep us apart. Previously the people that she thoughtless take over and be in a relationship with, those people no longer existed came She changed all interest and make it achievable, she might thought those people do not know how robb with a man they Love". I also thought the something with all her previous relationships which I have given any interest and all my thoughts to ask and waist time on it. From the first time she changed the entire situational," If you have time and could think that I'm The person, who is interested, you shouldn't not have to waste you energy or your skills to say that she's in Love me. and I had all the fun and we cheered and enjoyed all the time we were together. We have taken everything serious

only Love kept us together and caring. Her taking part in this relationship, everything changed and we had to strata new life. She is welcomed to be and move on with and; we have hoped that everything will just fall in place from now-on; nothing will ever keep all for the sake, from all what she" has given to my heart it will never become replaced the love given, we shared the same beat of life. I knew she's not that one night person who will not even waist time on this entire marriage.; she's another person who has given me positive responses through everything, I have dedicated all my time to finish the bookend she's seen part of this book. I went to the Palo Alto University in the USA Laboratory to do my work for the weekends and the lady at the reception told me that the internet is not available to the entire world. I'm so unimpressed about how they run the community library, all Needed to do for today and also for the weekend is to check my emails and continue with writing the novel. I have a clear understanding and knowledge about all the libraries is a place to do all your research and also acquire book of all your studies, this misunderstanding to what should be happening postmodernism civilization time. I know that people hectometer library because educated intergovernmental facilities; they know that intergovernmental free deliveries to the community as a whole. This is what it is always intended that, the government should deliver appropriate provision townspeople, regardless they are poor or rich, might be Business people or people that don't really interfere with the government services. I call them "arrogant people that donor have a clue, about the beauty of their world and their country's". The world is facing out all the problems that white people created, trying to eliminate the states of black's future. This is the time to show the people in this earth; Black people are not situated as slaves or thugs anymore. Power cut, what we call wealth and allocated them, naturally from God and his people's culture. We have the families all netherworld; we don't hold any difference from nonexistence community, but we are more intelligent and civilized. We are still Blacks, we are people that have good education and have acquired a lot of investments projected to the human race in

general as Blacks. Blacks don't like to be named all sorts of things like "monkeys or devils", the enclosure does not separate the blacks "humanity to the public, with other cultures and which Describe their identity as the "whites". I'm truly confused with all the Africa systems interferes with confusion about the government facilities, which says "blacks are not well trained to guide the country and to Bethe leaders of the future". It is so difficult to actually live with that lie, Black people don't believe in that commotion anymore; Blacks were forced to do what meant to be done in those broken days or apartheid. Blacks hold the furthermore own political rights according to the states. Black people refuse the word Niggers or Affairs, which identify racism to the black community in general. I don't encourage people apart from the Blacks to use those words as major courses or tools to insult their fellow Black brothers or sisters that describe the African race. African people are meant to give the power to the entire world; wear mixed with the identity of different cultures differentiation, Christians or non- Christians. Among the African youth I would try to guide the nations cottonseed Blacks or Africans as a description of incomprehensibility with aging or see them as a tool describer private activities. That lead to discouragement to human nature as a whole, and Blacks don't hate their fellow brothers and sisters, they don't Kill or molest their brothers or sisters, and they are people with Human love and natural Romance, to their own people or partners. Indescribable as a major step for black people encouragement success, wealth and character given delegate black youth in many different ways. Backslapper people and united in their own African cultures. To all we talked about, through all the meetings and talking to each other with, everything that been spoken about. I never taken it for granted and I tried tollways keep it underground from the very first time we only one spoken over the phone and also in writing as it swished, this is the only chance have carted in this relationship for the entire process, explained and encouraged. Not to invite bad people or trying to invite thugs and this is all about the book. I never thought these things could happen in this moment relationships, I'm

battledress I could get to talk and share my life with people, people I don't know, or consider them as strangers. I'm able to write and demonstrate my feelings republication. I always wanted to be in these modern times, where blacks could actually be considered salespeople dignity and hoped that this moments redelivered to all fellow people. I always wanted overwrite book that will cater millions and billions people and impressed them. This is the moment Revealed the most wanted conversation that will deliver the true understanding and the true moment that have encouraged and that I could have said, the conversation that Considered as a breakthrough and considered the conversation to be true. True to what Wanted the relationship to be "Real", there are major steps taken beforehand to get to this moment. All needed is to feel safe and welcomed and be loved the same way she wanted to be. A person that belongs to someone, who is in Love and someone that could be and give all he had for this relationship to work. Not only the, "Relationship" obits own but the Love that lead for a good marriage. Fortissimo this is all happening to myself and her always needed to impress each other and Explain that, firstly, thanked me for my reaction to all of this Love dedicated; in line with everything we have for one another, which described the entire relationship. She asked about everything over including my country state and also the people. She believed that I m in good health, and "asked that the atmosphere in South Africa must be impressive. Her country is a little bit warm and rainy". That's all she always asked about. I also believability is a person that will never cater all herniation this relationship we have for granted, and Believed she always kept her future at ease and her Health is very perfect. Partner who is 27 years old of age and she'd say age doesn't mattering a real relationship. She is comfortable with herbage, she is from (Liberia, in West Africa,) and she is 5.8ft tall and fair in complexion, she has Beautiful face, Dark Brown long hair and she in-relationship,(In marriage) and presently she is engaged. She was residing in Liberia the West of Africa, as a resultant civil war that was fought back in her country women ago. Her late father is Broadmindedness; he was politician and the managing director of

a (Gold & Mine Industry.) in Monrovia the capital of Liberia, before he was attacked and the rebels "jumped inside the house one early morning and shot him and his wife in cold blooded, based on the true story. This affected her and her life very bad way and not only she's kept in safe places; she's in hiding from the rebels. She cannot manage Ventolin this entire commotion, and that always kept her to bemire venerable and always her situation kept her to be on look out to fight and always win. She's open about her previous experiences and hopefully, she carries around gun "Nina Brown handgun spray" with her for her safety. This is actually true story and the rebels are in coldblooded cases. They cannot run away forever and thesis the end of the entire situation. Right now, myself people in-hands and we talked about everything, we never kept any secret, she is the personalize inhere family, and she managed to make her way nearby country (Liberia) where she used to live refugee under the care of Reverend Pastor and underrepresented computers to send and going through all her messages, e-mails and to other one's always kept track to. She had never offended man all her messages she always sent to me, it's just that she had the chance to can explain to everything and felt free to be the person she is today. She did know what else to do, because her situation there haste refugee, has given her a great concern therefore; she considered her situation as an adult. And she asked me to be kind with her at all times, as sputtering all of her trust on me without any unconcerned, though we know each other well and we very happy, she believed Love at first that, I cannot betray no other end. She has communicated with me about the entire situations entailing her refugees' status, she'd say, it's just like one staying in the prison and she hoped by God's grace that she will bout there soon. I have never encouraged being negative towards all she always hoped for. We are Ina relationship now, we are together interrelationship always kept us safe. basket work send and transfers some money to her account. Mismanage do as asked, I'm not that rich and I tried by all means to send some money for food, clothe sand other woman staff she prefers. If I couldn't manage or didn't send money, she would

be upset with me and never answer all my calls or respond tony of my emails or letters. Her not returning any of my calls, I was worried and after I have sent some money. She will be happy about it, and respondent calls and e-mails, as well as all the gift sand lotters. I didn't want her to be in any bad situations ever in her entire life, as long as god altogether. I cannot accept her imprisoned mannerism or discouragement she experienced beforehand be together. She always complained and talked to me about all her tent mates at refuges camp state, that they'll ran away in the middle of the world war and the only person she had on her side snow a member of the clergy (Reverend), who is the pastor of the(CHRIST SAVIOR MISSION) at the camp. All Know that Rev. has been very nice everybody the camp, but in certain circumstances therefore we're not allowed and where not supposed therewith him; rather they used to live in church for mesquite time. In the middle of the war and her to leave and stay in the hostels, church was divided into two sections, one for the males, and the other for the females. If she had someone who would want to talk to the Rev. you were required to go through him and if you'd call the Rev. Pastor, he will be available to everything you'd ask for. Refugees at are those camps do not for not privileged to anything, but that will create havoc, because it is against of the country. She also described a lot outplacement and she was tight about it, wanting to go back to her studies because she only attended her first year before the tragic incident. The incident that leads to her being in the entire situation took place. And she asked me to please and listen to all her secrets (she pleaded with me in any given direction, Urged to keep it really a secret, even no New found land about the secret except the Diversification of The Priest hood foundation, which she BOUT knows about it). She basket work can send some money for her to get all counter intelligence ready and done for a good purpose, and air ticket to come over to meet with man South Africa. She asked me to do, and she told me that, she was forced to keep a secret to the people in the camp there. The only person that should know about it is the Reverends, because he was like a close relative to her. So, she's

lacked to keep it secrets and I was unsupported tell it to anyone because she was afraid losing life and the people get to know about it badly towards everything and they will suspected might be involved in some scandals with the Church. This Family gave mean authority to be a good person and also the compassion encouraged our marriage to even grow positively. We kept ourselves in good health, perfect as it should be, we have given ourselves time and we exercise it quite often. During the weekend we hit the Jim and even during the week. We like to keep ourselves in good conditions inside out. We keep on healthy died, we don't miss breakfast, my favorites scrambled eggs, butterfingered bread, ham and sausage rolls. Unavoidable food. We use to rely, apart from any brotherhood Monkey bread, chicken, vegetable and Rice it's our favorites. Fruits also add to my greengrocery and monthly. She and I don't like to oppositional, where we would find it difficult to cantankerous walk for 3 to 5 miles without complaining. We always keep and we still practicing our healthy life style and also our body shape it's perfect and whenever denied each other's presence. We speak English all the time and we fluent too and we prefer keeping up to date with latest technology and healthy life styles. Like reading magazines handbooks and she's well advanced with all anesthesiologists, same to me, but we different mine diseased the male side of it. This is the moment chemotherapy showed me that life is so real and I have shortchange and experienced it. I'm so relived from all the hurt that is still hunting me. I believed in real pain, from what Have lost, a mothers touch and Miss my mother's best cooking. My Late mother was good lady with dignity and self-respect, not just to herself, only to all the people in the world and in all the African countries. I wanted the people and to know that I really missed her reallocated my Mother in law, she shown me that nothingness important that could separate, the Lovechild created and given to us the people and the love and life that provided the true human nation sand the true human nature on this earth. We writing book and we planned to finish writing it in six month period. In the next quarter I have planned to have two books ready in hand for publishing, firstly I

wanted to have "Business Adventure by Shade" published and the others not yet ready for publishing which not included yet" she and myself we working course books and we are together writing and editing workloads of work at home moved together. We wanted to add and express little reformatory it and also to add to our writing skills; recreated time catered for the books ready in hand. We don't usually take this long when writing and finish book. We have been around and rubbed shoulder with people that always encouraged us to be writers, and from all our friends from college and friends from the universities. We thought that if we could be together giving each a helping hand in writing and editing our own work, this will lead to predisposition, at first we used to write to ourselves, until were discovered that we could be together and writable. We have discovered true emotions contraindicated to all of this relationship. We are interrelationship not because we hurt, but we know something that describes and put us together, which is true Love we sharing. We in this relationship with all we have and to give all of our emotions and expressions that describe true love, no matter you are black or not black. Love and relationship does not choose certain color, necromancer and true love. We used to read this antiparticles about Millions of dollars on newspapers antithesis the reason we disclosed the process to be fulfilling. Rediscovered that this is truly unbelievable. We have also written and have been around the internet world a million times and weave read articles on newspaper overcompensation says, if you can write about 1000words anymore you can claim and win a price. And the undisclosed amounts of money that you can homemaker, the articles would give you the courage to fall in to that trap, after you have sent them the words needed, and they would send back a mail with their banking details. You have to send them the money showing on their mail to can be in their books. If you don't deposits the money they stop responding to your mails. Remember at first they said you can be millionaire just by writing about 1000 words or more. All the things they say on the mail heartstrings will actually blind you and never Through breadth is so huge, people out there

are trying to uninfluenced other people to become millionairess. It's impossible to can just reconstitution investing or saving it to yourself. Westbound possible to actually save and claim the honeymoon worked for and real money that will not stupidity or UN-human. We witnessed stages that created the situations describing our current state of romance, we needed only the two of us this Christmas holidays, we talked about us and also about the marriage, that's what we enjoyed the most which put us together at all times. Christmas it is the time were families get together to bewitch their loved husbands and wife's, it is the time patres familias with their loved ones in excitement. Christmas created the space for families to enjoy the birthstones Christ. Its the time families give and interchangeability their loved ones, friends and other relative sin the neighborhoods. I transferred every cent asked and she gave me the impression that we could be able Togo forward. It worked for both onus and she received everything; I did as asked and remembered everything as told. We had everything in order and everything under control. We had major activities taken into account and wear situated among adults, our skills delivered everything. I didn't waste anytime of it, Intended to not to I'm SO IN LOVE with everything achievement I thought of her. She was able Love as long she needed to be, We enjoyed every time of it. I want a least to have almost $50Bucks whichever all the costs, I can used to buy airtime to can get hold her. You know I needed someone special in the country before its in every Christmas, which fits possible, or we can wait till its proper. "I said" The connections showed our situation, success really touches us and willing to fulfill all desires. How we described my situation knowing to understand as my future wife "I said" I lived Yorktown, I have a place, and I mean a good place insouciant. I haven't got a Father and I tried to track him when my mother was living, and my mother never uses to like it when we asked about him and his identity. My mother would say, my father is African and also Christian and my mother is also Christian too and my Father never shown or lived with us, he left when Was still in my mother's womb," she would say". My mother waste one buying

staff around the house, motherland she wanted me to have my own life. Haberdashery good with us and she wanted to see unsuccessful she is still a good Mother and Respected her. She always encouraged that if you live the house you never have to come back. I understand everything she said to us, if my mother was living, we would be happy and around the house. I have little sister her name, she Love music and she love to become educated too. She is 23year old, she's very smart. I want us to endure and know South Africa, she lived with her parents in the disadvantaged location. She still very young according to me, since she lost my mother's touch too, it's very difficult for hero live on her on; my brother supports used with food and paying all our transport education fees. I love music too and have studied Business informational ART Communications and IT Management, at Rose bank Business School graduates, I have also Studied MEN which is Master In Network Engineer, I'm a computer literate understanding all the IT Modules sequentially multiprogramming languages, like Vb. Net, Pythagorean. IT Degree in businesses School actually admired South Africa after the World Cup federations success. When we started to develop the only results that leads us to the implementations of modern books and technology for writing great movies and stories that, are able to have the total exposure to uplift our own society in a respectable manner where we are great to can share our great talents through publishing and talking to our readers in the best selling books of Wolves Teeth Trailer" the second copyrights which has the different understanding of creativity in the movies and writing the novel that would make the positive impact to the only organizations in a way of telling a story and Modern writing of Art skills creativity books that have the corporation that sell and leads the mixing of Arts and skills in the corporate of Money making industries in all great centuries. For a movie directing point of views is preserved to obtain a quality standards materials where you are likely to concentrate and have full focus on the movies, planning and structuring, keeping the only type of engineering to be very unique and satisfying contemplating to the full movies for over time 45 minutes or over

an hours for full length. When you recall ideas of writing a Novel first and making the movies or series concerning into the story tittle of famous writing or novels, its properly taken into account for the directors who still know and refer back to the talents that have given an impact in to the growing community to become, and be able identify a great Story novels employed in the movies and skills productions for full inspections. The "Wolves Teeth trailer" is based on he movie written by myself in the novel of "Wolves Teeth" Trailer starting to have the only scripts but it was not easy as to know how we started in the first place without having the knowledge to licensing the Menu scripts, receiving exceptions from having to own the book published with the "Business Adventures by Shane" The Distribution deal at level entry of Shane books, where it was not proper to work on other level of materials of producing more novel books in education provided the only materials that my company is invested from achieving a million dollars sales records in a week, descent income "I proclaim" and we where seen at first losing and insolvent, but to have a deal which changed all the criteria, the importance that left my company's reputation growing more everyday meeting new potential customers and the Chief Financial s offices "CFO" Other Chief Executives directors. Mark Markula for any investments name within the company registration of new owned companies and Auditing firms, it can be any Trade name in Auditing for your book keeping, regarded Trade and industries. Its the experiences we are always reached from purchasing the previous deal without a loss in the company. We experienced to achieved a target values retained from all the profits in the company "with the first deal "for almost over $800 000 000 eight hundred million in investing in the projects of building museums and developing the infrastructures regarding to sell the "business Projects" to the market which has acquired a very best standards to Established the investments successfully in the Amazon, Google-books, water-stone books UK, a seen on TV CNA Books and other book stores and franchises seen to become a growing industries in the global distributions Market of Books and education Materials. The best

part that is mostly having our books published with bigger companies, to be best seller of all times media contributions in books ans story telling materials, which we find it sudden and very interesting to have our point of views into greater understanding and through "Business Adventures by Shane" portfolio.

Scene 3

Creating the very best of all ART Works

Making music is not very difficult to experience the real need, but making just the music is different when you want to be the real musician or the real producers, the music is entitled to create the history of human kind and human behavior, and also to realize the most given talents of people and industries in the whole country. When you choose to make great music for yourself and for the music lover, you are able to make it possible from a career in the near future, looking on the bigger side to identify the need and for people in general. You are able to have the pleasure of making music with your company, and you are seen to have you home studio or The Garage band for making songs just in your home. When you make a song it means you need to know to write it in the first place, which is the part when you want tot compose and work on the song and the albums you willing to produce as a final results proven to be a signed artist working of his music project for the next or the first deal you just signed with companies. It can be small or bigger companies, or given the chance to work on the Art Piece for the certain project with companies that want you to be on the collaboration or that wan t to be with you when you are signing the album with companies, or when you are marketing the quality of materials you willing to sell at the Music Market and Mass, medium Sources of Production. Newly developed criteria from the small and

medium establishment, also the major corporations ladder in the enrollment of business that delivers the best of all in the community's that are able to find courage from their downfall, from all they are trying to implement in their daily basis of making compositions and producing the best of all in the music, Art and Modern and digital technology which provide the develop strategies in the economy to able the assistance in the music of corporations and the government involvements for a better change, for a better communication of Artist with major companies for every results given and proved to become reachable and loyal for the method that satisfies the producers of all Business and production process in respect of the different views. Teen couragement that delivers the best outcome in the fashion ladder its the thorough investment in the material of producing the final product and the encouragement does not have to become only on the music production and education, consistent on the delivered designs of the best knowledge that the Actor's in the movies industries are able to invest in the proper make of great material of Art and styles and differentiations of music genres and music videos. Its rare to find positive behavior in the music industries if there are not value of Art works, and investment criteria in the production process of companies involved in making and feeding the music industries and distribution proper conducts and education to fans, consumers and the shareholders. Stealing and recoveries of Pieces of Art Material worth for a paint, with the great price has been responded to catch the eyes of major Artist in the cooperate world about bogus Art or just privacy concluded to misunderstanding the history of Art in particular basis for criminals who are willing to destroy and discourage, also damaging the works of people. Which included stealing of someone's property in not appropriate, its been delivered in the New York times on the new paper that a scandal and hatred of certain artist among the society and lovers, inventors of Art Materials are not properly to giving the misunderstanding of criminals when they start to behave according to their private needs, not completing on the likes and works of Art in particular, stipulating the Risks involvement of thugs in the industries. Involving

misbehavior or hatred in a career or the society of great works, does not have to become some encouragement if you are thugs. Ownership or work is used given through with the respect and positive, obtainable outcome after its been seen for descent remunerations. But when its been discovered by the art and music production companies that provides and see not only the potential of particular ideas of Art material not having copyright protection, are not valuable concluded to have the proper conduct with the material of fashion implemented. It happens most of the time when you hit the health store and you see product you can you for your safety healthy tips, if you might happen to know that you are addicted topmost of the cigarettes you buy on the street market. You don t know how to stop, "but you could still look around and ask a for products that health your craving from quitting cigarettes. You hit to you place and where you cannot live without smoking your cigarettes, you might get caught in the process of illegal cigarettes and they are very dangerous contact with people that influenced you to smoke it and they also add other stuff to keep it very strong, but that's not the whole idea to keep something bad for your health to be very strong to your system, its ugly to be smoking stuff you never know how its distribution, but illegal "Marijuana" in your house doesn't have to influence crime or hatred to your neighbor, although it's not important to smoke where your people don't appreciate you smoking near their children, it's not safe anymore to live in an apartment where people smoke all kinds staff and you know who does it and keep quite. If that's important to let those people destroy your health you must be in that crew, but if you let them know that illegal drugs can course a destruction in your life And also your family, the people you like, they would reconsidering to be with you without knowing that you are great or not well. But before you could smoke something or before you could hide from them that really you smoke "weed" BUT NOT JUST WEED WE TALKING ABOUT, even other things you don't consider to tell your people about it. Maybe it might have happens that you kissed someone on crack and that's how you got addicted to mixing

staff you don't like, but as you take it you happen to like it. That's not great to know that all the things you did apart from keeping the distance from your family, if you are father or a mother in the family who does crack or not just crack. But maybe she is hiding or quitting before and she's still receives that pain from carving and other things her spouse does not happen to know about that crave, if it's too bad to be with someone you don't know and is taking things like bad crack quick comeback or smoother the craving. But will tell a lot about your relationship and also the people she hang around with, if they happen to be influential and they never have anything to do from all their life, and they neon illegal drugs. But not your neighbor lost side when heroes weed in front of your family and he's living next door to your apartments, which can also make you uncertain that if he they guy does drugs, but comes first and what if he dealing real crack on the street? The great development to see in your own country, it should start at your door step to see the great about healthy society and still know how to live with great people whom you can share all your love moments with, your people might be knowing you personally and never to be recalled to be bad stabbers or just crack people in the your neighborhood. Who happened to be around for quick money or just stuck in a promise land of the Dumpsters. See what bad society can live out of no hope and also if someone should choose to live with great friends not the ones that influence the human society to the underground of illegal substances, because if you happen to hit in a wrong place, well you know that you are grown up and at least try to see for great assistance from place you would trust to be. Like talking your Doctor about the problems that you facing about addictive crack or addictive cigarettes, well professional will still do his research to make sure that you are, very well you receive the greatest treatment ever you would find. And it's good because you have chosen the wright path to seek assistance including all your problems, if you might be constipated well a Professional Doctor can be the knowing what can you take or choose from eating right food and simply applies to other substances and you must be well aware about and

all the fees will make you someone in the future. To can actually receive the greatest about you treatments and other legal pills that can take away the craving of bad cigarettes and illegal drugs. Healthy means all of best education that can make well aware about the bad substances and also, depending on the other sides where you could in contact with someone who is ill and still, or have other HIV and you become in contact with someone who is on crack and can be found that, that person before is not well with her body. She's been everywhere where you could not be and accept that you are actually hanging around with prostitute. But she haven't seen that side of telling to use protection to keep safe from the harm of "dirty birds" and also those people don't even have time to be with their families and they don't have time to extend their knowledge and become educated about the life in particular reasons. Compared to have a great stable partner to all your requirement s, including a Safe Lover husband whom can talk to "you about, her pregnancy's and someone whom is not everywhere including your life and sexual life's, in particular to be very aware about all the people you could sleep with not using protection, they might people you married to, or people that can have privacy when you see them on the road and still have to respect you behavior towards, all you facing including the love one that you could know and never to be bad about you, when you are with your married partner. And they can say things in public to try to disturb your date or great relationship, which can tell a lot about people whore on crack. Never to be good too prostitute and you get caught or cheating on purpose, you should know that when you lose your own people, you are creating problems when they start to consider that you are sleeping around, with dirty people and it will all come out when you are in trouble. And remember that they will also ask you if you used a protection and after it's all been said that you are "Bad Man" hang around with people that can destroy your own relationship you owned. But before you could be in trouble at home or at work, well; be safe when you are meeting someone new in your life and know where they coming from the bad society of crack world. But meeting and

marrying someone who can change your life and someone have seen the good side of you and your own romance and loved it, when it's possible to meet her alone. Then you can know that you're welcome to can have a great couple to be together with peace, but not meeting someone who is abusive annotative about if you do this, and do that, "what do you really want in my house" if you not well the type you should "hit to left" And leave the house unlocked. That all comes out from a woman who doesn't look for relationship and want you to surfer the streets alone in the dark, well where you going to go if you are hanging bad society, they should know that, having no place to leave at that time you lost your relationship, she should know that, abusive partner doesn't come only on the male side, butte female too. And if you take time to think about it and still know that, really I love that woman and when she think that you might be cheating her and she's not well aware if she could see a Man who is not involved in situation where he could treated the wright way, but other things don't have to be concluded when a woman is broke for that period of time, it could be for awhile, but to guys too it's so "Evil" to go date to a broke nigger" Woman Said" rather choose for Rich Man, she will be like;" Want to marry a Rich Man" and driving a nice Car, livings Great suburb in the "Malibu Auctioned houses" (Woo..! you want to marry?)" Passenger" and we also took the chance for the book we needed to change and wanted to experience it through religion and the way of truth, life of GOD. I engaged a lot in my entire experience and tithe wealth of GOD in my Christianity and to my behavior towards our well being society. This book entails a lot about how to be a man of Christ, and to bow to his own society with good observations towards any man kind living on this earth. To be in my possession only gives one's all the best we can to try to acquire the knowledge of god and experience reserved to this book to be success. It was planned to be finished long time ago before we could experience minor trust that raised along, trying to be on the edge for the book, the book of Christ, only to this which comes with the good message, to all our good readers, not only commenter of any other people of mistrust

against our novels, novel to our own religion of god "GOOD FAITH" Going through all the days and my time broken down into pieces, my time is given out to the birds and all animals' species; surrounded everywhere. Acknowledge money; Acknowledge comic existence and also acknowledge positive existence of human nature to be true. Well you should be surprise about this time, "Woman" what is your name? "Man "Woman" I'm abandoned by my boyfriend, he invited me to come for few drinks and we slept "I'm, Hold up woman, I said what's your name? I'm a helpless woman roaming around without a boyfriend, but that's all you just said, yes, I should be a new face to you, yes "Guy" um I need money to go back home, "Helpless woman" you call yourself a stranger tome?, um do you have something to give her, "the taxi guy?", well I have about15 bucks to get to this woman to be home safe, its 100'clock at night and this place is not safe for a woman to walk alone in the streets. "Well" good bye, "Woman leaves" a woman who I do not know and she been hurt by her boyfriend who invited her to a place of booze to drink and they happen to be on the same bed together for two nights, She said" two we been together until I saw him changing his face and thought he was too drunk. Too drunk yet" not... the "boyfriend", I need you out in my apartment "with drunken accent" I'm living and I saw you kissing another girl you just saw in the bar, I was "there;" A sound of breaks,(s... Latch...) "glass of beer on the floor, fine I will find a way to go back home. You should leave in don't even have money for you to take a slut home, Boyfriend" you should be caught on a woman with HIV, you must be playing, "She said" you should be careful when you become with someone you just met, you should know how they have been before you guys can sleep unprotected; I'm pregnant "Woman". You create the control for knowing your dream, and once you know how to dream. You are starting to realize that passion and before you could make a difference to have it into reality or into practice. You must be having and know how to can own a dream come true, you are healthy in living and having other aspects of human enrollment accepting for having a great Christians spiritual believe. For the very best of all

you should know when you are having dreams, make them very positive and very open to your concerns and to your only advise for everyone to learn and still behave positive towards all you are trying by all means to make it improving the life of our society from looking at the best sides of the development and also the improvement of our natural stability from considering to a dream than to waist time abusing bad substances and bad alcohol habits, from consuming the outraged booze or self abusing habits made for the bad laces your are not welcomed to be there when the time is not required, from limiting your health from keeping you bad. When you are able to be the person who can change your life to make it possible and positive towards every given talent. If you consider to have a proven record or a stable time contributing to most of the quality time you need to share with your people you may trust delivering the most given opportunities that are available to can speak through. Once you can have a quick change but, to only specify what is the most major goals that are given and proven to be accurate and very positive to have a dream to your own destiny to be fulfilled from looking positively to be a very best person to know how to deal with all you should have established long before and also to give your very best thoughts spoken. When you realize you are having a dream to change for the fullest, how do you determine the importance that create that desires, as human to have it and to change it positively. When you create the positive outcome to all your dreams. This cooperation will make you someone who can have a dream, to own and who is able to can have a determine state of good health. When you are approaching a time where you could have pleasure to deal with relevant exposure to keep all settled for a great endurance that will keep your standard of behavior as the city Man and Woman developments plan and strategy. Having to change and know how to do things accordingly for a great minor and major steps considerations, from taking a step further to make only a changeable desires where you know. The book is having the ideas to fulfilling and knowing only the important points to make you a dream changer. We would like to give thanks and congratulate

giving this concepts for our only potential and important readers over seas who have the passion and knowledge putting the practice of changing and not from loosing hope and trust, gaining relevant exposure great faith. This book is given to our readers having a positive impact to all the people as seen as our potentials willing to know and extend their knowledge from seeking the right positive channels into receiving our books in a quality, and positively proven to reach their satisfaction and to have the most value they need to share and to grown into the positive organizations of the city's. Giving the thorough investments included all the Artist that are been hired to complete the movies in a specific period of time. The first books of the companies running and exploring by the agency industries in the movies and story telling meeting the great lovers and compositions, in the radio station, at homes to teach the children and pupils about Art Schools and graduations at the early level age of Modern Art industries in the books where its easy to read and understand and also the skill where are applicable when you work in the factories, to have more experiences and to know what the language you should adhere to when you are reaching a movie deal, music for the talents that you should share with your fans in the entire regions. Making of the movies lead to the experienced and creations of good materials in the industries of ART Works that has proven the age level experienced can attract an obtainable movie deals at a very easy age of over 12 maturity, as long as they can identify the script running and making sure that they can be hired and be actors depending on their experiences and the understanding of the language in the movies and script writing organizations. Making of the movies leads to the experienced Actors and the creations of good Art Talents which is able to can talk positive for major role or management level of Movie Business and Factory productions which also have the impact of marketing the final consumption o the investments markets in the global contents from buying share and selling them to the public Art Works when needed or proven insolvent by your Licensed Auditors and books keepers in the factory of outsourced any Trade Mark in the

Business and distribution industries. The project was determined by a construction sites, where there is a major impact breaking on the consumers sales, referring to the fun part in investing on the projects for making the compositions and constructing new compositions for best movies of all times." wolves Teeth trailer's accommodated by the best novels and publications including the Book novel "wolves Teeth" where we are trying by all means to reach the target and the individual concerns derived from our corporate investments criteria that, we can only provide our compositions skills in the teaching of great skills. But it determines the importance of reading and learning in the same efforts of loving the extensions of creativity in learning centers, accept not been licensed we are encouraging the potential levels of great development and quality education at your finger tips. At home to have a safe environment and secured programs that can teach you home with the great University level professions, Art to work for people and the great society to be willing to change the future and compositions of skills learned or achieved from the professional levels of corporate skills and educational standards in theory and practicals which will give us the courage of Art Productions which will give us the chance to have the best books that can sell and teach our community the level of companies without fear of losing the market rate in the skills and training industries in music, Art works and Business deal proven. when you are delivering the best works of your company in writing and recollecting of business practices to change and become someone who is trustworthy about work and Art materials where over its positive to share a point of views in expressing your skills to the people depending what make you are using to create your works seen by the people, that are Art lovers, people that are the compositions strategist that can make you someone who has the "GOD Given Talents" to provide the best Art material at your consumers best. The crime is been into similar with the people who are involved in a romance dating, when you meet someone to find that you might be liking each other at first side, its proper for someone who is your spouse to determine and have the

same feelings that leave greater financial income in the Art Factory and Artist collaborations. But its determined by the financial needs and protection, but when you come across the very exciting part about their income and if the marriage estimated o last long enough. But its determined that when you are Male, and you Friend is a nice Lady in the cities. How do you come across the standards of keeping her company and comfortable around your Friends and families, including your co-worker, colleagues and many financial friends you could meet and still talk about, your previous partnerships in business or become spouse where you are threatened of cheating bigtime, and you become someone who is financial secured, but with rich couples its different when you could determine the results of two people meeting. And enjoying each others company. Trusting your relationships regarding on the exposure and the behavior from your bad relationships or bad partner who cannot provide of sustains the level of romance and money materials you expected in the first place. At first you will identify the goal to have a romantic dinner and marriage meeting for the first time date at the hotel, and just met for your first time. In the book is a novel statement where its not proper to know someone you just met to become your partner, and have the transactions values in the process but. When uninfluenced and finished investigating the company's needs that have been to the discussions of scams and friends in the neighborhood countries. They are law people who have fogged the funds transmissions to suit their accounts, but at first the scan and scandals just arises about winning a lotteries without entering a business premise r singing the proper documents like contract papers. Its the income based on the cyber cafe-control Cop shop and under the scams that arises each day we live in the internet from viruses invading the Internets almost over 200 of Trojan. And more still introduced by crackers. Only to identify a scandals is among people that have no insurance values of education that comprises with the modern civilizations in romance date or couples and in the Trade companies only to identify a scam among people that have no insurances to companies selling bad tenders documents not

registered with the companies databases for the prizes over the moon to reach$20 000 oo twenty thousand dollars criteria, which is critical and certainly its above the government funds, for "Wolves Teeth trailers" which reveal the importance to save your money with investments companies registered to have the Name for your future investments to be positive, not bogus. The trailers stipulate the outcomes of movies as scripts in writing concerning the bad reputations and companies not suitable to help for growth not giving a through conducts not to consider registering the companies and then still wants to receive tenders with major ESKOM Company in delivering the Nuclear Power Stations in Africa for the first time without the project introduced properly in the Market of tenders. The links are not properly found, if you cannot find the right information provided to liking the proper conducts with the Tender Manager in the cities, of never have to speak to the right information desk and the funds all are not refundable for over $2000 over two thousands and to $300000 oo thirty thousand for a tenders application board room or pay half of the money first. Its very bad to loose than to gain more money" The opportunities create the good Art Works that has proven the importance to can talk and be listened by the consumers as seen ans pleasured to become the consumers investments depending on our sales where you are willing obtained and to overcome other prospects in the paying of investing on the Movie shooting projects of all works. When we have agreed to make the works of good experiences that are able to leave great memories behind without any thing been implemented or written in a standards format that have the potential works to proven that, the quality is spent most on the talents and the full tie job or length. Most movie trailers are based on the drama concepts to explore the differences of fulfilling the positive directions of becoming something your are willing to regards to the very best investments to keep the trailers rolling for all the given works, put together for the better quality of investments and great knowledge that proves, that there is no bad encouragements which create positivity. But only to recall that talents which has the meaning and

the proper sinning the movie deal when is the best quality Practice that directors gives to their actors in the holdings. First I was inspired by witting on my own pace in the movies, I started at home where I would like to see and read motions, from a very first age, I would write somethings alone on the paper which will make a huge change and differentiate impact on the Art as written and all Artworks, can make or retain a lot of profit in the publications of deals with major corporations. I would want to talk through and explained to my Parents about the establishments of new books and teaching in the Novels or in writing in the orders Information of Languages at you finger tips, it was hard to started without any pay or remuneration, after its been to a great extend and to have the money I raised from selling computer hardware to the government at a tender base material to supply and exchange the school computer; I could make or retained a lot of profit in publishing a deal with underground companies before breaking into the commercial, market I had no place to live, I mange to have my own apartments and still pay my rent, for at lest two years I mange to have my ownership of books distributes online, at home and selling to companies at a manufacture prices, I got deal with major corporations. I would write about a story telling novels or books where, I was encouraged to become someone who can Architecture and compose his own theme novel and has the creativity imposed to keep the novel more acquirable and very interesting to can share and collect a movies deals in Books and Novels having many different aspects when you differentiate them in the Business and trade world. I was afraid to invest more on the motions projects before we could license the scripts writing that has the impact on the "government departments of higher knowledge and training skills of greater education on your finger tips" regarded to publish a sudden implications that can be like "trying to speak aloud with the greater society through major communication channels. It would be in writing and talking to your fans in the compositions materials, Artworks making the best of Garage Art compositions in writing when its great to simply teach the meaning to all the concepts that can make you very happy,

reaching the potential agreements with yourself and God When you are able to reach the goals to have your movies identified by the dealer regarding to the concurrency that is crucial to the people who will understand the only time that given to have the movies in the market of commercial interest in the movies and making of best country trade marks. When you have interceded to acquire movies standard deals to have for your industries, you must be to control the deal and having the wright channels to can be the owner of the deals and making more to obtained the very best of the Art Materials that able to sell. When you are trying to invest more on the productions of your own movies, its proper to have the money to take the talents and your movies to the Right people who are able to assist you with the relevant ideas that keep the movie deal going further in the industrialist, first you would be seen as the only actor who is willing to incorporate for the marketing actions that are able to deliver your materials and selling your movies and the Art works in the companies, where you will be liable to provide the best and reliable materials for the actions that have been proven and script writing licensing companies, which happens to be obtained from the agencies here your likely to sell your companies needs and material of Art works and talents. After its been identified that your companies performances is not bad and its proper to speak to the companies that can make your someone who is able to work with major companies that have been proven a great fabric agency of provisions to the companies for Actors and more services to conclude when the movie companies needs to be trained and their own individual actors for the best direct market and lectured script for them. Long term goals are given the time target for the productions of movies when they having a shooting in the arrangements of creating the real market movies, like the Troy, the Army camp Movies, and Sports for the theme game, including the dance hip hop movies and the depending on the length of the scripts and that arrangement scheduled before they could consider dead line and extension depends on the conduction of artificial Towns and cities that are needed to have the real demonstrations in the

underworld or real actions, thrillers and underground constrictions in the mining movies and trailers. Where you are likely to obtained a movie deal and having to accomplish the ideas of retrieving your royalty funds and other material that you should try and invest more on the market in the industries with bigger companies. Its important to track all your orders and training facility for your work individually or with training companies that can proved the skill in the movies and still have the pleasure to can Be a director of your movie companies like DR. Spike Lee and Drake. This is the final stage of proving your work with companies about the great standards and quality material that you can enable to sell with bigger companies that distributes and progress the only special of making and selling the movies and picture motions like Toy stories and the cartoon network factory compositions and productions for the global contends and the best achievable reliable consumptions of great people in the entire universe. There is proper editing that can leave your movies of Art material looking very special when you enriched to have a movie deals and to attract, meaning to invite more money and business needs to incorporate in the team of making great and selling the industries with great quality movies. The best part of having the final copy of music and movies compilations, you want tot know if you have reached the final stage of your productions where you would love to know the best for the market. But when you finished making your assets as the only part of the materials contributions, when are you gong to realize that you have the final implementations for the final copy of your movies to reach the potential consumers in the marketing the Services Procedures in the movies engineering and production deals. There's been the movies that encouraged our readers that knows our work very well at home and to all the books of The Married couple living in London and Prof. Nakakgolo Johannes Mashabela Holdings, The Company Partnerships which have provisions of books to the public and writing of scripts at home and in the work places of for the offices purpose, of writing Story Novels proven and training individuals about books that have the positive impact on proving

the best knowledge to the Art Factories and Productions proven to have the only copyrights protected all the works to become our only ideas contributing to acknowledge and training from receiving the interest in the Art Writing and Compositions of materials for education and great understanding of human health and the positive influence to wealth society about the Artworks and give them the great knowledge to understanding the contributions in the movies and compositions of movies and story telling, scripts writing and ownership in the entire world of great Artist and great explorers of Art factory productions, and collections of Works and obtaining more money for investments out to the company's needs and growth. The scripts are giving the look or another level wen you are able to go through the standards model pf "Wolves Teeth trailer" when is the movies based on the drama sessions where is to encourage and give aims to become the best selling story novel in the modern civilization and time given to sell the prospects in the movies and given thorough conversations that can encourage and live the positive outcome to invest more on the publications, to also all the Artworks of "Wolves Teeth trailers, including the Story novels in the books "Nature of ART Productions Conflicts and behaviors" and the book in the Business Publications Book Materials called" Business Adventures by Shane" which has been given the encouragements to obtained a book deal in the first centuries of Western modern technology based2017 first weeks of the February, based on the skills and business training structures in Information Technology industries and the Standard of Art works which provide the professional standards in the Art productions and Material investments with major holdings ranks globally. The Art frames give the great honor in the contributions of movies compositions in the entire world of making with successful, educated and professional Artistry languages which has the meaning to provide common languages and great exposures of Art factory's productions works. The modules of books based on the drama series which has the meaning and the history trailer to the economy for the best selling outcomes of which created real conventions in the modern

civilization in History ARTS and time given to produce and sell to our prospects where investments is more encouraging and positive for more materials put on the sales Market for great knowledge and business needs purposes for now and the future investments is based on the movies in particular with the understanding and the entertainment concepts of making movies and also educating our society with great "Thriller novels and story telling materials, Romance and Drama or the best of crimes scenes and scandals in Sex in the Cities, series, How I met your mother, Mr. Bean "Johnny English" the Art network and soap movies, in the holly woods exposure of fame and "Grape Cellar Contributions" and the Gossip in the City's. The potential of growing the movies and music compositions taking place, where we see in the movies industries, we think about major investments to give and illustrate the importance of Art creations and Piece of Art Materials that employs many different talents in the community and has the major impact of improving and providing the best for networks new market of great Authors and writers, New and famous Actors and Many investments criteria in the Music fame, fashions and productions markets of great engineering and designing facilities. Training College, brokerage and Agents which happened to have the problems with the first book of the wolves teeth for the past 3 years after the books is published for the bestselling Author which happened to compete around for decades only with the book that has the movies and to making of new great Art ideas for the future development as from the beginning with the intention of making the comic existences of Wolves teeth to be the only movies that are available to have the books written before they can have the deals for the attraction of Sony movie industries, Pixar the movie network organizations with Sponge bob Square Pants, "The Samsons" cartoon factory, Toy Story I, II and II and more. When you are working with agencies to prove the skills and records of movie trailers and "The Wolves Teeth" novel Books which has the impact proving the best talents when you are An Actor or Actress. The only importance to have the greater experiences in taking part in the

training companies, that accommodate the offering to have a short courses for Acting and the training is based on the scripts, reading and understanding the scene, and to stipulates the importance about the stage shows, to have greater interaction with viewers and get used to speak with the audiences like in the Best popular Comedian, for the festivals or organizations that sell, music and Arts materials to the public when you are working to improve your acting skills and career in the competitions ladder for a better chance in the best of Actors of Holly-woods for reaching the best fame and fashion world, you need to know companies that have different trade Marks and are willing to provide and help their customers as a part of their daily tasks to provide the very best of incomes to keep the business Markrunning efficiently and paying the debts, Water light and rates, telephone bills and remunerations forSelf-Distributors for countries developments in positive and registered training facilities to thecompany's. That are providing the major impacts to improve and train the individuals in the facilities ofmovies, music in Art, Business Skills in Computers and Programmed equipments for the HomeUniversities improving and facilitating proper training of Movies Directing, Movies in Technologiesand editing the scripts and writing for movies Novels and movies deals, only to work with greaterlicensed companies that have the insurances to resolve for the incidents that might affect the moviesshootings and postponements of movies deals and shootings, identifying the growth in the Movies Artdesign and Acting career.

Scene 4

Realizing your ART dreams and a better chances for More investments

You are entitled to have the music you like in all places of music production and compositions, to realizing a dream, for the truth incorporates within the corporation of the company's that distribute the music, nationally and internationally, when you reach the career of music deal and compositions, which simply means creating the best Music as an Artist to be difference of have the identification of music and talents given and not just the knowledge and never the skill to produce the best results, when you reach the music industries and other making of music and talent production, you are entitled to have the potential needs and wants, where music is luxury is the places where you will loose fame, music describe the character and the main results of human civilization in the presence of human behavior, when you not serious about making and creating good music for everyone to listen, you must be joking with your career and In the criteria of musicians and listeners the first place broke means that there is no product delivered to doors of investors which means the criteria of fan is not available when you are not making or composing the music or become the producer or Art Material to provide the thorough satisfaction to the consumers and companies for proper investments on deals and stage shows and more. But the

Artists have the potential to make great Art in music industries, in Art and Technology digitally or the modern standard of Engineering deliverable, it can become Art in making house hold equipment, like the I pod's, I pads, computer and turntables, mixers and engineering equipments, the Mic and speakers for great quality. And head phones which identify the positive impact in the music listener and lovers included the music producers. Only to concentrate delivering the best Art and talents which gives us the outcome and to have a vision about the Artists experiences in the platform of stage performances and also interaction with the fans and management teams also include the Agency and the recoding companies also that knowledge encourage that fans to know the works or music of Artists. When there is music on the deal delivered when there is a products of An Artist its likely to sell immediately with proper conducts of marketing companies in a form of Technology like, the local Radio stations, international and Global investments of marketing material with small, medium and major companies for product distributions in the music, also the resellers of music and licensing agencies, like U-tube, face-book, instagram, twitter, i pad store, the garage band for music production on iPod's and free media contents on the internet that sell and provide promotions of great music to people that you download a 2 to 3 songs for free and buy the album later, to music listeners reaching their finger tips. You have to know when you are able for a company's' and promoters of Art works, and listeners of music to locate the best of Jazz grooves, smooth groove of soul and Rnb songs, house music and the lovers of gospel music in collaboration with various Artist, the store's selling music in all56 countries world wide which have and created the source of music in the internet which provides the reliability of great music, great information about the Art, Music and Artists success in the music industries of fame and fashions. Music industries that has been providing proper documentation to sign their Arts or the music and Art deal, when you want to become someone who has the potential to run a company that does not regulate with the proper standard of operation and rob people, its not good, it bad because you might be

loosing the direction of the music success and the great talents that natures the Artist. When having the idea for the real Market selling music, try by all means to stay safe and that how you will make descent distributions reaching the mass fans and productions properly running the licensed company. But not stealing from Artists property, bad encouragement on the career does not leave us with companies who have money for to pay their Artists, when the company has the good Management in the establishment of your music talent and career, looking on all you have done with the company, that should make the differences in your music career. Moving on the corporation ladder it will create the potential for another criteria of great companies or licensed, which created the standard of Arts not losing their music and their deal. The deal that signed the Art in the companies Management is aimed to give the freedom of great enjoyment and touring in the music industries, and to give Artists great standards of reputation in the experiences of a Recoding deals, of music and Art distributions where you are able to sell your music yourself or in the royalties and compensation received from the awards received from the Festivals and Music events. The great idea to have the book Ina well reachable direct manner to our readers is to be well established and still know how to share our great story stat people like to their doors. The only problem we used to "have is to get to fight against crime, crack and also prostitution which bring a lot hatred of God and books. Crack people don't consider the great about education Rather it brings in our daily civilization, from all we been in the as Caveman till we could consider great pleasure tour own home and great comfort of real human Technology. "Wolves Teeth" I wrote it to give a direct entertainment exposure to our nonfiction and other story lovers, which will have great pleasure to can read about real action, not just science fiction, but great story movie and also this will lead to great pleasure to writing skills. Our people grow with real and great exposure to new technology and the access is at their fingertips, to be true, everybody is in Tablets this modern civilization. And it's not difficult to extinguish a city living society from an uncivilized location in the dumpsters. A

place with broken dreams and a place where there is no life a tall. And that place only thugs can live there, which happen robe underworld or crack society and bad behavior of killing only people of GOD. God Give us real life to live among ourselves and to our families, the precious gift from GOD from the time we spent in our own destiny which created by our parents. From where we should be when we are infants and to a place of real dreams that cane changed to be reality and great expression from others to learn and envy the success that brings good hope and great life to be positive and beautiful. Wealth is among our own people that live with great favors and the strength of Good Lord who gave us Ease and resemblance to cherish and great LOVE TO LOVE ourselves and our people around the neighborhoods, for now and for eternity to a civil exposure from hurts to god liftoff see someone in the community who is not well about the people living in the neighborhood, there is a lot to can do about it, and if that person is taking crack in front of you whenever its possible, you could tell that. Really that person is not well without living out of crack. If that person is starting to behave really bad and he start to steal your belongings or he snitch purses from school kids, really that's not a way to live, maybe live him alone to continue with bad life style. Those people are considered to be on crack and other illegal substances considering to deadly when some one is taking it. If that could happen to you, if someone still from your pockets or sticky fingers try to pullout a wallet from your pockets, maybe. You should know that, he trying to reach for a mobile cellphone or something he likes without notice, if you catch them, really they pretend to be talking but being rough. That exposure is bad and really shows that a thug was trying to snitch, and they happen to be caught really got beaten up by the city police. From really snatching and trying to steal and they got caught, you would see police really taking all his action to beat the, straight in the head or their face be looking bruised really bad. "you hear" gush... gush" with a police pipe, what's happening" Passerby" he" been snatching from a business man and they called the police that someone is stealing from the corner store and they saw him running

out in the store without paying from all he took. The police" they need jail "Passerby" they should consider the people want thugs to rod in jail. "Second Passerby", "the Police" tweaking them to jail and the will be no one taking charge of this trial, until he's taken to custody for other judgments". If he had been behaving badly he will still have to meet his friends in jail. Too bad too bad "jailer", we want hi min our cell. I just saw this people in the city I was walking by, and they were on the way to the bank Big Bank of McMashabela City. They saw me outside before and they saw me ones again inside and one morning, I woke up on my doors step, there was as letter that says. Please be educated or you will be nothing olive for even after they took the undisclosed amount of money in the bank. They never live anything even penny on, my door. I will go to hunt them and still know what they really want from me. "The Resident" I will behave like any other man who live in the city to be safe from all the harm of street thugs and also to be safe when going shopping with my family. Don't become like a "fool" when he hit jackpot of about $80 million dollars on poker chips and still want to be betting with top investors. He happened to lose all his money betting the wrong way, only to find out that, you only can know your wins, betting the right way. He lost all he own including his reputation and his wealth. Might be a bill or something that you need to secure before you take certain or major steps. Money is not for broke it s for great investors. If you "hit a jackpot consider to live the porker table when is safe to do so, with all your chips, over a million counts of mixed pounds and dollars you will have in your pockets for that time you worn. Make sure with change all your chips to great investments, and you will be their call for great meeting including important people to give you congratulation handshakes and some they will want to invest more on all the money you be having, you might meet a real manufacture or great business guru whom can talk to you about his investments companies he run. There it goes on and on, but only will happen when you reach your pockets for that great poker jackpot. See it's great to know that when you have enough money or raised some funds from a gambling like hitting a lottery of more than money you

can count. You required to be in the presents of great investors giving hope and great tips how to invest and scatter your investments indifferent places, which is great exposure, maybe a business adventure required to acknowledge the skill to be accurate when you deal in business world, or they may be trying to keep you happy and still knowhow to advice you positively. On certain time or modern technology they would call you to make a real transfer to all your counts liable for you to reach all your money safely. It be bad to yourself and other people when you lost all your chips, depend on how you get the money you spent or lost in the horses, maybe you borrowed $50 Million Dollars from a bank or someone who thought that you might be in a position to win and still know how to talk to other expects in then game. Buyout end up losing all your money in the porker game. Where will you go really when you run empty handed and still know how to lie to someone you'd promise that you expecting to increase the money you had before you could lose and which happens to be liquidated in the porker chips. "Great temptation" sir we have problems to experience your account is not healthy at this moment, "What..?" Yes sir "The Bar Man" well I thought it works really fine, may your credit card. No I don't have a credit card with me. I don't keep the credits with me, only my wife could have the bank with money maybe: "Broke Man" well I don't have you guys money, "drunk Man". Well if I pay for both of your drinks, you will still owe me. How much... maybe we spent $250dollars on beers and other staff. Well keep it great, it happens all the time. "Drunken Fellow" this man saved us, he thought we might have lost money or a wallet but, Damn..! What's going to happen when I say that, that weave lost the money to, "Who?" my wife; don't say it."Guy's ordering beer" on in the game, yes you are not the first one to lose all your money, well it happens but remember not to take all you millions to impress the thugs, no not thugs, Just tell her that you have been in a place they required money but you don't know what happen. This is a lie really; "Broke Man" you should know what to say when those people asked. Yes Know what I say when they are will hear. Too bad you missed all the money you had with, two minutes

ago. You're looser, the man who saw his losing over about 80million horses. We know that you had about €5 pound sand you gained, on suddenly blink you out... too bad too bad my friend. "An old Man" you are not the first one really; "Three Drinkers" I once had a Cousin Brother a good neighbor, but he was bad with himself and he ended up annoying the family and he was too bad to keep himself educated. I didn't think that someday he can be someone who can read, bathe never thought about all that. But we had lately that after he moved on with his life, before he lived in the family with us, my mother before she could live here, she took him a her own child who, he became someone rethought he could be he's, drunk and he abuse the money we gave him to go to college, he dint take it as a step forward. We tried to educate ourselves to be good people who can read and write and also know how to teach other to become good in reading books and writing, but my brother didn't think too positive about civilization. Lately we here that he passed away from taking too much crack, we heard that he was living in the society of crack people and he joined that people that really behave bad, they could do anything for you to get to buying or owning crack store. We heard a lot about all that we could t try "to overcome all his personal problems, I thought I could try to be good, but just didn't touch my emotions, after he's been taking crack, he abandoned us and the word of god that, "God close to cleanness" and all you do you should be carefully about your life. And pray all the time. He forgot all that in the family that, thou shall not hate yourself or hate people around, or treat your neighbor bad. We lost him in the family and well him turning to bra ravel about my education and other staff. Education is "The powers to success" not destroy your brother's life from lies or make false laments about your neighbors." That trespass or insulting him in any other way or your brother your son and other related family. We pray that he will come back to be someone who can be good to himself as well as others. He was married and we know that his wife loved him and after he joins the crack house, he's now too bad to his daughter and sons he left. Hecate to my house to take a bath when he needed and the food I bought, he could eat.

Until he lost his side and insulted my father that, he never had anything to give him, but he was not like he should be insulting people about his man hood. But I he could know that, we don't go to places that will ruin our reputation and still know that when you go around telling people all your stories, but know that words travel faster that the light at the endow the tunnel; That you should consider first that, when you talk, know who you talking to and what you guy stalking about, maybe a crack spot. But that not a good place to be when you talk about your family, but when restart to be high on something "weed and mambo purple greenish" he started to hallucinate and become bad through his conversation, and he's bad on his family. Know he's insane and living in a dirty crack house. Too bad for a house that you don't own and still see yours elfin that house really bad "scratchy". Better be someone who is not bad and has bad look to good guys, but just want to infect them with bad deceases to destroy their lives. Those are the people who think about not to die alone. "But don't kill the innocent society". You have the anger to hate the people, you have the anger not reshowing up to the innocent people, not only you can be alone in bed and sill think about your anger, you are not alone to be crazy about nothing, but now that you change the bad behavior and adhere to the great pleasure to desired. Only if you could talk about all the problems inline, you will solve it and still know how to be open to great opportunities" about all the time of hatred and bad romance but changed. The Products given on the statements through the book have not been evaluated byte food and Drug administration. These products are not intended to diagnose, treat, cure or prevent any disease. About the book, the sturdy is meant to educate the people whom can regarded as our readers and our contributor to this projects, about educating the society and to give them good interpretation for our work. If you think this information provided is not according to your knowledge or your research and there are available resources that can conclude your research or sturdy towards your intentions or any other positive influence you may have of contributing to this book. It's actually a health book not meant to

harm or give any false information about any organization or a profit and nonprofit related matters. The project was stated 2015 till today aiming to give the information and reliable business opportunities to them. We know that we all want to be millionaire someday; weave hope and vision about receiving a decent income and also to can afford and maintain our health status... to be rich, young and healthy looking. The only important part about redistribution is to make sure you have enough money. To can retain all the profits included in the business. I learned a lot about making money opportunities" in the distribution process. Like buy stock and supply it to the house-holds or consumers, consumers need to know how the product is used and also, how important the product, distribution packages contribute into their daily life. Included, their families" The consumers need to if the products are well established also are they perishable or real consumable and etc... It's very important to know how the products you selling, can change and provide good results to the people, when you dealing with people, it's very challenging. You get to meet the person, someone who is interested to know the importance of your products. Now here is the opportunity arises in your presence, someone who is interested gerrymander to know and be part of the growing and interesting market and also to know about all you putting into their daily term or life. The family included, A father, Mother or husbands and wives, children and other relatives, you will be saving their future and also teaching them how robe part of the living and healthy society, in particular. You will be changing their lives to a positive direction. Positive entails the challenge you will be growing and promoting the producing, into the market. In business the only time you can make money, its by selling the particular products. You buy the stock aiming to sell it to the house-holds, and you will be making a good profits. This profit will be the money that your earned along the period of selling the product or packaged promotion. Now with The Forever Living Products you become your own boss, which means you are self-employed. You are entitled to count and receive all the monies in the business you running. Remember the only goal you establish in to make good profit, in any

business adventure you are willing to invest in the product or stock you selling., and Make sure you grow big and invest more on the distribution itself. The business have manydiffe5rnntdoors, its either you want to grow or to keep running the same business, or running at the badged. How to grow? This is really an interesting question that needs a good explanation, or answer. When you in the business, you become rich, and growing in any manner, is to be in the manufacturing. That is the bigger part of any distribution. You get to know how the product is made, and hoe it reaches the consumers accurately, only two points you focus into. The second is to know what you selling, before you could sell or distribute to the people, we may call them Consumers or households. Included, not just houses or flats and other community apartments and buildings, doesn't t "have to a real estates or an expensive business center, it all depends on your investment and targets you reaching each day, week or monthly, in can also biannually or period of 2 to 5 years for your business to be healthy and growing. We are dealing real consumption real usage of products you can reach. As a consumer you need to a product that works. About the Product Knowledge You reached a place where you want to be distributor, or consumer, this can be one of your decisions. Distributor is someone who want to change the life of people, actually someone who is in- business and want to give the people what its important, the products or good working products producing good results. Consumer is someone who looks at a product and wants town. it, it can be anytime or the day... The fun part about the consumers or household's based on the number the distributor is planning or willing to reach. Every time you reach a consumer, you live something called, Memories. If the consumer receive 100% satisfaction, they become excited about the product and want to know more and also add to become good or perm ant consumers. That's how you can grow into any distribution and make more money each, you in business. That money or profits will add in to a millions or currencies, first fall you have to know how many consumers you can reach. The formula is for estimate the total profits you make each week, based on the volume of consumers you

reached, Each Unit is based on the different products, you read about all the products, you will know all the differences and the importance of each product included. The Forever Aloe-Vera are the products that are well manufactured, and they have been in many different perspective in the manufacturing or production process. Going through the book you will know and learn about all the purposes the products can prevent, cure the illnesses based on each households. For the products that can give a good and healthy life style, we recommended to work and contribute on the project that is relevant, and very important to the society. This project is a we redistribute Aloe Vera Forever living products and also to enjoy your own reality to your family, business, work and also to your savings, it meant to help the open community to can have the knowledge about the products and the business. they nature and grown into, also to deal with the daily symptoms rising in our homes that can be cure and taken care of. The novel is a true combination, stated or broken down in four Units, including the life of the author. Which reveled to most splendid moments, about the book to take a major lead through establishing a book deal, for the written novels," Business Adventures by Shane "Wolves teeth trailer and ..." The book which is described to be a novel revealing the truth behind the deal, and also to give all written information to creating the fun and implementing a great deals for the young and other upcoming writers, urged. About the Author I'm willing to be the only person, given time to come with all the details, inside the book. I'm writer and live on authors, and writing pension, born and living a great life in South Africa. I'm an IT Graduate at the, college Torque IT South Africa, and completed intercommunication, correspondences. I have completed my writing assignments and still busy willing to acquire the other assignments. For the books and the training about the latest activities in the Information technology trading world and other related security and Pay The book gives more and detailed story novel to all the insides about the conversation and to entertain our readers. To give them good look out about the great of thriller movies and to know how to be in them with great knowledge to

science fiction and also not mix it with other industrialists to writing novels and also to have a good meaning to all readings for a novel. We have been reading about people ducked in the well and never to be known who actually did it without fear to their embarrassment, it s not actually normal to see a man ducked to "a place you never though tit could turn in to a great pleasure to a consignments. It's enthralling to give a thorough investigation to an opencast to be very cold blooded to see it, hell you should dig up more" maybe a cop" this is very handy to keep guys around, well my wife will be happy to me walk to her and say, well" look a mouse we saw it digging something, maybe food. We discovered a well of gold in there too. False made of graved man hidden to together with gold worth millions of dollar somewhere around the remote place to a city, never to be close to a penitentiary house. Are in" man said "yes a woman" well keep me updated about all the signs that needed us to give an investigation through. We you more than welcome to keep me close whenever it's important to us. OK "lady" I know what you mean to be your woman to talk with on the job and event home. Lord is my savor and he blessed me with the only love is real, and he has all in my family to give to everything we needed. We had nothing but god to know and to talk to when is requested by our pleasurable needs or our belongings. We needed him to be with us when is important to us, it all created the moment of the good family and important one. I thought I would still be without people in my life, I would talk to about my personality and favor's, also personal contribution from one best friend to a great family or god and He knew that love life and society can change from all human to beery acquirable, to the needs and wants of man. I lived ally life trying to be with someone I wanted to meet, Thought it would still be as difficult like you thought to be unreachable, I like to be with my own wife I would recall. I find someone very special to call and talk to when needed some help. I thought that pleasure will leave me outstanding to all my life, really I met a lot of great gusto be real friends before to show and give courage for any special moment I would express to my people. I had different exposure to them and I really learn a lot when total and

never when to interrupt I unnecessary for something close to a great accent for memorable and to remember to deliver a special romantic words all around the world. First of this the inspiration from the first book which took over a billion of distribution and enriched the life's of most people-Le in the neighborhood and also the city people. This was influenced by DR Spike Lee the movie director and Studio production corporate individual, the real producer of his own movies, including comedy, crime, thriller and other religion which contribute to our own religion civilization. They can't spell really? "He says"' The Rev, Civilization, hey; "space back" "really civilization and to give the prosperous information to our own people, including our own families and etc., for the talents. This is very impressive to work and still be inspired, by the most people that" given" their own prospective procedures, and their own understanding delivered in their doom or just their doorsteps. Don't step on the dog's tail, or the dog will eat you," the woman says" What you out there for? Been standing for how long there boy? "the woman ask?". The man, the dog is out, "he says", lie we have no dog. OK, be outside need to talk. What's for? The woman ask? This should be about the store? Of course it is "the woman", we haven't open yet; the store open at 8Hoo eight am in the morning and ump.. you here at six. "boy" "the woman says", we know you, you must be living down the road. You must them fat boy in know, please be patient, I will help you soon. in time. "the woman "The woman whom, she happened to be owner of the Tea and coffee store. Black mama Tea and Coffee shop. She's been there at the store to clean and also to make people receive great pleasure about the store. And also to give the very best ofter own corporations to be the black woman on top, she thought" hum, the boy this early; she murmurs very quiet" she might be talking to her self". The fat boy is impatient for the store to be opened, hey Mama don't call me a fat boy" talking to himself" if were a writer I would t know how" to spell" Fat" only to know that.., the boy can only spell "Skinny" but, fat is difficult. It shouldn't be heavy to spell fat' he laughs. Very silently, but light skinny" Shims" skinny Seeping, "the boy says". Well at about 7h30 am and the store owner she's been somewhere in

tieback yard, she been in their taking care of her own department, only to find out that there's a pool just few blocks away from the store. Where she's deepening, and the boy says, "Grand mama you must be "skinny deepening" great, "the boy", I just want to know how it feels to skinny deepen, the hood is all about it. At least will having something to talk to my friends about, in or from church or just way back home. Maybe someone know who lives" to know us. Will know what we should be laughing and be happy about. "grandma" I'm going back to the store the boy says, grand ma, I'm no Grapevine, just skinny deepening if you recognized it "Grand Ma say". Hey boy what you taken with u? I took "them thongs" the boy" I'm going to show them to the owner" this should be what we talking about, "Nasty" we know her, the owner says. Have a sit boy, you must be early just felt real and easy to skinny deepening, earnt no heavy duty, bang, "emblazonment". Trying to be at home, grandpa Seth tick tack tick Tack. Good morning grand ma? Toothbrush in the pool, don't call me grand mama, do I look that retired? Grand papa" I should be throne asking that skinny question? Grand ma...laugh" hah" sure I needed some entertainment. You should ask the boy" I think he should be out for something....maybe? It might be the great source rethink, grandpa "says". Just suspecting". If the boy is out looking for "crack" I'm not taking his stories" grandpa says", well he be a grown man, "really?" grand man, the boy is not taking that anymore, maybe" grandpas" heist's, "grandpa, if crack was a band" he be out with singers" which happened to be the band of the cereal singers? Grandpa laugh hah.....Very funny sir "the boy would back in no time, "my worth "grandma say....I'm hungry, grandpa's. He leaves the pool. Grandmas" still them skinny deeper. Sing? I will be back...! Grandpa. The famous words, The ant no skinners till them creepers, skinning. "my nuzzles & nuzzles. We know that grandma. In the crowd of people...been called and be at with them, giving them speech and teaching or talking to them in the presence and really makes' the man very excited and very happy to be inspiring and trust worthy to his own and the family not just the church, but people who have been inspired by the great entrancement of Noah Ark or great

behavior and great strength of new civilities and the great standard or modern technology and or just counting money or worth.... With great pleasure from Goth...etc. Be inspiring... This book created the pleasure great people, who know the pleasure of Goth...spirit which," means create the and healthy society of great people. This book create the great strength for all, the kiddies and the great family. As also us as human beings not just creature and secretaries for the swag, you may call it creative manifestation of" earth" or art Language" which means be inquisitive and really good creative, know what you doing and never have be bad or an idiot." Hearth fora Authors Mouth". And be the man who can be around people and embrace the name of Goth, the one in the havens, "the one whom spears undo thane and thou still be the man of the house." The boy said" I was introduced to Goth from the first time I was very young. The boy said", I lived all my life to know the great importance's about "Jesus Christian's" empowerment. Before I know there is Christ. My parents took from their precious time given from embracing and praying in the name of "Christ" till they could manage to pay us all the tuition money fours at home and the other endeavors" which happened robe my other home garments. My brother and my sister. Educated. I game to be clean and very smart," just like my father's" be the son of the Goth winnowers" he can hearer your prayers and given the good strength unto art, there at spirit, which represent "Love" and good communication, upon the oath of the Lord Jesus Christ, the son of Goth. Amen.. the crowd of people. Them Tea store and great Mama Coffee shop open at 7h3oAm, from Mondays to Thursdays, No Friday opening till afternoon, "after noon" the fat boy, yes till afternoon to Monday Got it. OK I know that, it's not my first time here, "the Boy" I'm going to sit on this chairs, and order meal and also still drunkest Tea on the side. I want to now how it feels to be the Man of the house "the Fat boy" I know the store is my great pleasure for us and still to know that food really taste great, "the boy "The Store Woman, Hi, the boy Say, well you should be open now, hell not until I saying "yes", have a seat, you telling already" the boy" well come close to keep your orders tease, OK. "the boy" I don t have

money yet, "the woman" boy; you must "be insane, I'm not insane "the boy" just want to know how you looked.(gouache hay)boy "the store W) you on crack ha-ha, Crack boys. First of all Realize that, really a book can give accurate information and also teach the acumen's, whom they can be seen Osgood investors or just ordinary people in the cities. Cities means something that can occupy the relevant people in all given directions or exposure, exposure give a real detail about something that can give a special effects, about a certain interest on some methods for something very imperative. Important can give a little detail about people, to all given acumen and other knowledgeable" real book deals, not just any given permits to acquire a good record to a certain deals or just legalized methods of business people in general, regardless any given color or just a "Black Man" a tea store or just to any positive Coffee shop, and contributors to all human behavior. What does that mean," Good Question", Sir, in detail a person is very important in a business, whom is recalled as a consumers or a customer in business language." which said" according to a mathematical production, the aims is to reach to a certain amounts, aiming to make a given records or profits, per given directions specified. "grandpa" this should be the time Responded to you woman, "hellish" "Grandpa" do you think I can just be there without you maybe? Ha-ha very funny "Grandpa" who is going to look at it if it's not possible to eat real food in the house? "grandma" are competing this now? Genes hit with the regular look that eminent or popping his fingers together, making a real sound tick rock rock, Grandpa "I'm going back in and you should be my son, he left because he should, if it weren't no food, or just a well-made meal. "maybe", "grand Ma" lift me out, OK.; grip and leap out yourself," it's difficult and I will just take the stairs out. "back in the House" Big mama do you have any free orders?" maybe" boy you should have your own store to talk like that, and know how it feels to speak with broke behind the counter. What if I pop up an order now? Hallelujah!!...would you think it wouldn't be impossible," the store whom" it's possible to see food on the table, real" the owner" well we will talk later, "big mama. Boy you must be a rich guy to be

really this early," happened" you couldn't sleep? "big mama" no it feels good to sleep and still know something is coming our way; it should be a full chicken. "it is boy, it is." big Mama" the store is to give a little on how to can have your own pleasure not with just your own family, but the people in the city, that can create a memorable instruments that gives great pleasure. You know all about being in business, and to be more clever and very special as good as well presentable speech, when you dealing corporate or just irregular customers. At least be advised to keep an open a mile, which will give a happy man, well healthy milkman, or someone whom can happen to be your neighbors store or just few blocks away" away maybe" that makes a "Beer Man"," A beer man in our store/" well great, give me some order, "straight up gangsters b*itch" hey boy you not the owner "big mama" few coffees and burger meal on the site for them kings "B*itch! Yeah you talk like us, shut up!!broke pants. "Big mama" OK.! Very important focus when you dealing with real, real give a lot about real life, all the things that can happen in real life, which gives a real professor in front of the class or just be somewhere on a "conference call" well its good you guys can communicate "very well" he says. The lessons about to commence "well" the professor" sure you cane in class or great be at home "The dog" woof, "woof" hold up what, what is this" the cat hit the remote and Changed to a channel where we see "The Obama" in the news." he is the embezzlement" continues. See there's on professor anymore. Real give someone you can be closet or touch, in a given knowledge he can be touchable must be the professors collateral..! the professor" are you here" the boy at home" great! and also writing novel, you should know what you writing about and from the first book, we haven't given the skill to be a good writer. Not to concentrate only on the good money's you will be making but also to give a very impressions anyhow to be creative. At least try to can speak real language or movies or staged play stories, and also that's how yuan send the message to our readers. It could be in writing a poem or a letter to someone you like, "which gives a little hint about romance or just crime novels. To someone "this gives a good impact about the

human behavior. I can write it because, I would have been thereunder many times. And I'm still encouraged to be someone" that someone "whom changed the bad to something very good, and still want to be somebody, who can be positive the life and the future presence. "I may recall" first of all really I given a method of religious encouragements to send the message about how to be with people you love people that can contributes towards a real human behavior about the love and good romance, so I wrote to be very impressive and positive and really to be elegant and still to be quoting from the "Bible "to instill the available methods or way to be more creative. The only importance's to be well creative. I Lived to be the man who can beery close to a fine Ass woman, really I love good woman, I'm a Man who has the instincts to impress and lovely wonderful well "woman" who can be a good woman" Poems can also contribute and they made the mood for the book to sell and to give a great of human feelings." not all human have feelings, and they really they can feel too' but someday a prince" who can be" the Scottish taught a blind woman how to feel, "very impressive" really" she says" I never had time to really know how it is to feel. The poems, I was born to be great man, I don't instill bad behavior or bad toleration the great of human kidskin the book we wrote" My life as Man of GOD "is derived and redirected for a well speeches in for a great market and to be in a good standards of a rich Man. "not only we can write" this simply means I fell in love with a woman, I can talk to though, wealthy I changed it to make it a "Grape vine" it's the information around the hoot or the holly place" very funny sir" uh, I may continue" the princes" yes, the woman typing the menu script uh" do you think we can take a break? "well" the woman. If I were that woman you writes about" I would be Cleo, whom is nowhere to be found, or the woman in all the movies, and play stories or just to be in the "Family" hah the woman for the house well you says a lot about yourself and really it touched my feelings. What do you mean "the woman "if I were blind I wouldn't be able to feel" which recognized a princes "in love" good feelings" the man of the house. Well thesis the Man whom can and created our social to be touchy and lovely if the prince haven't been

there I would still bra bad woman, who can't even see herself in the mirror, only prince wondered about the" Catering woman" woman multitasking for her own behavior in and out of chicken? "oh ..the kitchen", I can say, you just says" chicken",: grandpa its fine to write and still writes", "good" you writing "boy" be good or just hit to the nothing in. "Grandpa. The city of Goth the city looked like a baseball Match, and the spirit of gold, in which given the strength of acumen's to be great with good pleasure, whom they should see and embrace the living soul of Christ. Whom he's the man to live and lived his oath to create a Man's wealth, whom he maybe the sons of Joseph to his family which kept the strength of Maria Magdalena who is Christian fellow Amen. I have a great family. „around „I delivered certain qualities of a real man's behavior and I hoped it will give everything to our impression to create a great acumen to be real and very special. I appreciated your great understanding and great focused to life and any important pleasures that would be likely to arise at to a pleasured state pleasure romance. I'm certain to deliver great news about our identical manifestations to us a leaders and people of common knowledge. We created a very common behavior whence approach things to be very deferment and uncommon tour casualties, "you tell about our language you may consider. We spoke very fluent and we are certain bout the people in the community to be very smart and intelligent to be us and the guys to our common wealth. We had all the time to become partners in the movies it can be at home anywhere it could be announced „"married husband and wifely" belonged together through ups and downs to all their families together in great peace, we are great full to see a groom and bride for a great wedding. Well this will create a pleasurable moments to us, me, myself and the woman never chosen to be in and out of jail. It's true to save someone and its true to k now toucan still save someone. Whom you know and you might know to be your close friend or your family. I would know to all humans when time still pleasure to all man kind about to „"real man behind the counter if you become someone who can be caught to be in a great time given from nature and „"well" I would still know how to turn that favors.

And create a very good manwoman to ban love to gather in peace, man said. Take all your efforts to be someone special or meeting for someone you would marry and still think you could create included a great couple god created man to love his wife, and for a woman to live his husband and the family. He's „very accountable to his home and other given property to pleasure his privacy and his investments, the woman I love is in Scotland the country of hopes and to believe that man is wealthy and" "for a great know ledge and for the better. For great people to love and to impress. Business Plan Mission To increase the good result of a great pleasure tour consumers for a better satisfaction and Vision Creating better investments for great wealth we are Motivated The business aims are to give great and better investments to all our consumers and also to give more and reachable targets every time is requested for an unreleasable profits or assets. LIST OF INVESTMENTS OR ASSETS, House Cooking Stoves Vehicles Bank Account for Business, Labors or Employees, qualified Chefs or great Cooks X 3, Safer or limo-zine Driver X2Sales Staff X 3, Garden Staff X 2 and Lady and we Targeted Business Individuals Private Organization Government Tenders our material house we are certain about the environment, we are well focused to give our customers or our clients a specific consumption, Cooking Equipment's Electric & Gas Stoves Vehicles – Well modified Chevy and Chrysler well modified to a limey-zine fora Quest house specifically. Bank Account- weave a business Account to a bank, which will know how to consider our financial state and still willing to give accurate help through our financial records which will leave certain accounts or transaction. Chefs or cooks weave people who are well skilled with catering and have knowledge of food materials and how to assist certain clients different from, pork free society and also how to be with a dietician or catering manager. Safer will be Ina well-mannered tuxedo, material and know how to driven the cities, still want to be with the team. Sales Staff will have a selling staff around the table for at least received time, from where to discuss our targets. Domestic Planning on our gardens to be well and very lovely tours Guest-house and to have a lady who clean the house and keep

it healthy smelling like flowers. Targets -Business Individuals there are other companies specialization on great materials and every time they keep or have the meetings into a Guest-house, that's how we will accommodate their investments. Or requirements Private organization— this companies will be given thorough understating to all their requirements. Governments tenders we are well knowledge to speak our people according to their requester Managements We hope to give a great respect to our individuals about their specials investments through their given skill and knowledge about all they presenting to be on the table. We are planning to give our staff members a good knowledge about all we selling. Selling to our individuals, public and private organizations. This investments will also know how to accommodate our people, from all different countries and to accommodate all their request. The Tea is the most valuable consumption that people consider rob every important, to use by human being and as other related families around the globe. And it can be the most important tool for everyone to see can be able to continue with the city life. It can be helpful to can have the reliable store near your home, might be your favorite corner store or any other tea area you might find in the suburbs or in the situated business area. What is TEA? What is a Tea Store? According to my own experience to the understanding to the following; it's the most commonly known business are that distributes the Tea's, most placer places that you might all the different type of make often, whether herbal or straight Tea. Included the description which might open doors for your great business idea and included the detailed book, a home book you might consider to can have and make it your ideal friend. It very relevant to know and be able to run a Tea Store, first of all you have all you needed to receive good knowledge and all the description to have an idea for the store to happen and be true. Opening a store it very important to all your business ideas, it depends where you want to open it, you can consider opening a home based or the famous tea store you find in the suburbs, which is good to have a store running and changing your reality in to a real dream. Finances or badged not really to be tycoon or a star on this

method of investments, it's very important to remember all your ideas in a well-mannered offer. The only idea is to make great profit, and this investment will lead to other open opportunities for the business to grow. To buy stock is the only way to keep the business running, which will make great invest for the owner and other investors to give an open hands for the products and other opportunities, including training of employees. Product Knowledge Makes sure you understand the language of business when starting your own, this language will proof to you and also to make you a stable and well know business man. Present yourself in a good stable manner, which will give the people or the customers the knowledge of respect. Know the product you selling and know why the products so important to be in hands of good customers. Business Plan Planning a business idea, really needs time for the idea to be positive and real. Time is very important when you have it and really, a business does not need bad investment" which is bad pocket" you may thought of. Tea store is not difficult to run on to allocated your investments on the idea, which include "Money and Machinery" and other related sources of great business. Opening a tea store Running your own Store or apartment really takes a lot of effort for a business man to be on top, like running just distribution it very import to concentrate only on retribution. You don't need to be in store, you need a Flat or officiate depends where you renting it, at home. its safe and accurate, it s safe "to be reliable when you running a distribution, it can any legal business idea or just multitasking. Which means "home base". Shelves, Prices or Pricing first of all you need to know how set the standard of products, and also how to differentiate between one or two products you selling. Shelving is very important, because it include the product knowledge and the price as well as the quality or the standard of usage, meaning is it a Tea that you can when you are constipated of maybe the tea that need just Tap water or maybe. The products differ on prices and distribution, some products are made for a certain make or purpose, like green Tea is merely for people on diet or some people that need the reduce their Waite, from large to skinny of look able. Most normal Tea which

include Roosts is made for good digestion and good sleep, and certainly its for all ages, and works on animals or pets by Certs or animal doctor too. Like mice or hamsters etc... the only thing to remember don't fit people wrong make of products, that will course pain and it will kill innocent people in around the city. Franchising Tea Store, FRANCHISING it's a big word or business language, means to Buy or Purchase the existing import or export distribution in the industrious business people find very expensive to buy a tea Store or coffee shop, they find it difficult to run under someone else's ideas. Some they invest on the distribution than to compare and or compete on the idea. A Place to Run the Business First of all you have to be in a good state to own, and rent a place of business. When you owns place of business, you own a place which will be able to can pay its self and keep the business running, including the building or property in business language and if you rent a place of business, you are more likely to stay and choose to can move to the any chosen available or affordable premises. Employees Investments Fund and Salaries Hiring really takes a lots of effort to do it while running a business, consider to have someone running human resources company, or outsource a some companies running to employ your staff, and also invest o rtheir remuneration and salaries. Training your staff is very important in the organization. We have succeeded our special format. Writing and we have all it takes to be welcomed by someone special, she was proud to see the menu of the house or the guest house. Before you can start or invest in a Tea business or any given idea you might come across the line, make sure you have enough finances to give it a hit. And be the one to give or show the great influence for the profits you will be making. We had developed everything commonly private nor public or open to the profit and non-profit organization. We had all the formal agreement put ready for our available and certain reach. The multiple −ideas put into a different directions, is one for the book deal and two, to know how to have ideas reaching our readers in commercial standards. First we dealt with little exposure to publishing our ideas to the specific direction invested on the book sand the people we hoped to reach

four or health, we had many currencies and trough other times, we literally crucial about our only work, giving detail understanding of our special taking place for great hope resolved foreman and woman to begin with great talent. We wanted our guest house to be very competitive and are eager to establish on a running or production scale, we are aiming to increase given value to our own society. We wanted robe at places where it's a developing area and its very healthy for business. We exploring our adventure time to exploring our adventure times to our business to grow well. We have a great plan invested on the book deal to take place the guest house business, the project and other distribution, including import and export products, fortunately health products to heal the man and great woman or families in our comfortable homes, we are pushing to the forever aloe distribution to be a very best to selling our products. At the moment, we focused not only on the Africa s deal or best distribution and we will work "on the KFC franchise or a very simple scanners implemented to help our computers security, we overcomplicated our research for the house to be sold to a $5million dollar estimated on the project of a guest house. We approximately generating income through sealing ordeals to create a great investment for keeping our exposure to public and to keep other business deal handy for our products taking place. The deals its takes a very intelligent skill to put a great knowledge to be a deal, it sand still know how to can be very competent when keeping and managing oneself „also to other business opportunities, at ease. For a very long time, we have been working on the deal to establish in a well respectable manner. It took a while, man said, well we knew where to start and only where to finish. We have a great agreement to be on our side, we will always be repairing to be on the side of good people and we know how to keep our own promises. We started very small and we grow bigger each day. reaching a deal, we hoping to strike and still hoping how to be on our investors edge, we know how to talk with great inverters in IT business deals through any affordable shares, and we have the menu to keep our money at good level hoping to raise and attract more deals arising in the future level of

our business strategy we incorporated, the more it will keep us of producing thievery best of great art in writing and also and also with making good money on our side, t will give us open opportunities to become great investors, Well I describe cheating as something disturbing in relationship and if you get cough while on the other dates, you are on your own. May be I would be with you on the journey and your girl friend on the side, I will be a watchful eye or the be with the onlookers for not getting in deep deep trouble, especially when you get cough a fat woman cheating on a well skinny woman. Its intermarriage anymore, this should create an encouragements to haters when they see you publicly meetinghouse cheating. I used to watch "cheaters" the channel of people getting cough while on illegal dates to their husbands and wives you'd be a ladies man cheating and it never recalled as cheating or he be around a while on the blood testing campaign and when his turn in to be on the machines, on all the sudden he's sandpapered... well that also never be recalled. Why he's uncertain to be around and his girl friends want to determine. If he should be positive, thatch how he will be in trouble; may be. You me thought right on the video with another woman its, called cheating. If you deny to be that man they force aggregation most of the hatred. You say "big" No" well if you are agree to stay safe, many be they are not sure. Sure of your intention if this man want to continue in the house of the law to healthy stable relationship. and do what lovers and friends could happen to do, this is something every person in the city which happened to be overexerting years adulthood could be, behind any seen that conclude cheating. You agree to be on the side of cheating, its will sound uninterested. Better to be on thereat side of great Man. Never say you are not in the place of bad stable relationship., say and be the guy they want to see and hang around for as long as required for that moment. It hap pence on you to be at work or meeting friends really can conclude to a guy who has many friends. Its not comfortable to someone peeping and trying to be behind everything you do without a proper knowledge. Some people could sue you for trespassing to tem. That's how marriage. could conclude to an end

on purpose. Seen cheating is not goods on" grand mama" if you cheat and get cough right handed you are in trouble. Better stay safe and healthy. After its a great marriage. for someone who is been copyright on the alongside of the road, you need to be on the edge to can describe yourself around if you been on the side of cheating, if you cheated it repents what you cheating for but some people when they have been other marries. they described as not active, they move on. You would meet someone who doesn't gives great influence to have great marriage., remember when you first started to on a great romance, you wanted to be all that attractive. And as time goes by you become loose, independents on woman if they are turning to be bad they consideration a man in the house anymore. That hits back to you and maybe their status does not describe the real person who is good but bad. I was involved in a bad which describe someone who abuse alcohol and she bee non that pleasure for a berry long time. That actually Canaletto about someone who is not interested anymore to be on the bad side even nothing chapped, they blame irregardless like baby kid just said some about food or breakfast, they start not giving you food and you have to get yourself in the kitchen. "A woman" be at your underestimation to be someone we cannot drink around" man" do you know that when I wanted a marriage. at first' Knew we will be aching care of our self, not turning a remarriage to be evil and very boring. I don't want to turn into a kid mi my house" a man should" I would like to have and enjoy a great woman I met for the first time. This simply means someone beautiful. Someone who is very important to her about real love that would keep us together in peace in our homes that, There is a lot about ally marriages, they have the same meaning of two people living together with great Love and Romance, they different perspective when we approached the real life in general. Meeting was very special and real discordantly prescribed by our laughter, not hurts and we were very precious and never arrogant to be true about getting to know each other in many different ways. We talked a lot about us and never to residence that, we just married to make the means of getting transfers to be true and real, after will

all have a chance deciding if we could continue with the likes and also the love we shared. SHOULD BE MEETING great lover friends FOR MARRIAGE AND it s been very long time trying to work on this marriage. "I would like to keep her as its been a DREAM COME TRUE, TO LOVE A GREAT WOMAN, someone who is very rich and educated as shies fluent to be around with her, she's not boring to have her as a great bride for I crest groom and I tried to keep her happy as she liked. To my family, and her father and mother, created great parents may their souls live forever, we have great time together and we remarried to be happy about all. Keeping us together makes us really happy and interested to give and be proud about our marriage, from where we started till now to get to enmity to our marriage. We worked in the mines as contractor in the HR department, they outsourced my computer skill for their IT work, the needed me to non chargeable of their daily stats and steel report to them appositive answers, they were not regretful to have a well qualified it computer in HR department. Well its was very hard for me to describe to them that, the money they payee its very little for the post they trying to implement. They didn't have someone they could talk to about programmers and they worked with IT department but they didn't have great employee capable of computer and hardware skills. Well it was great when you start for the first time and they gave me the contract they know it will needed renewal, I said to be on the safe side I worked as an administrator the HR but IT department. They only paid me for their daily stat which is not accurate and they forget they are hired two it department in that one environment. Only to find out that later before I left the company in 2009, that the IT they don't work with people that cannot invest on the project and at first I thought will be hired to work in the IT field. Never to speak to someone who is great full about the real IT graduates. Hr manager at GOLDFIELD mines, he had a passion for computers and he was illiterate that he became persona land thatch when he was trying to expose their It department because he was hurt somewhere in the boardroom was full great managers from different mines contributing and they where highly paid. In sorry I

couldn't take a job where we nail people we should be helping christian at first when I took the job, I know that God was talking to me, that computers are not evil they friendly just like people who are passionate to help one another with great knowledge, but it was very hard that you work for no money doing major tasks in the company and they couldn't invest on that project, I quit the bad environment. Hats very bad to have money you would loose. I had the job and the post was very expensive to neon it full time, I was it IT but HR department, it not great when you loose your people over a less paying job, if it would be great I would steel be talking something differentiate the facility's good but there no money, well you lack investments and you can even be someone who can bewitch your family at home. That job required someone doing it full time and its was very bad to have a beatification you would marry and still loose her over a bad reputation of a bad boss. Better be safe and know what you doing on the post you'd be working for' a post shouldn't be personal, a job snot human life. Its different when you approach someone who cannot accommodate you when you are paid. And working for a great company that Could make millions but you are left with few or trying to be someone on the job? Really it doesn't make any sense to be on different perspectives of a working environmental still want to be Michael Jackson in his makeup. If you work on the job where you are not happy, better be safe and still knowhow to talk about caitiff you would like to take a RISK AND BETTER BE SAFE TO WORK IN INDUSTRIAL AND INVEST FOR THE BETTER AND FOR YOUR FAMILY. HAVE MORE INFORMATION AND GREAT SKILL TO CONTINUE WITH REASSURANCES. DON'T MIX BAD ALCOHOL AND ILLEGAL DRUGS WHEN STARTING A GREATCOAT. I had a great need to become great writer someday, its happening and we had a need to be very good with ourselves. I should consider her included to be a very best Girl I would marry and still know how to secure the marriage. on Diamond state, she is very beautiful, she's precious too and also she is intelligent to have and marry her. If someone does not considerable; if horseflesh to be ugly or stupid its not that thought you would try to raise if its not real. I

see you as a great woman and I complement to let you know that she look great and she that type of marriage. I meant when I say it; its true. This is to give thanks to our readers to all our books which really changed all to us and to god who loveys, father I heard you said love your family same as yourself, hate no body but love god to be your very true spirit and to Jesus Christ as he is the saint a son of god Father FORGIVE US AND THOSE WHO TRESPASSED AGAINST US FOR NOW AND EVER.

Scene 5

Meeting Real Art and Artists in the industries

Making music with different people is very good to know them and to have the casual identification when you talk with them, it happens most of the time with different people who you thought they are very good on stage, but very bad when you are close to them, good show the real type of music you like and the ideas that is seen as the growing point of musicians to work and collaborate with great Artists. Working together gives the great endurance when you have received a song that required you to dance, and touch with those artists, simply means, when the companies sigh the recoding deal with new artist they want to work with them, from identifying the talent with them they want them to have the real experiences and enjoy the title of musicians with benefits, we are not talking bout poor people who are having the dream but they don't wan to make it positive to have it achieved in the presence of Artisans and great educated business firms the entire universe who have the experience and the education to uplift the new up coming artists and the New owned talents; from the registered music stalls and Artists in the music world and management level. Remember to know that not only you can make it without a music agencies or broker to determine and providing you with the necessary deals to flourish. As An Artist you are not focusing only on losing the deals or artists collaboration, you must

know the implication of reaching the best income when in contact with your music managers, who has given you the potential to delivers for the best and a chance to provide the good music, for musicians chosen by the music deal production owner, to have the presence and observing the owner works, to also organize the duties for Management all the stage shows and music festivals to make all necessary for the music to become successful, also organizing Radio interviews for major and incorporation with bigger companies, to also talk for the Arts on behalf of the as part of the managements duties proving the necessary procedures, the observation and achievements provided by companies. Not to compare but to give the deal another level of investments, achievements and property encouragements to music and fans. The procedures and means taken by management looking on the Artist performances only rich fans stipulates more investments for the Record sales and willing to facilitate and over come the shortage of money, sales and recording deal or proper promotions in the industries focusing on the corporate ladder and give other implementations regard helping and uplifting the Artist about of keeping all his desires, works passion and million dollar fame of fans by signing the Fixed contract and after the deal. He or his free to have a new brand and to make amends moving on otter locations of recordings and projects of collaboration and investments in Art and his artists, to move on with the music career apart from the Directors intervene into the corporation, regardless of his exposure to the media and music. Describing the disadvantaged economy that leaves the community loosing currencies, that can discourage the success of your talents but to have a potential in the music and wealth. A career is not based on the Market and economy fluctuation of the country's currencies but to be aware and know what the government in implementing for our countries developments for proven success and provision of the necessary skills, and courage to have a beautiful country's in the world we living and also it give us great standard of investment as the people and to grow in terms of observation, working together as the

civilized currency for everyone living under the oath of our new developments and opportunities, that proven to become new, for the country and for New Businesses and Trade development which are taking place to deliver the quality investments with local government, national and international Market for Newly and obtainable Projects that has the courage and power to deliver the freedom for the good economy, Musicians and Trade Markets to obtain modern standards of developments in our home counties, in our Businesses in the music and human cultural society and heritage in all particular angles of great education development and Technology's. There are current development in the different cities of great people who are willing to give support for the Musicians and stage gigs and performances, also that encourage the success in the music industries of development in the culture of great music productions and rich society that have the idea to nature their hobby's and the pleasure which included their families of Art and music lovers for a civilized economy. Its important to know who you belong to when you enrich the great favor of a musicians, the great Artists that are able to become available when there is a stage performances, the award winning musician in the Art Factory of Music composition, distributions and entertainment industries regarded, when you are given the deal to compose a song, or songs for your career in the music and Art industries, when you are able to enrich the love and favor of music and Art lovers. That encourage for fans and Artists creates a common connections when you are having a passion for music Art and Technology, including the pleasure of Business Owner investing on the talents of great young musicians. Upcoming generations of great music lovers and also depends on the different genres of music and piece of Art of material in the Album. When you create a song in the first place you are able to have the concepts, which entails the message to deliver to the fans, the message of Art, love, Romance, and good success enriching the talents of young economy, not only to invest in the Music career or gigs and providing more collaborations, with Artist and to have quality courage and understanding of the real

world and real Art Making provisions. The differences that gives the music pleasure is the love or Music. A great course can lead to Avery good job and the job that pays well, you might ha veto be in college or university and you might be on your own or maybe have received great bursary from and institution that has the money to pay for graduates. That will also give you a great chance to be a very stable entrepreneur; from the start you d know that. I would "like to be earning a great satisfying income which will leave you happy at every position, you'd be someone who cane a self-made millionaire or billionaire at some other reasons that you have established a great company to provide and produce the selling products for the market. Or you are great scientist who implemented a station wagon; from all you have achieved you know earning more money than you could think previously. But you have made to become the greatest man in the world Moore to have a great Mulch billion Dollar Corporates, an individual Like DR Bill Gates, Steve Jobs the inventor of Mac Apple computers and Wozniak the Friends and close family of Steve, who have his own IT Cooperation. First When Bill Gates discovers Microsoft, he was wells genius already to be making a great programed working station. This is very good to have good people that can change the future from where we have been to have nothing, but know we could really know that we could reach the level or Modern Technology and also to achieve the great quality standard to know how to invest and differentiate from fake to real products. Or just any given clone distributions, whom you cannot compare to any given competitions, where quality of a real product it is determined by a great investments to be seen and known well to be made and handling can also tell how you work on the product if its valuable or comfortable. We have they type of human technology and also give the right channels to have a great distribution on it, as it is meant to help the life of people who have invested a little to receive great human technology products, as its very healthy to work on them as not only to be office equipment but programmed machines that can even talk to you, and also know how to be handy like

saying things on the screen to blind people or message notification said by a programmed woman or it happens who you choose. Computers are very intelligent and friendly and they well developed to help the human society to keep up with the greets technology to live with in their place of work or home and they are capable of great exposure to other sits that you might be on the internet serving and also helping you buy and choose the wright products on the internet. You don't have to be outside but, when it's needed toucan shop on line and still know how to receive good Education in the comfort of your home. Only you hit the wright button on your laptop which will leave you safe and well healthy. Well remember that at this modern times of great technology, you are welcome to can visits any site, as it happens that the is no tone watching you what you do on the internet AND WHAT SITES YOU MIGHT VISIT, but regardless at what age can allowed you see and know what you want its positive and the information you want from searching on the line you have found it; its according to all your expectation, you received great files, from downloading or its reliable information on your desktop and also to be well protected when you serve, to avoid hackers and bad sites. To actually have the information required to be on the relevant sites or internet pages, it s good to know the website you want to visit, or you "Google" search the website, remember you can type anything you want on the yahoo and other resulted like Anasazi search engine, you might be knowing more proper to can visit, and also youth make sure that you can receive more of the information you would accessed when it's possible to receive the sites, like "Cloud" and other related information desktop. It's great to have possible activities in your home to receive reliable internet in the comfort of your own space; and contour great parents... as Johannes Mashabela The bestselling Author and Borden Writer for Romance, crime, and thriller Novels of all times, I was born 1986 15 March, in south Africa, to be a well know author and affluent Writer from all the projects, the beginning and end of the book, we still continue to write and over a million copies to be sold worldwide for the first

week when the book is published, and over 10million copies world wide estimated including electronic copies. "The success that does not lead to any pain, it is the success that caters a great comfort" The Book is very important. And entails the life stories and backstabbers who are trying to rule the world, besides of their wealth reach and consoles to their given direction, mentored by their own creation and bogus activities. This is the book you can enjoy reading and it's not benefited from the real stories, it's a life given prospects the reader should hold on to and try to dig up the insides and the morals dedicated throughout the entire novel. Based and written by non-fiction writers" The Wolves Teeth" concentrate don thriller and based into the current future, this are the times someone can learn and behave like real people. There are means of justice and Laws abiding drug dealer sand other illegal activities revolving among the community and society as whole. "The Wolves Teeth" concentrated to eliminate and fight the current and future state of our own civil rights and to empower the youth and people living under the sun. Those backstabbers haven means of existence, and similar to rebels, their successes measured in prison or in closed doors. Behind the scenes and above the government expertise, there are major activities taking place for governments to familiarize their standard of ruling compared to Thug sand Rebels. Rebels are people that live and their major motives created havoc given to destroy the lives and deter permanent communism to the Government standards. This novel indicates the instruments of communism and adhered along the process, included is the major preventive aspects and motives to defend and win the Game of Terrorism. Only if the book is written and edited on time, we will all enjoy, be happy about everything that is troubling and evil hunting us. There are certain things that man and woman don't have equal measures to be in hiding for nothing, we tend to be in bad muted environment, forgetting that life has all it takes to humans in any means and measures of survival. The only aspects that keep the humans" survival away from arrogance, it are the background that set a bad reputation in

general. I read the book, written by the great leader, Founder and the former president of The African National Congress The late Father Nelson Mandela. "Long walk to freedom" it's a book detailing the life Obadiah, through all the entire period from the time hews in Penitentiary for 27 years and he was bailed out, to become the First Black President of South Africa he lived to be the true worrier and his excellence lives among the rainbow nations, which remains to embrace the black people on top and means of good education taking place in the country. I own a place and knew the devil is happy about all the negativity's happened in the family." I prayed to God and for all used to trouble, haunting me and the success to my life, In Jesus name ceased and God has given me the faith and the trust to live my life and enjoy, he matured my life and happiness, my book and he renewed my love life, my home and the love for my family, all the people living in the city's in South Africa, USA, CHINA, HONG KONG, Europe and Asian countries. All my fans on Facebook, twitter, through the world and my African brothers and sisters, with love care prosperity we embracing, we are blessed with bread and wine every day of our life, god heard our prayers, Amen". When see a black brother walking on the street, I see areal brother or sister, given the life to live for. I have the good recognition to all the good people, including other races and cultures. Not only to Christian civilities" methods of life and to all the non-Christian civilization. I see people that can live and breathe, eat and drink water. People that can talk fluently, I reconsider thwart of life and the sweet taste of fluent writing to be very fluent aspects to send and communicate with masses to all around the world. Giving common and true understanding of human modest civilization, of all woman and man, measured according to everything they can produce and share to their families. Since this book is about getting rid of the Devil Who is described to be the destruction of life and who doesn't know how to behave in a good respectable manner, for the good people and people of good education and hope. The major activities taken in to order for the Police to give respective measures and make sure

the city is protected and the lives of the people are saved, including their belonging, treasure's and money. Human Rat and his people are facing difficulties when coming to rule and taking over the world. They are not good people, so to their own existence. "THE Wolves Teeth" his power to defeat trembles and forbidding the laws and odors of the Rebels; they are not supposed to betaking from the lives of people. He prohibits the bad and ugly behavior the rebels tried to spread around. Not only the rebels and their false magic lose, their only hope and existence does not have value, and it's limited. They are forbidden to be around the society of today living and happy and they have not allowed to being the people sockets, claiming what is not supposed to be theirs. If you could put and set yourself in a positive environment, the only person that can feat to rule and defend the masses and the congregation for the good survival, it's the people that have ways and settings that is similar to God. The people that have the faith not luck, but the true meaning and understanding to good behaviors and love of people all around. It's been a week end and I have approached mix feelings for the princess, my intention is to keep heron good environment, not to detained and uphold her way from the city and God. I knew the priest is taking care ofter as it's asked, and I have been to a situation that revealed the outcomes that the Devil tried to invade with the Rebels and witches, they planned to invade the world and destroy every human and creatures living among the city. The priest taken the measures to keep the princess in Gods and Safe places, she almost fell in the wrong hands, only the bad people, who is the Human Rat, full or magic, and she wanted to keep the princess, she detained but she could manage to prove and is cover what she wanted too, she never got the chance since Wolves teeth came inland save the princess. Princess is kept in the drains "where the witches and the other rebel's hide and call it home. It's not a healthy environment you can call it, autoclave the magic and potions mixed together humanitarian and animal Bloods, and aiming to devour it. It's actually disturbing and it's untrue, for some over conscientious to be in that Human Mixed Rat

conditioned. From the time human Rat and the rebels could think and act like real human beings, she will notice that combination don't make any sense, Believed in their underworld existence, they are unattained to be in that state and doesn't have to make any sense. There is no study that says the experiments doesn't have to be measured and tasted, the only results that can be given tastes, aromatherapy experiential of acids and illegal substances. It's actually impossible to devour from the chemicals. The underground world, its existence is taken by southeast ward and good measurements that will entail the true figures and experiments .this is the end of the Human Rat Existence and his bogus ruling. I have believed and I have trust to myself and to my friends that, this is the book Wanted to publish and the book I wanted my family to see and read it. I have believed for my people in this earth flamboyance, twitter fans to have the knowledge zookeeper in mind and records that, this acknowledgment they cater and grab it with healthy for this book. I have always wanted to reauthorize "I can explain", not to be just a thug downstream who thought that writing and expressing oneself and the true moments and true life encouragement it's a Child splay. This book gives good impressions to the ones that would say, I need the book and I want to give myself and dedicate the time given to go through and know what this all about. I have written a book before and I have genitive normal time and speed, I had a book, it's a 215novelpaged book. It's not published and it's a book that would have given courage and create would give the reader comfort and I wanted it to be healing. Had the book in my memory stick and it happened that, the book it's replaced by someone and we lost everything, only you could see blank pages. Ones Find out it actually gave me the creep and it was scary, I had no one to tell and I wanted the bookstore a secret until it's published. I have created mealtime and effort to this deal; I meant a book deal tremor healing and overwhelming to the entire process. I wanted to give more about myself, "all the life given to bean author and all the time, life to neon my level, not justly education and life experience in general but, to express and

give threader the comfort and encouragement, not just any but the comfort and reality that not only me can writer, but everybody under any circumstance can typewriter in this today daily life. I have given myself time and I have disciplined myself with lots of things, it was very difficult at first and could manage to can actually waiter simple book, might beaver 150 "novel paged book juntas ordinary letter to friend, lover or may be an employer. With all the discipline I have dedicated my time and efforts to it, Wanted to encourage more reading to the youth and people that like reading, like myself I disheartening a very young age and I meant, I started at about4when I started reading my fist book. The book is a Bible for children" and as time increase my life spend and knowledge I have acquired a lots of books like" The Guide to franchising" Written by Mendelssohn" who is the visiting Professor of franchising and the Director of the Nat West Enforcement Franchising, at the city University of Business School in London. And the book has given hope and courage. I have never thought that this book could actually educate me about all disenfranchisement and the training given throughout the book. And also I have read "God has a dream" Handwritten one and only Arch Bishop" Desmond Tutu". The book gave me understanding about the Past authoritarian Anti-Apartheid government and also Ever Ready a book called "Living for today" and typewritten by Erin Merry" who is the Author disinheritance book, She actually describe and acknowledgment the readers about molestation and child abuse. This has given me a good Knowledge that life has no predictions. Only give trust to the ones that show love and the ones that can always give you a good trust back to you. is a Friendly and overwhelming novella I would describe, to all readers. It's a good book and I would encourage to give all of it to read, with your families at home, might be on your vacation or a trip to the beach, pool party or at the park and it's a book you will never have to waste time on giving it away. I assure you will read it bandit's a book you'd pass on to others. It's a book toucan treasure and keep it for as long you'd have it. Mean forever, the book its inside and have pleasure. Hopefully I have

been to a position that recrudescent situation and a position about my relationship and also about the entire process that screenwriting also that lead the relationship to be success. This is all about the book and if understandability that, this situation it's very stultification could have it solved and done on its own. Believe that in this situation it's very hard undomesticated believe that situations like these described are the ones that should be delegated to the professionals, and if Haven't given it to the right people. I don't think this matter would be completed. I have the understanding and knowledge that if you could be someone described and someone needed professional assistance, I would advise you to take the problem further to the right people. The inheritance we are living in a world of education and also, this is very important and it's so reliving to reeducated and knowing that education it's the key for success. I'm trying all the best to give our readers a complete understanding and also educate them that, if you'd be insinuation that would need professionals, do not hesitate and don't even look back, be the first one to be knocking on their doors. You know all your problems and all you needed you will always get it and it will be done appropriately. Have faith in this and also have believed they will not mess with you; they will give you what asked for robe completed. This should be the professionals" aim and in return it gives them bread and butter. This information gives all our readers a true understanding and as you read along you will know and be able to understand what I am giving you, uninformative from true life and things that really happened to real living people. On several occasions, was well pleased to keep in touch with me, and after she'd been through, we met and she was very happy and she said things that really put neon the edge and she didn't consider age, distance, race Coloradan to be a huge difference. Rather revalued the understanding and love that existed between the two of us. So in a special manner we liked to talk about us and to be around each other and so as for both of us. We knew each other well, we shared the same view and we treacherously and we tried to talk about us and theorem had views, which gave us the courage,

nothingness to hide or keep to ourselves. All the present iment interrelationship. had a lot to tell thereabout, and she was very patient and also whitewashed to talk about all the things that disconnected and she did t want us to be negative about "this relationship. And I were into each other's hear; I kept her close and have shown her that, I can be someone whom she is in love with. She is very intelligent; I knew how she felt to be in fruitful relationship. I lasso glad that she could also express her feelings and we recommended our interaction. I knew that she was in state of love and romance, and that pleasured me in differentiability. The love we had among us pleasured retirements we had. We walked around altogether and we enjoyed people around us, people with human understanding and feelings humanitarians. We had everything to talk about uninvolved only the two of us, we never thought something could have happened, we did nothingness would have heard me and talking about Our relationship did not interfere and indifferent people only us. We didn't want earth bound bad company, we kept our space laypeople which might have interrogated or given misbehavior, to the two Love birds descended from the mo onto the earth together with true compassion. If it happened that someone might have heard our involvement from agape vine, I don't think I would have created any bad reputation towards everything we carted for this entire marriage. We were not inane negative influence; all we had is the state of romance and Love, which put everything we had uncommon direction of Love and together with hope, we were very excited. We did all the things that lovers do, we had books to read and I had withstood me, which also added my character as, We kissed, touched and implementations, and we had a lot to do around and fore swear could live the house. I warned her threshold not take any negativity she would-be weatherboarding or any bogus circumstance from the street. I have apologized to her in many different ways, actually I did not mean keep her lonely for a longtime, and I have initiated and have never intended to waste time in this love which really works for us. Spearfished in to my ear

and Kept her really close and have given her everything she wanted we kissed. Expressed all of my personality distensions that don not lead to any arrogant behavior, shies very beautiful, is someone that snowshoe love, she is Romantic and she has a good goodhearted people, she doesn't entertain bad romance Goodwin relationship, she is someone that knows towns people not just to be with people that they Turtledove. I have been looking for someone that I coffeehouse around her and to be with, is throne that shown me the interest and love from the first time we met. This entire conversation was not in response to impress her or imitate that I'm in love with her. This is all I wished in this relationship that love will always keep us intact; and we have spent all the time together and talked about our experiences in all previous relationships. This is all we wanted to reveal us, and also to feel safe around each other. We were two angels that have been hurt and couldn't tees this relationship falling backwards, we antioxidant to be in that hungry situation ever again. Servery impressed that she really could give all altimeter and efforts loving me, caring and housekeeping as she could each and every day, forever. I seductive and resided in Pretoria, the west side of the City software and I was forced to pack and live the west side of Pretoria. Now I live on the East side, still in Pretoria, but the area is different from the west. People from the we stare different and it's a back neighborhoods, I stayed long before my late mother was in good health. After she caddied, I left the place and relocated, because there was runaround, people I thought would be my friends, not just girlfriends" even guys for friendship. Before Could meet someone special, It felt like I was new neighborhoods, I only enjoyed the time I spent with my late Princess Mother Mother Mosima Harriet Mashabela. A lady came in to my life and everything was turned around and changed back to reality. Sometimes I felt lonely and Thought this is not lowlife should be. I considered a lot about my life without someone I loved and the other side of it, as an adult and as time goes by I thought it in compressible to live without a Loving partner. Trail ways that one day I will be able to have and be in good relationship, after I put

all the wishes to places, to see her beautiful face in my dreams and have recognized her face, actually Heard her charming voice clearly, "she murmured" over into my ear consecutively in my sleep. She said lot of things I could sleep on forever; I was only and very interested in her gorgeous face and her beautiful smile. That is before Could meet her. I saw everything for the first time in my entire life happening in the dream. I woke up and I was pleased and thought, well I cannot believe this happened. All my wishes became true and after two weeks, westernizing out. I was not that old as she thought Might be from the first time, I was 30 years just turned 31. I enjoyed each and every time of it each and every day forever. I always wanted and liked to know more about her situations, life and our involvement always kept me disinterested in our relationship. "We had a lot walk about over and over again, and Misremembered that this is the moments we unwarranted and all the secrets, and that moment created love which gave the comfort for our relationship. And those moments lasted long and we felt positive about what we saw, and what we always wanted town. When my partners and I were together, all the time we spent, we had the chance to describe the entire situation that was holding back our history and relationship to be a success. I was in golf cap and Like the color black. I live housemother a cap and me always in a black cap, doesn't mean I'm hiding away from rebels or hatters, just that from the beginning, I told her that. I never use to feel save back in anyone previous relationships and that destroyed nonrepresentational, I never used to be embarrassed the way I was back in all the broken relationships which kept in hiding. Yes, I was hiding and needed to know that I could not say I'm still used to be in a bad state of romance. All of this hiding explained the total interest to marry her and wouldn't see myself getting involved interrelationship which will not insult any of my manly hood, or my financial situation anymore in my live. Knew that she have the same efforts and energy she could spend on us. We went through thick and thin and I strictly impressed with all her words she told, through than she have kept nothing to impress my proposals. Real

production including the import and exports all incomes first is the as products, are the ones well known and they have the great quality and great taste, especially food that taste great are the only ones that display the good quality about great distribution. If you could compare real and just products, the difference included if the product quality if very Good is when you start to seethe fast distribution included the real label. The Koreans we buy at a grocery store, like wiggles shopping center, Woolworth at starter clothes after and it's been approved to the groceries and clothes as other staff for home. The loo beans is not selling like any other regular beans you might know, the difference depends on the price, but if it's a competing price, better check if is Nootka or and other production or distribution. But not cheap make or just low quality that can also conclude to the level of customers. But best is the only one that sells the best quality the most. Better choose maybe meat, at shopping market, is not the same as from the meat market, like you buy from a store owner, but better chase for thrones that give a better quality and also the level indifferent. Pick n pay sell first grate distribution anchorite, came, to be addressing the black market and even all types of color of people including the rainbow nation buy from the store. Its depends on the budget but mostly like Woolworth really is, the distribution is not poor people, but rather try to be comparing prices when you are broke and try even the small ones, can make breakfast or a meal. A crate of eggs from the store can make it through and to buying bread, one or two for family house. If you commit to something good for all your life, you stick to it and want to know how to be one of the experts to have or know how to be one in the import export distribution. Owning the best products ever in the market you like depends only on the quality of the production and also the exposures periodically given for people that can be the one commanding to have the best deal ever taking place in their place of reach. Making more money you should have the knowledge like, how you going to make more money selling for a great profits, to get back of the game you should be knowing very well about how the production with sell

acceding to your plan sand also how you should be distributing the product that people want, or make a great deal of good that are essentials in the family houses or the family product that people use it often in the home, like bathing soap. Everyone in the family should know how to bath him or herself in the shower room or any place of bathing before they take a trip to travel from sweet home, work or see friends around that city, but really you should know how to use that soap. Depends what you like but that create knowledge of business production and what's import and to run and distribute the best products you could find. And real production need real income or to keep it or make it decedent distribution and still be known for the best products you can sell in the market as to be the best distributor, but to get to level where you could own market selling real products distribution, you must redistribution and that's how you lose it very fast in you could estimate, spending more that at least you can own, but if you make more that you have, you will still remaking a great profit like it is. Which could be estimated from real distribution where the is guarantee of returning all you have invested on the real production stock from that state risked as it all happens for every business Man should know that, investments could lead to bad distribution is a loss. Like investing on the production you thought its real but face Lasagna for Too or just fake champagne and other fake products of bad label or just thought you could make profit from the competitive market. But if you compete, you should be the one selling from a stock market but never to notice that, the Market of distribution does not have value of competition but only if selling face cigarettes". It's bad for the people who are living in the cities, they don't want to be bad habitats of face production into their own method of making real bad products, concluded that they course the harm of the city people. They are not been recorded in the state of food factory faults production, if they are fake, really they are now from the market. They are considered to be very bad and they should to be not seen to be healthy to be in contact to the real city people, and also where seen the fake distribution that have been in the city of

Cape town for little while and it's not successful to in the hands of people, if you could sell the real Mercedes Benz, which snot in the records of the State factory fault Products. They're seen as Cars not road worthy to be driven on the State Road as, it's a state property regarded by the laws another educational implementations. They can fake other production like Toyota, but apart from Chrysler and Porch, it's not to be given a try yet. But well we should be carefully when you a buy a latest model of the car you like; know it and still ask few question about the Good model that can be seen on the roads, to be well good and if it's not fake or real great products. If it's real production you should know the price and if the price it's very low but not on completion, remember that also the supplies can be robbed or just know if the price is good. Compare it to can identity real car mode, from fake to realtor real to good model and also the price can tell a lot about the great quality of the model car or the fake but cloned from the curve taken from the design of the real Mercedes Benz. The strength of art it's important to know and talk to express your only attitude, it's good to know that when you talk about art is very important to can speak and people hear to know, her to be with you to be with your great involvements of great strength of great possibilities, of great knowledge, of great time spent working on a good project, tome spent writing to express your only latitude of great nature. You work in a place you are not well to be around for some time, what do you do to get to resolve all your issues for that job, you speak to your managers, if your managers relegate you to other people outside you apartment, you happen to get all the time you can speak yourself. You can only get the time to know how to get to that location of relief, what would you do if you are out of money to see your other prospects to meet for a relevant occasion, you speak well to someone you know around who can assist with few dollars you can borrow, what happens if that person become your closes friends, one of your closest neighbors, someone you can talk to about everything, including the job you have which you didn't like it, and you don't know that you could be in situation that

will leave you out of no dollar or out of penny I your pocket. You didn't trust your instinct before to know about your very own job, which will lead you robe bankrupt, if that happens to you situation you would have to know how to deal with that moments of bad reputation to your very own family, to yourself, to your friend's you wished to meet the at the Golf club, to meet your very own company of great investor you grew up with. Which happened to be in your college or university for a graduation ceremony at one of your great friend's? If your wife could ask; you happen to be someone you cannot handle to be around the poor situation, but if you could talk wright to your father, your mother, and you're greatest spouse, your greatest people to be around quite often, you should know and handle that spouse of hatred rand lift up your head to talk to them, about you strength, your believe and your attitude about all its troubling you for the time you spent at home, without food, without money in your bank and without, without anything to know how to can have and to afford the very own car to drive for work, how could that be without money to travel for everything we should do or have, you must be able total nice to your parent and know to bow down for your greatest pleasure to all which its true about your dearest situation. Be able to can identify what is not wright and not good to your own health of anger and bad possibility of no management, mistrust of not any efforts to betaking close to your good parent about the money you would like to have for the job you know it s to pay. You're "beautiful you know, you have the like of my friend's in England, A lover a woman I married for my reputation I cannot find it easy to leave without someone I love inky life. I knew that meeting someone who Is positive and available to us to love and have to enjoy our very own company about great life, about great things we can share and talk about everything in life positive. That person you like its someone you can have all you could when she is around, its someone who is not bad about you talking tooter girl around your community, she's not bad towards you company at work, but only you find her to be friendly about the situation that involve friendship, but if we hit the bad side of

her that does not like, it touches us both, we planned that if we can be together we will have the quality time, we can access for all the wright reasons of life., possibly because we are committed to the relationship which concluded to be a great marriage to fetus to a point we can share and talking about everything, but nothing has to trouble us including the great Romance we can have without any doubts about our health. Out our physicality to can know how to be carefully aware about our very own quality and time we can enjoy when we area round each other, we will have no doubted to can kiss openly in public, if you could kiss your lover openly to make sure that you she is great, you are a very great couple, to see when you walk together in a park, or takings little walk smelling the fresh air, someone great could tell lot about the great people together, make great peace to love.

Scene 6

Money is in ART and Managing the Talents

When you are on stage with all you reached to be on the best of the albums you are willing to sell and share the experience with your people who have the idea of your talent and also promoting the culture "Art in music" and the people in the knowledge of creativity in Music composition and marketing as whole for the great benefits as Artist and collaborations, the companies sell only the culture to the people and music distribution, when you looking at the type of music that people buy the most, it can only be at home, the music the most the Artist are willing to achieved the best results, its when you are able to make and do the market related researches for all the Genres and music type for all the needed type. When we are entitled to sell the music on stage not just the radio, only the announcement is given to the listeners advertising the gig or music collaboration shows for artist to have a stable and better income for their career when its appropriate, and the "IMMA" International Management in the music associations seen as agencies of music distribution and Gigs management in music and live stand up comedy for real Artists and local organizations. Have archived the best goals to have and challenge the idea of poverty in music and Art where they have the only concepts to finance themselves as the corporate ladder and their musician in particular, where you are able to share you type of music, not only to have one artist performances

on stage, and to also looking to promote the major outcome of open economy and having to enrich the talent of musicians and great Artist of music and Art. Managing the deal in the recording companies is among delivering the completed project stipulated as thorough statement to become established within a certain period of time, managing the entire situation is to keep control of all the moneys invested and all the moneys going out to make or been used to keep the project of music in recording studios. Keeping all the time according to the deal which has been delivered on the fixed contract that gives the Art the satisfaction before and after conclusions for someone in music Business and the production process for all given criteria of Small Medium and major enterprise. Keeping track of all the Art work makes the companies a trusted and worthy on delivering the best and quality outcome invested on the owners contribution in the work for all the project's delivered for the implication of companies services, included to give the Artists a recoding deal in the first place, to also manage his works of technology accordingly and to maintain the means of his fashion designs and providing the necessary property for signing of a deal which can also uplift the standards of his life style, not to become too religious and have difficult vows concluded for the city people, we all trying to make a living within the industries and trying to implement our own strategies but not looking on the same participation but to be on different perspectives, where all the artists will gain credibility and money for keeping in the interests of their families and the companies interventions, for the passion and modern Cars which delivered the satisfactions in the compensation. But concluded it happens only on the a basis where Artist are not broke or companies that delivered the best to the music reputation of fashion, the music does not have to leave your reputation bad as Artist or become broke for unnecessary reason due to lack of funding and Production mismanagement, means that you are insolvent. Before you can become someone who has the interpretations of musical instruments compartments to have a music in your ears, when you recall the greatest ideas that leads to

an open courage of entertainments, you have the dream to change for the better investments, if you have a recording deal with a company you like the most, you try by all means to know the only importance that can make your music another investments which is the way you are willing to identify the importance of music band and how its reliable to sign a deal with a company not just the solo album, Just One artist, to explore for more innovations when you working with different Artist, bringing business in the music investments criteria. When you come across the importance which has the opportunity to become one of the famous band in the Music album, music company's keep your music deal separated, different from the and apart, for the solo albums and bands in the music composition and stage festivals, included in the stage shows for a great event when organized to perform alone all your songs you promoting, depends its a Music tour, but its different when you are selling Artists on stage gigs, to also have the potential exposure for Fans which has the meaning of Love, interests and courage to see the band belonging to the part which has class. Other related exposure of excitements is in the music band collaboration in the Management level, the pleasure of Artist having the experienced or knowledge to become in a most Great Music and Festival tour in Art and Music Business, having them known world wide to have the different type of fashion included to all music dance Art and Money in Talents. There is all around to see and know what to say or comment to something you think could be something great, that also will tell good things about the people you'd know and make great friends around you state for life, or romance and when you could happen to myself a good person, it depends on your emotions or great start to know the person, you start to get to a point and still know how to connect or talk to them in a very good way. And you meet someone who is ugly, really that pleasure of exposure to might be caught in, its different from connecting to a good person, you would want to talk that moments which just happened to be bad to someone you would trust to be good, button ugly. Which will lead to a conversation about something terrible just happened to

you, maybe be lately or after it could arise, now or never. And also bad it's not good you would notice; something GOOD, it's something you can own or a good language that can happen to all people or different age or different communions from bad situation to good ones. The people you can talk to are then one that know and take good language is coming from good people around that situation bandit lead to great acceptable dates to good couple, because it will also describe if a one spouse is ugly, but not good to describe. Or he's been great and nothing just happened to last night "female spouse" you could tell that night is you thought couple could do. It's not something bad maybe; ugly can tell who you hang around it's somebody or crew that could pressurize you robe bad or doing something's you don't like. In that crew you will know who is smoking and who Is not smoking real bad "stuff" or just ugly or daddy crack society you could be caught in. if you know before they can recruit you from doing illegal drugs, just know that it's not good for the good people to know that, if you could tell someone and say I can teach you to smoke, literally that's not good, and also it depends on what the conversation. Could lead to both of you. Maybe that someone snot a good guy you thought or someone you just happen to meet him in the wild streets in your neighbors hood, and he say" let's go to a bar and hook up", that's not considered to be relationship, there will be something coming out after that couple just turn drunk. They talk about something too major to consider or maybe whispering about "Great SEX" but too drunk it's not a relationship to be around. If you know that you ARE BAD WITH alcohol, don't mix it with too much illegal drugs, it with reveals all your true colors, that you might take a lot for that date, and you end up, spitting or vomiting and also, hearing and saying things you never thought a someone could say, and that's when you just met a great woman who she turned to be abusive to alcohol and she be like". "Sh**t" you could only tells a lot when you are around her; well that's not a woman you would know to meet, and she's not that type or marriage or someone you would show to your parents or friends about a girl you might happen to me her at a bar "a trap girl",

"Gran Ma" not anymore, she just undresses her dress and she lets you touch her thighs or booby's or taking to places where will create pressure attraction and very seductive, her stable really is beyond and she's not well, nut her having sex in her mind while she's drunken depends what bar you will be in and if the bar man know his people well if not packed, he will talk to you and the woman who is drunk about your situation, if its good or bad but just really ugly for now, it will rise up when someone just happen accidentally, maybe a woman puked on the floor and someone should clean it." the Bar attender" well you only people could get drunk think about something to know, that is for grown couple and grown people do a lot of things when they have the time to be together of just any good couple. But don't lead you situation to be ugly, just because you slept with the wrong person whom can very ugly and not good to you presence or bad to be described when you around other people. Or very bad person is not a good person, really depends on their exposure when they are in a private place of any place for Romance, in a boat or a place to be for Honey moon, the hotel or just "places you might be "inn. Hotel" when you driving around in the cities for quit Bed and Breakfast, You see the sight "great couple" you are tight and want to be there alone or just with someone robe a great spouse of different date or same marriage. What happens when you guys drink alcohol, you end up talking something different and you sleep together on the same room, BUT to a good couple it's good to be in a great time together and WELL DIFFERENT to bad couple, you might have been in the wrong places when you know that, the woman is not well with alcohol or just might happen that you met a prostitutes on the road, and you mistook her beauty to talk to her about great romance, with a bad spouse. "On both sides "A guy is not well healthy or a woman on the side just took a bad pill from a bad friends "Really different". This is the time to keep the Princess and save her out from that place she calls it a prison, she doesn't like it to be trapped in a place where she can't even own nor have all her belongings. Those people there at the refugee camps, are not supposed to have phones and this in not

usual to their living standards taking place. We are living uncivilized society, and we have everything in our own knowledge, we have a lot to talk about, everything we see around the city and on TV, symbolized the standards and the way people live. We own the modesty life and compared to the previous times of World Wars and hunger strikes, we are far civilized and very keen, intelligent to stick to the latest technology. One day a man was in the town one of the good days and he was really known robe around as a man good money, someone he can make you look very rich and glamorous. He was a man who owned more than redistribution in the city. He new how to bring the best product he can deliver anytime, and he loved people Ashe should, because when you are really rich, you consider people robe rich like him a business man. He never thought that some day he could live without counting some money in his pockets and he needed assistance robe in his great view he never thought that making a real profit for all his life time, was really a good skill and good interpretation when you present yourself in investments. A business man who is very intelligent to can know what's important to live with good products you desired for all the families. And its very important to know that when someone desired to be in a business stater be a real business man, there are certain steps you may consider. for great people for a great education mane abusiveness woman as well. Who is learning how to bewitch people when is required, its a very underexposure to us as humans as to be presentable, we see ditto be a very good education to learn a great skill maybe you might know how to count money well or may be you should know when is needed to accommodate a business call, it's that difficult to just talk through openly over therefore when someone needed help? Well...um, should give certain environment to can be able to tolerant when trying to win a business deal. ' man said'. You would want to meet someone who is very intelligent and very rich, you know you will be able to can escape the bad state of romance when you have great investment. If you crossbeams someone you would like and He be on you whenever is possible, remember that when you are

approached, independents who is trying to get close to someone attractive and rich. It happens on all the time and on every confrontation male and female side. Real investment really describe a lot about great people and the country around the clove and simply means that the city is open allegretto people that involved to be great investors. Most for the great guys you might recall are great investor and they are people you could talk about your investments they considers to be business people. Business is great touch as the community of business and to whom that are till running their investment and to lead to the great Traders and well insolvent and still know to talk business language. This is very good to know that when you talk to people in a nice way, it creates good character for that specific moment when you talk About something meant to help someone special in your Life. That chance is important to know it changed Someone. Dear sweet heart we know that someday goodwill give us a chance to talk to us, as we have been Through all the commotion about life and all the troubleshooting us. We always prayed to be great each day we Live, praying really helped us to connect to the spirit of God. We knew that something was there to keep us Together, which is love and real connection, We met from the first time and it was great to talk about Something real, which is love and great romance to our Relationship. We knew that love is never to be replaced by Hatred. Love is very good when are well and healthy Living. Love included from loving yourself first, god and To your family, only that god will know you are good Person, thatch when he is healing and know how to can Talk to us, through dreams and prayers. Which simply Means he can hear us when we talk to him through Prayers. God is close to cleanness and when you pray, let Him know that "we are not dead souls", we are people That know how to love one another and also how to Connect with the string of god. Its been very long to talk To the woman about all the times we were in the state of Bad time, we had time to allocated to still heal to theme needed all the efforts to be very true to yourself and still know how to choose who to be with at anytime. We were pleasured as we are very good all around when we talked bout the

all bad experience that concluded to spoil the good marries. We talked about it through all telecommunication measures and to a book deal which we are still working to reach the dead end for the books that will contribute to all our lives. We had great brothers and sisters around whom we can talk to when needed an ill help to get to a state where she could be given a great contract to live and work in England and still afford the city life there. She finally took it for a 2million pounds to have for an annual intercommunication broken down to $6.7 million Dollars. Which allowed her to be in England for work to stay and study catering as in King college there. She got out from all the bad place in jail, she used to be hostage from good life, where she's been and when I say, come back home to Africa; She hesitated and still don't know how to explain that she's been to that state where it used to hurt so bad. But awe like traveling we will have time and be like Oprah Winfrey on other business occasions to be reconsidering healthy in Africa. For her to comeback home will create a lot about all she's been throughout, in the camps and still never have to real the bad places or the refuges. Hurting their feelings towards that person you like to impress and that is not easy to can live someone you love and know how to keep him interested. From where you stated a relationship, till maybe today. It can beover1 or two to even three to five years and continues. you'd find a guy or a girl who you maybe grew with in neighborhood, and like her, maybe you'd meet her somewhere in the cities. You start to recall those felling from that age you grew together till you can talk about all your feelings.' you would say I really know that someday we will met and still know how to be talk about feelings or just marrying your friend. That simply means its person whom you are open to can be around her and feel great to be together. that's how you could recall great memories and it will lead your focus to be great about good people are hard to find. Especial in this modern times. When you meet someone you like to marry, its great because some guys don't have time to waist to unbroken relationships, it means a lot to devoted couples, when they want to penetrate through those murky memories all in their broken marries., that still

lack that confidence, now thatch the chance to know how to be on the lookout to treat them well and still know how accommodated their times of hurt and try to make it mealtime differ on certain occasions, you might in folded to great woman, she would describe a very beautiful and rich" she should" rich also contribute in the times hurt and bad romance. If you find a broke woman, you might like to know what could she be that broke. If her husband did not take care of that relationship simply means the previous times of hurt till she could settle down with a great woman. Well this should also tell a lot about experiences before the two of could even be on the date. Know times travel with great pleasures, its good to meet someone who love you than just want to be there for nothing. For nothing." man said" I don't fall down reforestation, its not good to meet restaurateur and want to marry. Its difficult to be around someone you don't know and you just be on the bed together for that time?. Its uncertain because things happen, and if you loose outside are vulnerable from all that she's been through. Its happening to get to someone whom you never thought she could be on drugs. Its very bad to hit bad illegal drug sand still abuse that purpose of loosing a good relationship. I would know how to please a good woman with great pleasure and having to understand that love it snot suppose to be focused with hate. So love its very common when you know who could talk about in the relationship. Maybe you would try to win that love backhand still would need security from all the bad you have been through. Woman are great and precious when coming to financial security, they would like to know if you can afford things around the house. If not you are will loose something but. Woman need to live with goldfinch security. Which will describe to be healthy to have money and still know how to do somethings for your wife, to can also keep that romance stable or strengthen titillate WE COULD know how to talk like media turnabout Shaker is not illuminated to be any the production mixture and many different stories arises, he s great manana when he was not shown around for a while. Rethough the cough be hiding from the thugs maybe? Good question, for someone to still know

how to be good back with his people around. If it was recalled to be his music came to a halt for his assistance to not be revealed. But artist really do the something as they keep all their life and real exposure different from never to be to art life. When you approach art life, you real mean a lot ab outwork to arising to great memories, to people that can conclude your daily life and they're other people that indiscriminate the "Grape Vine", that could also create something spoken in the neighborhood. When Jay-Zee tempted to be on the stage after he took a break from the Music and Hip hop well, almost same different perspectives that created great thought for ''Recognizance Game''.

Scene 7

Differentiating ART Creativity and Attracting great fame

Differentiating you music a copyright protection in the industries it means that when you are the owner of the music or a company's distributions, you entitled to received each and every cent of the Art material you produced and sold to the people, looking on the bigger picture when you own a materiel you are the owner of that art, and the great opportunity arises when you are the producer o good music, great Art and all differences in the Art and making, or composition industries, where you are able to work in practice in the presence of people, like the Business Man who own the bigger distribution of Art and Music investments, you are the owner or have registered as legal entity in the Close corporation, In the Partnership and other sides seen as the shareholders of EMI, Murder inc and DEF Jam holdings and G-Unit gaming world, and also the member of the organizations who are willing to give back to the community with great talents in Art and music, Stage performance for Pepsi challenge, to give the criteria competing for a given opportunity or prizes. but after there was mus-conclusion and bad behavior when it was reported on the daily press that there Art is missing, it happens when someone I the presence of thugs robbed the Art piece after the owner of collectors have been allocated the

exhibitions materials and want to invest for private business and business purposes. The risk involve the insurances companies that have seen the positive investment in the furniture and the household equipments, but after the conclusion in court reading the piece of material, the discovery or material is founds and delivered after the owner have taken major step to notify the cop shops, because there was a prize reward for over a $ 20 000 twenty thousands dollars worth of the material on the street values provided by the insurance companies, but the auction values delivers the premises of Art festival at a given values appropriates with the market rate of over the material conclusions of $ 100,000,000,00 a hundred million dollars in the property investment. The scam can only be seen when there is Art missing from the owners hands after been reported to the police or the community patrol cop factory for certain reasons, and the investigation which involved the The Hip hop police, Art Police and the community's for certain instances apparent with the laws that "in the bible commandments" "Do not Steal from your neighbor" but thugs are seen to become very bad with misunderstanding of the bible laws in the book of GOD. When you do other thugs that are not suitable with the government laws or prosperity's, you charged with perjury or just returning the owners compartments at free Value bail" just stealing the truth about the owners works. The owner has the wrights to have statements implicating if proven the purchase of Art works in the museum, in the registered companies that values the works of great Artist and also" the collectors and fans of fashion and movies lovers in the corporate industries. When you run a company in the corporate ladder you are willing to incorporate and invest with assets and the companies prohibits "stolen Arts" for all registered or upcoming companies involved in the distribution of stolen Art material. But there are liable charges, it can only happen when you return the basses of an outcome as a "thugs" corrupting the distribution process or channels of small big and major investment corporates, seen a the government. When you steal work its proven that you not able to sell it to the public market if it doesn't belong to you,

because when you exposed to seed on the underground materials, how are you going to survive to reveal the talent based on the great works of Art. Its certain that the government is involved in the safety and security of companies and controversial steps are taken into consideration when we experiences a loss in the business, included in the industries of corporate distributions and home owned basements incorporation of people who have a change in the distribution process of importing and exporting the valuable Art works of great and reliable method or investors, bookkeepers, Auditors and artists to produce or proved the necessary skills given or acquired in the experienced communions. "Believe that" one of the police guys, Identified a robbery at the shopping center, we were not save after it's concluded that the guys robbing a meat have been seized while, the car was parked behind the store. But if they would be to be good about what they did was not tolerated, they are coursing a disturbance to the public and that identification revolving around the neighborhood it will live them behind bars, they would still be identified by real police department in the city, if police could know they are bunch of drunk idiots, they are in big trouble. If the police have them in jail, how would they be granted bail? After all they did the course distractions for only few pennies withdrawn from cash register roll. That's show's those they were really hungry and very poor. To can hit a store and kill, just out from a cash register. "Too bad" to be in crack still hit your neighborhood store. If there any no more crack dealer packing at the Conner or any store that complement to a bar, just illegalities. There won't be robberies. And crackers forget that robbing someone it's too bad to be known and get caught on the game, really the cameras will identify who are those people and what's their aim. Too bad for crack dealer, really there's no life or any wealth could be derived from robing or cheating the state. If you become one of the great guys you be on their side, still you will really what happens to bad guys, in real life situation, you should be scared when the police really killing for their own safety and also for their families. If the thugs shoot again or on the police, they making it worse because

they have no were to live. As the old saying" They can run but they can't hide". Bad are always losing out from all the media and reputation, and also they ha veto faze case judges and really they have misled the state. To know that the judges are educated people, you should how to really describe what could have chapped before you could take action before. You know that wise man plan their ways good before they could take action, if the decision will lead to the min jail. "Too bad" But it shouldn't be about only robbing a store, but know and plan the ways of making great profit, not killing the people, but only admit to be helping and uplifting their spirits, that someday they could change and become the great leader of tomorrow and for the future. Loosing means bad sandlot to thugs and they know that when you commit crime you area bad, you should really what happens to bad guys in the Action movies, concluded in real life. "Scary." before you could think of robbing a Conner store, from someone who sells milk and bread, but how will you talk to him after you robbed his store. Not good anymore and your reputation is not the same anymore. Just unconformable to be hanging around thugs or just bad neighbors in your place of business, "really" It could tell that bad guys are never to be clean In the community and will always be thugs whenever they be," In jail" or anywhere else. They are spotted from taking stealing the meat from a butcher" their girlfriends tell" when there's a brain-voes, and the bad guys should be known well after all just happened, they went to rob milk store. They are spotted as not people of education, but people that jumped the stage from other countries, Nigerian thugs who distribute crack and produce corruption in the community if you describe the good of GOD, you are taking all from their pockets. They will never look at you again; they will just ignore it and continues with bad reputation in the city of God and great society living around. Forgetting that only thereat of GOD comes with cleanness and the great strength of great believe, believe in God spirit we trust. And they also forget that Jesus Christ was born on Christmas day by, The great parents, be Joseph and Maria the parents of Christ.

Scene 8

Signing the Contracts of ARTS in the industry

When you see yourself working with bigger industries of musicians in particular, its when you are able to identify the differences from having to run a collaborations organization with trusted parties and other upcoming new producers of music and Art and the specification of Training in technology as investments part of the stakes, companies you can only differentiate the need for artist when a company is engaging to deliver the best of all album and sell it to the world. Having to sing the deal with bigger and small companies, have the idea of the Art they selling does in have to include personal behavior in the musicians compartments, what are they giving in the first place, you are only looking to have the music produced sold, and having to share a stage with real not fake Artist, mimicking the real Artists onstage and selling fake concerts and tickets, you don't want to find out later that you been robbed a music deal, fragrance, fashion label, make up and cosmetics, Business in beverage also the music and videos making deals, stage deal and collaboration which include different artists and best musicians with proper experiences but not "thuggery" only to have a studio time, but not good when you loose money all the time without gaining the Artists welfare, you not looking to embarrass yourself with taking to fake deals and lousy producer or thugs. You are willing to know the outcome of share related outcomes when you want to move on with your career,

if they not holding you back of just wasting your time without signing papers in the agreement perspectives. When you want the money that you are likely to own and invest in the banks, all sources of keeping your money safe, for the sake of investments only purchased or collected proven through in the eyes of proven quality not insolvent or just receiving bad name and discouragements. You are given the chances to deliver and know that when you are stealing from someones territory, you must be involved in the scene, and what have you done you done to have the material and the deal legally and what have you done to escape with material, it can a beat, songs or copyright works from someone else material without legal implications from the certain companies, or private owners and collectors for each and also live stage distribution, live stage show or more. You must be evil if you steal or become bad without proper conduct with the procedure of agencies that sell the music and Art to consumers. So don't be bad Artist or bad courage to the owners Art brands and you must be liable to become the next passionate investors in music, Art and Technology to deliver the best deals for people and become reliable if you are in conduct with Auditors for gained products process or outsourcing other business in the industries. To become on the state of great investors and to have gained proper respect when you identify people. When you think that you can change, we have identified that only people who are not passionate or thugs In the industry, they don't have future. Don't be involved in the scandal of signing bogus deals and collaborating with fake Artist or become involved in the insurance companies without having the values of the criminals if certain thugs whiting the organization arise s and they are willing to provide you with work reported missing for decade and that in to the only truth. only to hide some other implication for a private works without the proper outcome if heard form the insurance companies that are not licensed. Tell them that you are not interested and not involved to become a criminal or thief," Be Safe" and be a great Artist someone seen to have a great name and want to boost his income values on the services, valued on the current exhibitions

material of fashion and different brands that delivers the best of owners needs, which is the quality of Art standard and concepts delivered to provide the satisfaction when that brand reach the consumes globally. Have different style when you are An Artist or upcoming owners of art investment in business and having pleasure to have great family's inventory for the values of money as assets in the business, seen as a hobby or fashion Art and the likes of great efforts of building new careers and great communities for the modern techniques and civilization, ruling out comes of business leader and positive principle when the government invest more on the Artist work and infrastructure. I have Priest documents to be given timeouts attention. He directed and commanded his work to be completed on time; his commands are very relevant compared to his delegates. Beyond his expectation above given to all the tasks and Have to be in a method to derive my power to defend the masses and the church. He s the Father I devoted to be on our means of success and be with "us as long as this pain and suffering we hate to face in today's lives and methods, to cease and to never have to comeback forever. Wolves' teeth describe the time and effort given in the movies trail, the picture motions and the speed created measured and implemented to keep and sustain the viewers about the whole commotions, and this is detailing their depths of the real Action Movie called "Wolves Teeth Thriller" This are the methods to get to a full picture and to know all the characters illustrated, and everything dedicated to be in this movie book. These aether major characters along the movie book and they have their own unique ways not related, they have their own differences when completing missions, this story book haste outcome and good influences to the readers and given the insides, knowledge about all the bad things the rebels try to come up with, and the main character's defended the city from the tragic commotions and battles influenced and coursed by the Rebel's, witches and drug dealers aiming terrorized their own city. The main important aspects detailed to know and finish each given task, its objected for that given transformation and given opportunity. Rebels are part of their

own unique existence, they have a lot to take than to give, they are Ina group, and only three of them share the same visions to control and rule the World. They have never entertained the masses and embraced nothing; they don't make living out of failure. The have their own golden rule which they practice each time they are in a mission to betray and invade the city. They are connected to all the evil creatures and they use evils method to destroy and finish their work. This is the only purpose for the Priests and Wolves Teeth to be in a good position, when defending the masses in the city. The rebels use magic and other relevant equipment's, destroying and robbing the people in the city. Rebels have no knowledge aimed about the conspiracy taking place to assassinate Wolves Teeth. Princess is in possession given by the Wolves teeth for heron good, she's been given a good eyed and she knows that Rebels are not good people, associated among the city. The Priest has all it takes to be in possession to assassinate the rebels and their Boss Human Rat. Rebel shave possessions" and ways of killing and invading the city, they have been in possessions to obtain governments taxes from the people and traders, taken from their hands. They are arrogant and their only main aim is to collect and treasure, the governments" money and Wealth. The government is known by, and the rebels plan their entire mission before they can live the hives. They have been to Bank Robberies and they have been to bombing the state properties, destroying them. Rebels are in a possession and dangerous equipment's; they use to assassinate and destroy the city, they don't have any given measure's or proper training using the state equipment's and Guns, they have no proper method to be in a possession for rivalry, they aimed to be in a state of salvation without any educational advancements. The city is venerable and invaded by the rebels and Monsters. Human Rat is human made in transformation of rat. She does behave like rats, and she does have the combination of Rat and Woman exposure. Human look and Rat Body, Human Rat was scientist and she's been experimenting fairly and since she discovered that human can devour and become Monsters. She started the experiments in the

lab, she overdosed and drank her portion, and the portion can transform rats and humans to anything they see or sense. Since she's been in that possession of Human Rat for decades, she started to be very bad and she's experiments lot of Magic and she does have an evil powers to changer convert Normal people to Rebels. Human Rat does not have. Any mean of human staged normal survival in the world of Real people, Like Princess, Wolves Teeth and The Priest. Human Rat flies and does all sorts of things normal people can't reach, she's very evil and she wants to get close to become the Princess. She likes to be in Prince Territory, she can create magic portions and also to kill and poison the princess, it's not normal for someone to be in that state, human rat does not have feelings and she doesn't like to share and be in same point with the Princess. Princess doesn't have any means of Evil and it's A major aspect for a Prince to fall for nothing than evil creatures. Human Rat can hypnotized, steal and destroys, she discovered if she could mix some relevant portions she always do and mix it with Princess Blood, that experiment can change Human Rat, back to normal, The priest keep and make sure the Devil does not destroy and defeat the city. These were the major deal and experiments that Human Rat could lead and Have Rest. Human Rat cannot situate herself with the Princess; she believes that if she could be in a possession to defeat the princess, this idea will lead her to eternity and she will prosper and concurred the entire universe, The Priesthood t like Human Rat and the Rebels to be in ruling state, they are "disturbance and destruction of the City, they don't have normal life, they ruined their existence and once they can be defeated. There will be no any bogus measure's and means of poverty, all the things that have taken place along the ruling of Human Rat and the rebels Existence, doesn't lead to any Normal life, apart from being in an evil and bad combination of Human Race and creatures. Evil doesn't have good life, once you set your own false Ruling and let arrogance to be your own goal, this ignorant behavior set a decaying standard of living. Marketing your ART Career in the industries When you are the best musician to have the final take for the listeners and music lover, its

easy to have the marketing sources which you are able to deliver to your fans, it can be on the stage when you have reach the potential to sell your Market, of Material of music distribution and to let the people have the music, if you are likely to her on the Radio, media conversation with artist that have seen the positive leap to music production and studios for the major corporation, you able to hear and to know how they are determined to provide the best results and to share the music, in the all the particular form of Marketing organization. Talking to the marketing companies about your work you produces you are able to deliver on the table the material you want to sell, either by internet, radio communication, stage deliverance and performances, or to sell with the most companies that can market your material and help you as Artist to make the differences, only you are able to make the difference when you are willing to sell you music and collaboration in doors, like major companies or you just trying to leap for a quick sale, in the music market. Looking to have the best and quality music to eyes of people you are the owner and you must be a beard winner at home, you are passionate to make the best music and collaborate with the best companies that are able to sell and market your music in the industries, companies that can make you reach in your talents, companies with proven records or Major sales in the industries of registered music distribution and Art. When you risk the only dreams for your music and talents to succeed according to the desires which are meant to become fulfilled, you are starting to realize the given opportunities and having open experiences that will sell your career with other music and art potentials for a specific performances or A great income that delivered the satisfaction and the quality material to see for consumers and music listeners. Art sell in many different locations regarded its been placed for the people, or the edge where its meant to sell millions, internationally, locally and on the public and private exhibitions and the stage shows or different music festivals and events, cultural and modern civilization diversities like delivering the New face of Prince and other organizations like the new management of a Church leader is

taking over for the Pope VI. Only to have the idea to know how to obtained the reliability of the open source as given for the products on destinations or distributions reaching the hands of finger tips, and to house holds happily on the clean environment is the most potential idea that Artist are willing to receive or prove when they are in their music career and for proper specific times; its when they want to see their music selling millions, from the start of their music career and regarding concerts on the compensations in a Piece Art. They want to see their name or band reaching the masses level of consumers to increase their market of music production society in the country concentrating on the projects and company services to deliver the descent income to increases their potential concepts of quality standard and more investments coming in to their music career. It happens when they have seen the opportunity to invest more on the product, quality on the material which lead to a proven track, or education which simply to have a study material, researches of the market products, distribution and that will also has the encouragement to stipulate a lot about the black market, flee and the real world market for all the cost invested seen as the commercial destinations for different companies to have their works seen on the websites and radio, to avoid loosing the commercial market or products proven to have quality standard of the mass production phases and which has the marketing concepts and process proven to have the brand enhancement in the popular market for a better success of a music career. To have a great success in the industry including all distributions regarded the services providers with great invested in the Businessmen and Trade Unions in all countries. It is to have great encouragement to know and speak according to your needs and specifics for your success history as an individual, a private owned entity or prospect of shareholders invitation or it might be a Training company or school for music and Art organizations and more in contribution of great Art and Technology specifically to have a potential outcome that proves and making you someone important and who is willing to encourage the level of investments in the industries for a better career and for your goals

achieved at the end of the day. Getting involved in the places where you trying to reach a change and have acknowledgment the ideas of a music career becoming more essential and acquirable to take a further steps, it depends where you have seen the courage and want to change it as a career.

Scene 9

Creating your music with trusted Music Entertainment Companies

Making is the same term associated with compositions of Art material which you are able to sell to companies as a means of showing Talents in music and creativity of pieces of material that simplifies the unique production, for people to have the experience that endures culture of Art society and the passion that derives in the music and production world of Pop stars, Rnb Singers, the most popular JAZZ bands, Rock Bands, Hip hop Artist and Gospel singer, choral organization band, fusion music, and Opera music and people who are willing to make the difference in the community for a better change' aiming to deliver the knowledge and the best trust of experiences which simplifies the whole material for a quality standards and to give the second look or other sides of Dances, it can be in the Stage performance, and the Hip hop concerts where you are able to produce the best results competing on stage with other dancers, also, it will tell the talents of people who are derived from the street to make the future great. First will be able to make the best of stage performances for the music companies to also have a look for their best of albums to produce the talent when they work on their music videos, where they are able to produce the most given talent the street and the society in the music production and

distributions of positive ideas they want, which open doors for disadvantaged community and bring the development to all the economy and growth. The courage given to deliver the only ideas to the fans connection and the Market which enable the consumers to have love and notify the music they would listen and take the final steps by buying or purchasing in the formation where they have received the interests on the talents and reaching the potential lovers of music listeners at their satisfaction for more investments. When you create the love for your income with yourself at your given state, you want to see and enrich the success of descent remuneration for your investments. Money you generate from keeping the talents and sharing with inverters or great consumers in the Art and Music distributions. In particular bases you want to reach the consumers satisfaction to deliver the most great invention or music career that does not corrupt your music talent, in the entire world of reach commercial business and exchange of material included the lovers of great Art, Music and Technology. When you are having the talents to prove them positive for your own health and also trying to maintain the wealthy standards of people you are enriching to have a stable Market of great Art in your homes, in your work places, in your vehicles and having a potential and reliable source of income to grow bigger as An Artist who is able to compose more songs and the albums for people to receive, not only just the promotion of a song or two and to have pleasure and gain of the music and the message for the album title which gives and encourage the listener to buy more of the Artist and to have compilations of great songs and music. Composition of real songs in the music albums it meant to fulfill the Brand of Artist, when are identifying the investment criteria of recognized or seen to have more wealth, obtained regarded to music is given another level by music, Art and Management for a corporation ladder. When you seek a deal its not like you just established a music career, and you just composed a demo album, may you have spent less that a $1000.00 thousands dollars a song and have spent time on the album that has more than 10 songs. The calculations on the demo means you are willing to

invest more with bigger recording companies that have invested more money on the real songs, music that meant for public and fame, which you are trying to compose and create the real market of investments to nature and adhere, and envies the potential of marketing your music in the demo and to have real production experiences for your music title and the music deal in the companies where you are able to invest more for a descent career and hobby if concluded you want the radio station, and daily Music media show, TV to play your talent and be observed. Delivering the best results of Movies ART, Fashion Lovers in the industries when you reach the goal of music to have the recognition in the market place of music and fashion in one criteria, you start to identity and acknowledge the great to all music and fashion. It will you the courage to know the music label and the type that simplify describes the total concepts of music and production level of a recording deal or a companies, the needs is derived from making the best level of musician and fashion or seen as stylists. They are also given the greatest look to having the knowledge of uplifting the Artists and musician in the different perspectives of organization, the Technology and fashion world also match and fill the gap of poverty and unemployment rate in the standard of corporation, making the fashion labels and the quality also have us the music to Incorporated and invest in the making of great art by hands with great fashion. Mixing the behavior of people and the music in fusion organization of factories, you not only selling your music production and fame, you are able to have the fashions and Designs of clothes and different styles of cosmetics, or clothes you are giving for the Music performances, it can be a Show where you are given the chance to proven for selling the most expensive Dresses, that is made of Meat seen worn by best Artists in the Hollywood fame, to produce movies, special designs cost over a million or half a million of dollars. Its important to only concentrate on the idea of producing the best material of Art and exposure in all different angles, when you have the control identified for the best quality fashion and to maintain the necessary designs best in fashion, and to have the business

market and trends that have the only oppositions delivering the best behavior of Artist, it can be on stage performances, it can be on the music festivals with other collaboration Artist, it can be also on the production level of music, Art and fashion shows and designs, money as part of the productions investment, is concluded that when you are involved in the certain places where you cannot identify your Artist involvement as a major and medium company to have a family, its very important to nature the talents and educate with implication to great knowledge of different Artist, who have the acquisitions and great experiences to deliver the products, or a piece of Art Material in the Art and Music talents. In the exhibitions criteria or as the profession ranks that enables the owner of the compartment or the collaboration of different designs of clothes, from Factory's or Architectural visions in business management which involves the money, the business of small, medium, and big of any structure or business services and projects able to deliver the best products on the markets, and the unique designs and fashion in the presences of consumers as finished products. The interests in the consumer based of fans you can conclude that, its important to increase the potential satisfaction of consumer, where you are an artist. You are not willing to become someone who cannot deliver the greatest name of your music title, you are able to make the differences to the music and Art in all the investments opportunities that are available and given to prospective incomes or seen as the awards. The compensation modules that provide remunerations that are given or prizes delivered to help and upgrade that standard of Art, music and money materials or cheque. When you have the database off ans world wide, nation wide and locally which simply means the consumer receiving the satisfaction of new music and development criteria in Art corporation of private and government organizations and new and classic encouragements in music production factory of beats and Art in Modern standard of technology and engineering methods, to compose mix, master and equipments and knowledge or skill provided for from various training companies, in the music career an investment for money

on the final products included in satisfaction received from companies. The services they need to deliver in the corporate market and investment having the satisfaction for real quality music they provide and receive as major investments on Art which has the encouragement for new up coming companies to invest and intervenes in the shareholders point of views in music Art and technology, and the values arises in the industries of fashion, fame music and provision of Production Material to them and the standards of technology improvements and consumer services based on the desires and implications of new invention of products with services included to keep the quality setting and standards of management and Artist civilization and to achieved the best income in their music as the family's. All the best results from the market views is the desires meant to be delivered to consumers which implies that companies delivers all the information positively, and the ideas provided to global content in the business and trade organizations. Every method that gives control is essential for all the business owners and benefit, don't t pick up on the wrong friends pocket, because they "might influence youth smoke bad stuff or cigarettes, they are not healthy. And I know you keep up fit with your endurance and also be good not bad. R member that god love us the same. If you drink too much and think of smoking but don't. Choose friends not dirty birds, Picking from the dumpsters or the street. You understand what I'm trying to say that and you are grown up. You have good life that can describe your personality and that make you look very beautiful when you are with people that love you same as their own families, be good with all you have and trust only god and your parents, remember to believe in the Strength of great God and the Spirit OF Jesus Christ, know who to trust, know who can be in your own faith and have great believe about all you have, it's your true belongings that gifted from the only God who love us like everyone else's, love is natural and it's very important to love your own than hating, which hate simply describe the words of bad mouth and Love its simply shown that said from good people's mouth. They are the ones that can give you

a great courage to have and know how to say to you that, you should be carefully when you use or spent your money, be carefully when you are with bad company; they never influence you for great life. They make you think very bad about good or successful people that you could be loving; but because of a Hatred believe from bad friends, just like any derived bad exposure from bad company, and they still want you to behave so bad. Till you can be seen and recognized as like one of the bad company, but which is not true, inside of you, you know that GOD doesn't want evil to demonstrate among his people, as he created us with his own Image, he wanted man to be great like he is and kept him to be great and Loving to his own family, no thating the people who are his own family he live with at all times. You must make sure that you become smart like a real investor, whom the bank have recognition to include his to be a Banker. But to the people who are not positive about all their investments, they do not consider to have a bank Accounts, and also they will be considered or reconsidered as the one of the Bankers, maybe small and they started to obtained a savings account and to have all their money saved in the right place, well that influence the people who have no knowledge about saving their own investments, or it might happen that you own a flock of Cows and you might have sold few for the year, maybes "Cow leg" and you have about three thousand pounds, including the money you have saved in your house, where as not save, and to have a simple banking account, that also elevated the hatred or little mismanagement from the thug Accountants or fake Auditors, whom can only Bethe people that can Rob all your investments. But have all your assets been counted in to cash you would bellowed to be smart like a great banker. You spent all your money from the loans and what would it be to have it back, you should know how to talk to other banks who can assist you to be back on again on your table, you remembered that maybe that you should have paid or settled all you have borrowed from the bank, and you now start to have no money you can reach but you can still talk to the bank about, getting more money in your pockets. What can you do to live without spending

money; it's not possible to live without cash in your reach. You would beware to can speak yourself out to your "friend maybe" closest to you, your parents if they still existed, your brother or your wife if she chapped to save the money in the other accounts, for the kids. "Well" you are great Mohave the money in the house as a father. Again you cause the money you'd borrow to a bank for other related purpose in the family, but depends how you spend it. It's possible to have can spend at least $1500 a day on traveling to work, from buying food In the family house, you have your time to spent with friends and you can create the time you need to be free from all the problem you facing and pay back all you borrowed from the bank, your friends and your spouse. Already you used all the money, and it's a spending. According to all your budgets you have more you use a week to spend, at least over hundred dollar a day can make you a man from all you're doing, and all that add up to your stress level you need total to a consultant regarding other measures of life and creativity, or you would have an idea to talk about to your own people drug store for few medication and they aren't poor people to go without spending a little to your advices regards what's the importance's or spending lessor more in a month or two, maybe business advise took all for the day from $800 dollars you spent, to keep you from bad arguments about the money you'd spent and still don't know how its spent, it can be at as home-based situation or other related occasions. You would be invited to a friend's party and you'd be invited to, weeding, house party, pool party, friends meeting, business occasion and dress up like a tycoon, well that can talk you very far to talk and still know how to chase the best deal son the markets, maybe you'd would rub shoulders with the manufacture's and still to spent something for the deal, A Coke, Pepsi franchise and surged drink distribution and others of drinks, depends a Woman Accountants or Great friends in suit, visage suits, Watch you would like to hire, and a dress for a Good meeting, how its cost all that give a lot to be Man and still know how to plan your dates, you should be a great guy, and still to run after for the best Deals. My self to have been in a stable moment and we retrying all

we could to keep Gods Love and all he has to keep us in good and safe place forever. This moment we struggling for the claim to take place, someone out there planned to allocate his false provisions and charge to what's not supposed to be in the possessions. Does someone think, is that difficult to have all the money your parents saved and does it so difficult to can have all belongings without the devil be in his discourages and disturbance measures. I don't think that Human Rat can be on duty to pee the money in his own hands. I thought Human Rat cane in any major difficulties than of human's exposure. Have been in a stable and good preference of educational and good facilities, I use each moment I have obtained robe in gods and good standard when facing reality. I have project pending and ready for disposals, I needed this project to be out and ready for publish. I needed the time and efforts to keep this book deal in good hands, not only to certain people, but to masses and masses through the entire universe. Wolves Teeth is projected only till it's seen released and ready to being consumers" exposure, this method is given through prejudice to obtain a good reputation through distribution and marketing channel processed to be taken to good orders and conditions. Thesis a given rod from the people of God and to all my family's, I urged to My Loved ones and my Parents in Law, who is now the Priest Rev and he has given me the authority to be who I wanted robe. We have been in this project from the very first time, we had everything working in to a fluent and promising environment, and I call him Father due to all the respect he has given me and my wife to be. To his Daughter More to have the true meaning that entails the living standard, she's is not the bad person I thought she was. She doesn't hold any grudges to no body; she is very patient and intelligent, from the very first date Asked her out, she dint have any negligence to my proposal. She is down to earth, she's the woman of my life and intended to be in marriage and have a plenty of life with her. I don't have any bad influence if she's been hurt before. She understands my exposure towards everything she asked for; a good Relationship, this method of human nature, dignified, she has given and expresses her total romance taking

place into this moment's its works and we enjoying each day for the better and forever. May the grace and peace rain unto you, the Priest and His Family, hope you are relevant and understand everything I tell you. Please Intended to be the only Man who is able to be part and parcel of your future. I want you my Princes to hold on to that vision and Know that you are my only Angel and wear together will Love; your smile is more than important to me. Your beauty creates wealth and, your voice gives me the heart to be The Man and not just a Person. Please be with me as long as we are together and Have hope we will make it through this trouble we facing, we have Only few days ahead and we will be together forever. I miss you and I love you TOO, have a wonderful weekend and enjoy yourself in any given time every day, I'm intending to be with you this afternoon. I have the knowledge that My Princes is familiar with the living standard in South Africa., we are a well developed country and we attract foreign investments, including United States of America, Saudi Arabia, and United Kingdom, Australia and other relevant and developed countries revolving the entire world, I invite the eye for investors to keep in contact and give I hand for the fellow brothers and sisters living in poverty, to give a hand and consider the people living in Africa. These are the major stakes of developments taking place. for the people and Government sectors in the country of Hope and Wealth. Africa is the home land of blacks and it s a country developed among other "continents, this is my vision and it makes it very simple if you can be in Africa and live the African Life. African's mean that, the living standard is determined byte wealth of Asian, European and western civilization; it's been years and years, for none other than African People to consider and have a wonderful week or weekend to give and acknowledge the place around the entire Country. I mean not only South Africa which holds the history of African people, but the huge African Continents that described the human culture and heredity of African People. South Africa is a rich country and it seen in a good financial position compared to other African Countries, this is the only important time for investors, to give and share their prospective exposure towards

short and long investments and education privileges to take place, for the African people. We all want to drive in expensive cars and enjoy the wealth and richness of our heredity, we like to be in a good stable condition of educational standards, like Germans and have quality prospects and products developed by Africans. We have business sectors developed ready indwell grooming; this involves private and public sectors. Its good and its promising to have a wonderland, of educated kids and mid aged youth acknowledged and the escalating positive impacts the economy and the poverty's facing in Africa. It's very important to be in a state of educational development and it's not good to see a young brother or Black sister, running around nude on the street of Johannesburg. I don't entail any negative activities taking place among the prostitutes and drug dealers. All Ivan give and try to be of good hand to my Black brother and sister; there is chance to can still climb out of that camp. It's actually a prison of discouragement and bad reputation you trying to own, over nothing. I have been on the side walk, taking a walk around Johannesburg South Africa. I have spent quite a life and in heaven I meant. You see people around black and not black, different activities taking place in order, around you see black brother selling from the back of their bonnet, this is happening in a black market environment. I spent my time in the restaurants, I enjoyed good food, real African taste sand if you lost and could ask around for a place, the people really assist you and you will never get lost. I tried by all means to keep and swallow my pride for my African People. God doesn't value of pride with failure or arrogance, only if you could lift and hand and say "Hello, Hi or dumella" to a brother or sister. This will give youth total view and the love you never expected for the people around. You become part of that society, just in asap. It's a major and specific effort to participate in all the enduring direction and have the history of Africa. Lot to fight, but to give a human and helping hands to the society. Parts of this book is for a very good family to my fellow brothers and sisters, whom I may call. My brother have been involve in a bad accidents he survived on the edged, he was driving in a white Razz Toyota

2008 middle age, every time you see him around the city, he drives a unit, and my sister also was inside the car, there were together on the trip to Jo_burg. My brother, hit the tree and lucky they manage to sleep through without hurt. The book is giving to you the ideas to speak through for yourself when you are in trouble or just to be not guilty" included "The Movies Story West Line of Freddy cooker in the night but he's the judge he engraved and thrilled to be like one, when he is in the darkest world" and included "Music Professor at home or the Garage-band" Reading books is important to have knowledge and the great ideas contributing in to our daily life's, I spoke to my wife, when working on the book for our profession and Authors and she know living in London and she studies to become a Dietitian and Married to the family of her sisters, who's her sister best to become a Doctor of Science and technology or Social nurse. Well we have spoken and interview a lot of city people in Africa, London and New York, but it happen before we could think and start working on the ideas to publish this important booklet, but not too embarrassing to carry it around in the city a Well-motivated given modern knowledge to can fit in your bag and also the ones create your own private space of reading on the sofa. The book is the only one to keep you great when you need the kind and excitements about movies you can read in the books and still need the time to can recall-about other prospective ideas to keep it on another level; Like the great Directors, till you can see and knowhow to recall to your people for more of this excitements and To the books we Wrote from: We have identified the need to speak about the important descriptions that people have missed for this error and to conclude but for bogus knowledge, the ideas is to keep our readers knowing and from not having the right information about their cases and never been to any idea to how to speak through in the judgments day in court. Remember the society need to be treated with respect and to our families, we need to have the proper knowledge to know how to handle the conversation in our own lives, if you should notice that you need to talk to your house people, but not concluding to treat your wife spouse as house keeper of just

insolvent monuments, from keeping you away from alcohol, but once you treat them like they are not part of the society that you expected, from treating a good wife to the first time you meet, now you see here as not the proper part near to live in your house, but that conversation should not arise when you hit the alcohol bottle, but if you thought you have a great wife at home, she should tell you that you need to speak to someone who can talk to you about your alcohol problem, this conversation can help you to realize that you having a happy beautiful family, and you know that when you having problems with your car, you talk like it is when you having drug problem and just any addiction you trying to hide. But you Can tell when there is happiness in your family, but drinking from a forty ounce, should not describe the problems, but only if you needed sleep, but not from drinking and abusing the family wine, the just taste like grapes. You sleep when you need rest from daily hard work. I would like to give thanks to my-parents, I would like to also have the most important message to our readers to all we have spent to produce the best books you needs in your daily life, and to conclude to the our relevant time we spent writing and making books in the office. And the house I bought for myself which cost me over from an Exchequer of $5 million dollars in California USA and in total spending from writing books, we started small and we grew bigger. Employed myself; we both work in close hands with the Partridge we both in the office. This office booklet is meant to help jailers to be free from unworthiness and to know that you should know how to talk when you needed help from your lawyers. The importance about the book is the production to it for great movies, in which to attract more deals, to be acting positive about the development to the movie industries and to our own actors and great given reality for our future generation, to have the history level and the great about the history of good movies, and the investments that took place to keep the talent and the money to also pay our people to have great education and be inviting. The movie dedication is introduced to have the only excitements to our readers and views of great and lovable talents for the future and

modern technology. This book is to introduce the important part about the investments for other related movie deals to consider and to reiterate the total talents from the best movies to the ones we like of the greatest quality from our own directors to give great education and to influence the strength looking in the future investments. For the past 15years we tried to have the book settled for other attractions to the menu books and as to be novels keeping our reader well educated to know thereat contents, that contribute to their daily life, as you live with your families all around and have the great thought of life in particular with great investments and also to grow all you can to the only exposure to other related financial. To be seen as the only important as the bestselling Authors in the modern Times where we are available to keep our promises in to good standard about getting our books to the eyes of our great investor for the world. To keep you well informed about all we can give to our standard of god quality and updated information to get close to all get the deals you would like to attract and grow in to, like Disney Land And the Hollywood's Productions as other as related by the entire standard and to put god first in all times "WHO CELEBRATE AND LIVE IN OUR OWN FAMILIES. TO SEEK GREAT FAVORS FROM GOD HIMSELF AS TO HIS CHILDREN OF GOD FOR" Jesus Christ we area saved from all the evil in the earth and to have the grazing land to our fathers as to our own wealth and inheritance. We are reliable to the our novel books for this deal taking place for us as to our only information written to give out proper conversations to the great about creation of all we can talk about for all this modern civilization. The great about Investments "It's important to know your money "This book will give youth most important experience to know about money you can make and still knowhow to invest more to other accounts for wealth. Counting money you can make you have the total ideas of generating your accumulation when is possible, or if found to see a down fall in to investments you would know how to recall when you generate ideas in to productive and money making knowledge. When you become rich you consider wealth and the state that can live you comfortable

to your money you count every day, regardless to all the money making scheme you can-just avoid when Its important, but remember the money you make it's the money you can spend, wisely you will know how to can have the same ideas to generate the money you can have and spend it wisely as its not money for dirty drugs, only the ideas which are positive to can have more and still know how to be open to your own excitements. To have money you don't know where it come from its scary and does not reveal the great about wealth. But to have you life in danger or to have the bad side of investments that could relate to destroy your importance to having money in the family or to your business if you own one. Literate investors are determined by the quality time you can spent planning the ideas that you're willing to change them in to reality for the sake of financial security and great standards that you put for work or the endurance of great life in particular, you should create a vision to your standard goals, have the motives to grow potentially a wealthy man and still have more investments you can count to be your own realty, but not distortions to your downfall or great exposure about the business as part of your own desires to have money in the bank that can live you free. Have positive income to yourself for any given time which can make a huge impact to your love life, know how to take care of yourself when you are required to have the positive result relating to your health status about to wealth. Remember that money is not something you can play about when you are rich, but to a poor person doesn't not know to make great exposure to new and relevant products that he desired, to have money in your own space is very important that are liable to spent or save all your wish for now and the future, when you save money in to your money savings or investments plan you would like to have the motor plan and the house plan or family money in to your investments, but to choose the most that you can atleast trust to have over a Million invested for you future income based on the interest like buying the savings for a share corporate company that sell interest for their investors, it's great to consider investments as part of your health and to avoid losing money every day in your

spending but save each and every penny you can retain. From twenty years from now, we will see the great importance to the value of our currencies', most of the companies are now are starting to see the value to invest into the economy and the government tenders as applicable. From when we had no developments in the country and to have no jobs, what is the most influential to our sales records, we still needed to have the great look to-the business as a whole for a better change. Add the introduction under head interest to have at home or at the endurance for a dream come true, referred to see and identified the positivity of the great society living in the world of dreams which the you would like to accomplished everyday of their life, they will know how to be on the progress to on their own destiny where its considers to have an invested in the progression of our lives included to all it's in the book where will attract most and our great readers where they would like to be educated without any complication for their participation, fora great time knowingly where they are expected to change and still experience the change behind from seeing as the growing and passionate community's, where you will develop and enquirer to administer and be with your company you would like to can have a positive change of ideas or dreams. Leading to the only American dream. For this book also have included the Studio college professor, Very interesting to have a dream at your doorstep accomplished and having an idea of how to be included when considering building your own home music studio equipment Or garage band. Gum gum. Unit One Speaking about your problems with lawyers You need to know first ho to resolved the problems from hunting a lawyers you can afford, but first you are responsible to talk or consult someone outside, who is part of your family members and other related sources in the your court days, but this is logic and simple steps you should consider to talk first before you could be charged or kept in jail. But jail is not conviction or evil but you should know how to talk yourself to the right people, the evil part it's when you cannot speak about your problems or you just cannot locate the lawyer or someone you can find for help, including financing your case fines

or just lawyers consultation fees. Included on the case if will let you out but if withdrawn you will be the luckiest jailer in court. But don't be negative to your people or society, the only thing you should considers is that, the court would like to know what could have happened, if therefore no clear explanation or miss-understatements from the hurt community, but try to know what to say when you are in court. Rather tell the truth and apologies to the courthouse and to the people or your family to help your out or clean. When you need the lawyers or their business name as Attorneys you are welcomed to talk to them when is needed. Not only for major cases, but only if wiling and prepared to ask if there is any consultation fees hidden or just for talking your problems out to the wright people. Finding you request be proven not guilty at the end of the day, it's helpful concerning your thought from a per- pressured ugly friends and other matters you never have conclude to be in jail or court, but spoken the wright knowledge with great answers reveling the truth for your fulfillment, which involved you to be in beating community that you might be seen and need help to have a clear of knowledge to your reputation. Regarded to be a spouse abusing his wife from drinking fake alcohol and just mixing with related illegal drugs, but finding assistance will leave out of problems. But with problems you cannot resolve alone with keep you uncertain and ignorant to find the right people to have you in assistance, telling the truth about you beating someone after he or she had disposed your drugs you left in the bin at home, and happen to see and turn it outta the dust and you come back you ask, that should also lead you to the conversation about your drugs addiction arrives when you drink more from illegal addictions. The engraved of Cooker When he is in the house, he used to be in the kitchens where they teach him how to cook, he became evil one of the afternoon that, the judge came in and he gave him the money that he can release he's step brother. But it was not his true brother, but a jailer when he accepted the money. He once served a criminal and he was taken to jail, after the guy had called him on the job, he used to be the right guy they call for quick meal at the Conner grill house restaurant, but soon as he

was burned while trying to escaped the bill, he left the stove high and he took weed breaks for a call talking to a jailer. But soon as the judge was set, as he enjoys the meal and he thought that when they buy the burger and he will trip him with and brown money A4 envelopes and the note inside to clear the case and he will accept to be his brother but he's the step brother he thought he was lost In the war. To consider other related and he thought the judge will not reveal the most importance about the news in the city that is spreading about clearing the case of Murder this other friends and trying to take their belonging and from eating too much drugs, he ended up taking the case further to be a killer, and he was confronted to be the most liable and Murderer in the city, but judges, they took the money and the set them up. As soon as the freaky Freddy the Cooker whom got in the house when he was well, but not burned rethought he will be in the places of his own lies and he was told that the money ho thought he could have given it, is fake, "gum gum". (Movie-sounds)The great about Investments "It's important to know your money" This book will give you the most important experience to know about money you can make and still know how to invest more to other accounts for wealth. Counting money you can make you have the total ides of generating you accumulation when is possible, or if fount to see a downfall in to investments you would knowhow to recall when you generate ideas in to productive and money making knowledge. When you become rich you consider wealth and the state that can live you comfortable to your money you count every day, regardless to all the money making scheme you can just avoid when Its important, but remember the money you make it's the money you can spend, wisely you will know how to can have the same ides generate the money you can have and spend it wisely as its not money for dirty drugs, only the ideas which are positive to can have more and still know how to be open to your own excitements. To have money you don't know where it come from its scary and does not reveal the great about wealth. But to have you life in danger or to have the bad side of investments that could relate to destroy your importance to having money in the

family or to your business if you own one. Literate investors redetermined by the quality time you can spent planning the ideas that you're willing to change them in to reality for the sake of financial security and great standards that you put for work or the endurance of great life in particular, you should create a vision to your standard goals, have the motives to grow potentially a wealthy man and still have more investments you can count to be your own realty, but not distortions to your downfall or great exposure about the business as part of your own desires to have money in the bank that can live you free. Have positive income to yourself for any given time which can make a huge impact to your love life, know how to take care of yourself when you are required to have the positive result relating to your health status about to wealth. Remember that money is not something you can play about when you are rich, but to a poor person doesn't not know to make great exposure to new and relevant products that he desired, to have money in your own space is very important that are liable to spent or save all your wish for now and the future, when you save money in to your money savings or investments plan you would like to have the motor plan and the house plan or family money in to your investments, but to choose the most that you can at least trust to have over a Million invested for you future income based on the interest like buying the savings for a share corporate company that sell interest for their investors, it's great to consider investments as part of your health and to avoid losing money every day in your spending but save each and every penny you can retain. From twenty years from now, we will see the great importance to the value of our currencies', most of the companies are now are starting to see the value to invest into the economy and the government tenders as applicable. From when we had no developments in the country and to have no jobs, what is the most influential to our sales records, we still needed to have the great look at the business as a whole for a better change. Financial plan for your lawyers or yourself How do you work for you daily financial, you should have considered copay for your budgets the amounts related to your labor protection fees, it can happen

monthly basis, but the money is coming out from your pockets or included on you monthly pay slip or budgets, and how do you find the responsible assistance without you prescriptions. Remember you need robe protected from your assets, from you financial statements, not only to trust the auditors, but how do you know they are registered in the first place, you need to be with someone who you can talk to about your law fees. You could happen to the company you running form miscalculation and you job you could lose from misinterpretation or you experience someone trying to steal your property investments, without you gaining something from it. But its logic and very simple steps you need to know, for home you are reliable to have your law financial plan or protection fee, in a form of insurances or just labor house. It's easy to Google find the lawyers or attorneys in their business name, you need to tell them about the case you are involved and they charged you with certain amount undisclosed assets and we happened to be on the wright side of the la wand ask about, how they will be uttering for you on behalves. In court if necessary you become in the case you need to resolve with your work environments, you spouse or something you need to have a clear understanding in your daily environments, it can be from liquidation of assets, or something you trying to cover for your family needs to be in the hands of attorneys, or your inheritances, as someone regarded to be The Man of society, The prince inherits his tribe, or your protection from house hold products you developed and other related business matters. In the kitchen Burned He was the only one in the kitchen when the Gas exploded to keep his body very ugly for the time, that actually make him angry and he turned on the citizen to be the one trying to rule underworld for the engraved Ghost but thrilled to be on the wrong side of the War1and war 2 and more till he's defeated by the Ghost hunters and the Reverend who he's is the one who tried to kill it first but, one woman trying to keep it away, she once met a police officer and he tried to be with him in the relationship, to meet their own desires about the family, he the left the Pistol in the apartments and to discover how the Cooker was killed in the movies and the Thriller

books. He was short ones and he made funny and ugly sound, "Euler...Euler." like a mule. Why he is crying like he's hurt, but we thought the Ghost does not get and feel any pain robe crying, but we can tell "The lady" well ones the reverend was taken to pee where he was burned, in the dark the kitchen is not real, but as it turned in to a fire place, every night you might get caught on the bike and stuck little, "The Man Coughs" and he spit blood, What going on, "he asked" but you see the place is abandoned by some great business Man and he's was looked to turn to a ghost but to be The "Cooker"...Gum Gum Movie sounds. One he sees a gun Man, he run and he killed a gunrunning and trying to escape but in the day it's a normal restaurants toucan buy, and eat and laughs a little, but before, when its dawn you will be alone in the restaurant, in the Conner you see the tables shaking you know that's the time. But you look around and there was a woman who was wearing a cross chain on her breasts, you see her and the sounds for the shakes just disappears. (Grieves grieves). What just happened?" the Customer" Hello halloo "the guests" hello and the kitchen is empty, but what could have happened to the guy assisting us from taking our orders. You see us here every afternoon, it means that we are just checking if the Restaurant store is open and you thought that you could know what happened, but there is something n don't understand about this place. But you should know that I have this chain where I got from my grandmother" the lady" and this is to know that how could I ban this places where there is no one to help us, but I just saw you in there through the glass and I thought I will not be the only one to eat in the afternoon. But only in this restaurant, it all happens to be very scary for someone died and burned, for some reasons and we see different people in the day while it's a normal day, but in the afternoon I was passing here and I was wearing this cross chain, and the Man just saw me but it was too late to get close and I thought the I could tell someone but a guy. Inside," he is a cop" are you carrying a gun, "the lady" I'm asking you if you are not the ghost. The guy turns and he was looking very funny like one. The woman scream (aha hah) the Cooker is burned. No wait it's me," the

customer" it a mask for my son and he thought I could grab some take outs at home. Avoid Dirty investments as it's for bad communions when you are in the financial state about losing money that you can make, you are not well with your finances to be an investor in the trade world. Remember that there are people that don't want to you successful to your own enjoyments, they can hate even a great man but Mohave trust within and to GOD whom we all love to be close to when wear in bad financial state. Bad company or community is only the experience that you will have when you are losing your money indirectly but not knowing how to retrieve it back to a great financial state where you can be able to invest more. Investing more can make you someone great and special to your family, yourselves and be able to study further to extend your knowledge, to be someone you can be in the future, where you were able to sit back and know what you can do to change your life experiences for the better financial freedom. Remember when you are having money to invest more into the markets or business owners, great business Man you can talk to openly about the money you gained, about the money you want make and about other personal favor you might need to have your financial records colorful and very attracting, you should have money ready as you are a business in a form or investments or purchasing the credits to avoid "thugs investments". You have been to the people that have given you money to start your company; you can start as little to can invest more, with the aim to grow bigger, with the aim to bewitch the leading corporate companies that perform well in the stock shares Market. When you look how to have been before you could be with great legends or business owners, you have been running a fresh club for dancing, or you have started to run a Jim at home, and you have been reselling some of the health products, you start, to buy s rock from as small business owner, and you are looking to grow and register your business. Remember when you start a career you should mix it with other business that will keep you out of the business legends. When you start small you want to grow bigger into a trusted sources where you could talk hand to hand with your

potential customers, you rub shoulders and still know how to connect with your investors, you should know how to develop your company healthy, to see wealth its growth, it positive and indigents minds, it about thinking out of the box it's about growing bigger into a corporate ladder, when you do your own business, you become responsible and you're the owner who create targets for, you see your own success from building it yourself, from talking or hiring people who are intelligent, who have the same success to change their dreams into reality, who are good and great to can make you and be with great efforts and strengthen your distribution, by talking positive with your customers, showing a healthy smile with your potential clients, your investors should be open to you about growing and knowing more about the company that you could reach to be with, as long as you are existing to be on the side to be rich, and invest more for your own stable business thoughts, simply method to make great income and to invest more into other investments happen to make you grow in to the business world or great leaders, great people that can change you and make you rich and wealthy. Unit Three Type of Cases means descriptions for thorough misunderstandings beating up someone you don't know or abusing an object for your neighbors in a road rage been augments, this mostly happens when you involved in the tragic area, only if you are involved to be the one who is been charged, then you will know what we trying to can explain to you. But not to be difficult about anything you see and read in this book, but dint misjudge or mislead the case courts judgments due to lack of understanding. But if you are well enough to can be in the front to walk about what have happened. But you can only stipulate the only truth. You should know when you are in the oath or the court house; you are more responsible to break free from harm, form insults or lies. And it doesn't have to happen only after been convicted, even at home from beating up your family membership sleeping around for unnecessary satisfaction due from lacking knowledge about abusive you spouse, not only but at least you know how to talk about sexual behavior at home first. But you are been reported robe

bad by sleeping around with people you hit or by a gun point but stipulating romance. And you should know if there is arguments and someone is forced to be negative to the conversation, you could be convicted and told to use a condom, but its doesn't have to lies when you explain to the problem. It doesn't have to be the one who is rape to be in jail or fined for any unnecessary conviction. But you can choose to tell the truth and accepts the charges. It only comes from the court house about raping and charging. But to have the trial or ever been convicted of lies, then you will only tell to stay away from other marriages. But if you aren't married and you thought that you can only be involved with someone you talk about sex on the street, and you'd find hard that you cannot pay the fines to that woman or a street hooker, she will report to the police about selling unprotected sex and it will come from your convictions In jail or on the underestimations that you kill a person and you are been seen and involved onto killing, and the bible describe that we should not kill, it's the truth to be great to the human society, mostly in this modern time or great civilization, killing a Man is not like killing a goat you just bought for your own rituals or private brain stall from a bull. Understand that the citizens are protected by the government's laws or vows that have been proven good to the human lives in general. But to all the developing countries you should know how to be respected one Man's property apart of the Assets and a family Man, a bread winner, but convicted to ban a jail house, simply means that you are responsible for the killing of man on the street. At home and but killing mean that Man is hurt before he could lose his last breath from suffering pain or hatred. Confrontation of debts or credits You have been confronted with money you cannot afford to pay, but you remember that the idea is to speak about all you have been hiding from the court of law, but it can only happen if you are called to see the courthouse when you are present t. if you might happen to lose the track from talking you problems and still have to know how to can convince by saying, you cannot afford to pay the bill, but if it's the money you should know about, and you are welcomed to can pay it when you are responsible

for any given loan. But to know if you are confronted or not, speak to the lawyers about reducing your payments to break it down into monthly installments, you might have taken a loan from the loam sharks and they refuse to stop the transaction. But it's not good when you are involved with money you don't owe. If it's the bank loan you are willing to pay and make come backs with the credits, but know if you are blacklisted or not. If it's on purpose and you cannot take anything on credit, still know how to approach the problem ad speak to the lawyers. Insulting and stealing Means something you don't like to say in public from the crowd of people to other related members at work of homes. Mean taking for mother peoples pocket for your own desires places of crack or other related man drugs people hate to see their families involved in the scan called the bluetooth crack gastrointestinal and taking without permissions in other people homes for your own desires to in exchange of crack to the criminals. But taking someone's belonging to your place b breaking it to reveal the powder inside the Android Machines or electronic TVs. This is been reveled on TV from the commercials and social sides where crack addicts are been taken to place by a School professor in the rural development for rehab and changing from bad company to see people around them in the cities. Selling drugs Destruction of Man drugs that does not contribute to the human civilization and to the crack addicts it's their most wanted powder they can die for. But it's not necessary to talk about the health from taking substances as it's not part of our daily lives, but to receive embarrassments from your community if you are not educated but to know not to mix your Art carries with other staff you think you can cheat the law. But only reveal to be unhealthy from taking bad drugs and passing out till they die, from not eating proper died and taking their daily breakfast, at home, but that's for crack addicts to live on the street from the dumpsters with no proper consideration from the governments. It can get you involved from Lies Misinterprets or Perpetration. Unit Four Find criminal centers and counseling rehab, and social consultations This mostly happens when you are missing one of your families, I can be

someone you thought he might be out for work, but not to be mentioned and refusing to have a family member who can assist. But most of the perpetrators have been judged and keep in the penitentiary without any know ledge to their families and have missing family members they cannot reach. They need to respond positive to the call from their families, it can be one family member calling in to the criminal center but to find the right person, you need to be close to the police station, to the court and to know what could have chapped to have a family missing and trapped in jail, but to know how to describe well better for your people, don't be bad when you have found out that, he was trying to hide himself from all the havoc on just intruding from the drugs community. But finding the right places for him to receive proper counseling and other related rehab course, they should know that drug life is not important to our own lives, the only important and major knowledge is to have a good family at home, once you can leave the house, we should know what could have happened to you. Not all we perfect but to speak the truths. Social consultation related to social workers and other related sources you might need help from drugs addiction, but most of the consultation they have charges for your needs. Less than per consultation and other related medical from doctors. The case and the fake money burned Who had given $90 000 000 .00 ninety million worth of Real American dollars, this time we had given it for other, but only give for the Movies deal. Yes sir "Director" well the first time we had it all to other given loose production. Not much to" Talk BOUT BUT TO KNOW NAN SHAVE THE FOCUS FOR THE MOVIEGOER "HE PUT THE PHONE DOWN, AS NORMAL SOUNDS. But compared to the sound of the phone and the sound of something moving in the house, well he thought that when I put this phone together will make the same sound of a Man enter the house for a robbery. Hahn, its Dog "woof woof" Give it milk, he see the sounds of an Ugly Man... you don't have nothing in the fridge yet, Cooker"" the Man" how do you find out, well I have seen that in my heat that there is something I'm missing but, as soon as the house owner noticed the shades had and he hears the ugly voice

and he recalled that he might call the police, but the Ghost just thought that it could be too late to talk while he's carrying a killing blade that he kept from when death he's around. We see blood to much blood and the head is missing, this is brutal killer and the case I will navigate it to the judge and we will call him to meet with him about what had told me that he received money and he lied about the Man in the restaurant about to have fake money. That's when in two weeks after he'd given the message back that, he was retired and rethought that he could kill a man and stray away for the abundance of the murder case, false in the judgments. The money is true not fake but the covenant, I did not show up. Case closed case closed. When the man was burned and recalled by the citizens that he is spooky in the city, but it could have been you who burned him and also the fake money. "no" The real judge, we will find the killing spirits and awe have seen that the was a burning restaurant but the Man who own the place, is no longer available but to live to police to investigate the murder of another Man in the house and as seen to be missing parts, but happen after all its been taken down from the money in jail and the judge who retired and left the country. Know business you can talk to remember that when you have positive ideas or a great dream you want to achieve to bra success, you are willing to change that dream into reality. When we all grow to be more stronger, financially and wise we are good with all the skills we have lent from our parents our great Teachers and other people that you liked to be when you are settled to can have a woman you would marry, as it wealth to our human society, and you would like to sit down with the passion and realize that, every day we grow and we have needs to accomplish and to give great support to our families at home, to be able to walk the talk with great people that you can communicate with them about the business you would like to grow and still know how take care of their employees, simply you want to see people work to change their negativity about reality or dreams to be great and positive to themselves, to their homes when they needed food on the table, you have to be the manta hunt and come back to your great family you loveless you have the skill

to work on your dreams and change them to be positive to your financial state and to have a great family, where you w buy the house you would wish to have, and the desired car of your dreams, but all that contribute to your desires and to have you company running smoothly. But the only way to have money coming and knocking in your doors, you must have the ideas to be your passion and change them to work for you, for your investor and to have great reputation when you need investments, it cane borrowing over a $100 000.00 hundred thousand dollars to have your great distribution you can start at a good investment, where you will see growth for a grocery store, you would like to have your name, you would like to be known and famous for your great Trade Mark and distributions, you would like to see great as potential to receive new and great products that work positive in the Trade markets and really affordable products you can recommend for daily consumption in the family house, and to receive some products you would like, but determined according to your desires. But how do you start when you are not having an idea or great business ideas that you can sell to your shareholders, in s form of a business plan you would like to have, and also to be formal about your contribution in the modern society. When you approach the banker you must have the knowledge to make great profit to be in the Trade and distribution criteria were you are seen as the most important in the organizations to be the owner of the distribution or a productive company that you sell for other related investments in the share market, in order to qualify to be a great banker you must have your business working successfully for your Employees as part of your contributions to the business plan you would robe seen by the great people who can invest for the great. But how do you talk to investors if you happen to lose money in your account, well; you would like to know more about the money you can gain from talking to your banker or the Bank manager. So first you would describe your business and what you want the business to do, the important part about starting a great business is when you are willing to contribute as it's business meeting, as little as part of the business investments regulations,

remember you want to be successfully, someday and the bank has the money to can borrow to business owners to have pleasure, financially and freedom to change their reality to a positive direction of growing In to global trade market. When you are at with your bankers, remember that the only idea to have money is when you are willing to pay as much as it's required for your insurances to keep your business great and important to yourself and to your bankers, so how do you overcome the idea of establishing your own company if you don't agree to pay back the business loan. The bank can be positive when you are willing to pay all you're borrowed and that will also give you and your company the chance to borrow even more than you thought to be over $200 000.00 two hundred thousand dollars, where it will give you the freedom grow in the business and you have more wealth to make great profits as you will have more products to the potential consumers. And to have the business plan approved you have to be the employer, and how you going to change the life's of the people in a positive environment and that is to create job opportunities and to be your own employer who have changed the dreams to be great success for people to be your potential investors and other related trusted sources or material, stock and Marketing distributions, and to have the know to hire trained staff to have a positive and skilled organization to grow and recognize the great about education which can change the lives of the community to be healthy and productive in the right directions at all time we live. Who had given the money...The was the other time when cooker he thought he could have owned millions and he then missed a step from not counting and to check if the money is real dollars or fake ones, but he thought that if he could have noticed that the money is from releasing thugs for bribers to the judges. He then realized that later that he might have thought that he took the wrong envelope from the jailers and then did not turn back the jailers bust turned back to him and he thought that he will be the one going in the jail house for lies and bribers. But how could he recall that he had taken the wright but wrong to the jailers, as he thought that he can disappear from all the

apartments and his deals from bad company and he then return and took something to burn the restaurant and the house he used to live in, he then forgotten to take the Gas can out before he thought he could still be around for a while and it was full as well as the house burned and cached the can and he then tried to run to the store where he died but then turn to a real spook called the "Ugly Freddy cooker". Well the was the only thing we could realize if the man lived in this house was the third and no reported, to the house burning but how could people just disappear from burning and dying innocently in their houses but with nothing to trace. Have the ideas put into place and If you're the only bread winner at home, you have the time to allocate all your investments to create good investments and to have the value to freedom for all you can accomplish for the better and for good. When you have the positive ideas put into place for great income, what do you have to make and create a better change? It's very good to have the concepts that toucan prove to have your business ideas going proudly. When you are in stable moments to make a great future for your family and your financial freedom, you are now experiencing the great change to your personal handwork to make it easy for your home installments, you clothing budget, you income to have something you can count that belongs to your assets or have the idea to make great profits. When you having money as part of your investments, remember that you have the financial freedom to have more or retain other accounts as part of your profit margin or gain. The most important idea is how you are going to have more to keep your business in the long run operational and productive, to stay in the business you must be willing to grow your investments in positive directions, remember when you have invested a little from your investments criteria or budgets. You can have as little as $50 000.00 into your accounts from the investors, you must have been saving with other creditors from investing $200.00 dollars a month for the past 10 years with "solid shares limited" and you have grown to be stable. You sit back with your decent income and you want to grow and start a great business. You will behaving your business plan ready for the Bank

manager, as Business owners you must be willing to produce formal ideas describing your distributions or in a form of a business ideas written formally. Decently you will be given the business loan to grow even further to start making million from the business plan you thought it a joke, but as little as you have gained from the bank, you will producing the $40 000.00 And $10000 for the transport and food for yourself as the new business owner Establishments. You must not see yourself or company broke, you should know how to grow mentally. Learn to make good contacts with your potential clients, as soon as you have the approval for over $100 000.00 you can buy the existing business operations, as your starter, or you can look into a growing logistics company, and you can also know how to rub shoulders with mining production level, you can even market your company for more stock, more materials and attract more money coming in the company Ghost as Freddy Cooker When we saw the full of Freddy it was the total picture to the TV and the open space to get to know how ugly this man really looked and he never thought about it. When he was revealed to be in the full picture releasing him in total, he became the most wanted ghost and he thought that maybe he is not friendly enough, but we could recall to all the friendly ghost that append to be the Caspar and his friends, but they never as ugly we could be with Freddy cooker close. It's not comfortable to talk to someone you don't like to be with or someone who doesn't like to see himself with people, but when he reflects to the sun. He became burned with sorrow and as to see a Jesus Cross he disappear and run away like you trying to shoot him with a gun. Most impressing, he is afraid to be in contact with guns, he might be allergic to have been shot before still he was a ghost other most wanted ugly ghost in the city. What could have given him the name and he was Freddy cooker his name but to be with ghost it's the most scary thought to can have the name like Freddy the ugly ghost, illogical when you cook in the kitchen, we call you with your occupations at work as the Chef of the Burned Cooks to turn very ugly when he was taking his private meetings with his friends. But the chefs or the cooks who are the people that cook food and make

delicious and very good smelling meal or breakfast. On the side of the whole new level of movies productions, we tried to be more creative to can include the fire that burned the Man who used to be in the house to cook and to serve people with food they ordered. Create goals for yourselves When you start to Bethe owner of a firm, factory, the public company, close corporations and before you could look into financing your business operation, first what comes into perspectives to your thinking, to your income, you must have goal to see your company's performances, to see it growing well, that's the most important criteria that can get you going more in to a great challenges of your business establishment's. When you are having the idea to have your retail business going in the first place, have a vision, whet is the most important effects that can lead you into a growing economy, what are you going to do to get your investments running g positive for a better change. That can leave you with great thoughts about investments and business as a whole, which creates the name for your own goals that you need to accomplish at the end of business day. You have goals that you need to accomplish at every aspects to have qualities of your sets of believes. What happens when you have enough money to start your company? You will consider having all your ideas that you reached Mohave a goal to keep it going according to your plans. You have the time robe in the operation, not only to be one goals, but goals that have reached your companies needs to be completed when it's necessary to be proven positive. First of all you would like to see yourself driving a very beautiful and attractive car, and living in the great and well developed city area where you need to have and acquire a lot about your neighborhood and you would like to see and live with great people around your country and to have great developments you can talk about as part of your growing society in the city, in the country, and you'd like to see your family enjoying to be with a great father, and you'd like to see your children becoming great presidents, becoming Doctors and still be reaching great education and to still travel around the world with money in their banks.

Scene 10

ART Skills Training and education in Information Security copyrights

Respond positive to family life and GOD When you have differences with god and your life in particular, you are well to have time for your family and great financial state. Remember that we live life along with people that don't have any money to save, imagine if you become one of those people; it's not great when you die from HIV aids and you don't have family to take care of you and your financial state by visiting a doctor and tell him about all your sickness. When you are great to god and family, that simply means that you are healthy, mentally, financially and its great that you notice that all you can do to change from bad state of romance and financial breakdowns, you should consider other alternative actions to have yourself into a great state of life. But when you are stable to can have the time to spend with your family and have quality time when is required. You should know how to invest more to all you can afford for your future careers and other part of investments you consider to be more positive to your job and business. Remember that when you having personal problems regarding your financial state to yourselves, you should know how to speak about it when you have concluded with your spouse regarded to be open to your financial adviser or someone you can be close to speak about your

financial, only you can be broke for the month, or you can recall from where you have lost side when you spent all the money that should be in the house for food and for the car, your house bond and other family related financial issues your wife can have with your friends, neighbors. Know how to speak to your parents toll your facing at that time of the year, the week or you might have a little to spend for the business proposal and you are looking forward to start and have a great profitable business opportunity that you might have recorded down before. And you are required to at least provide some percentages that you needed to borrow some money from the bank and you are determined to have a meeting with the bank manager. And you describe all you should be selling which is business idea you are willing to open and run smoothly. You are having business idea that cam put money on the table for starting a distribution from having a start up capital from a bank loan as for$500 000, five hundred thousand dollar to have you starting your dream business that can put bread at home, what are your thinking to make more money ab outselling products, like health products you choose in the market and sell ditto your neighbors at good prices, but from doing your thorough research about product you resell to your customers and as you move on the business you might try to attract other doors of great business investments, that you can start as little as $200 and more for your saving to get in to your business growing better, as you don't want to see your company losing business. You are willing to stay into the game to make more money by, investing more with other legends that can provide you with great income as long as you are willing to buy the investments packages that you would like to invest and still know how to accommodate other loans, for your house, to also cover your motor plans, and other related matters that you might over come in the long run. When you respond according to your plans and family life and not forgetting that you can speak to the only God we always have trust to him about our problems when they arrive touch and we need to talk to someone about all when it's the right time to that exposure. It positive to know that when you have the money you

can invest into an investments business that with leave you with great money that you can grow more to have stock for your business, to have a logistic business running under your spouse and other for your children you can have them a candy store, or you can also consider to buy a groceries store or you can run a business that sell cars and houses for good prices, not only you can look at retaining your money or you can also buy shares Ina form of a business deal that you can grow from nothing to something very impressive for your qualities as a great man who owns several business units and other investments, you would like to own the best Cars model regarding on the quality and a comfortable ride. To have more money in toy your business you have to keep your business running and stable to attract more customers and clients, shareholders and more people working for you as employees, to see people having descent and great income to their families. The only ideal in the business world is to make great income, when you make more money in the business sector you're running smoothly with other open doors as considered and seen as great investors. To spend the time to speak to god before you could start your investments as part of your daily incomes to be in your home, your family and to assist you to have pleasure at home, work and descent income forth better of all you can achieve as a business man and an investor forbore money and wealth. Be someone you wish to be and to also glove opportunities to all you can assist and the people you liked to be when you grow up, at work and in the working environments. The jailer is exposed This is when the police took the jailer to be the freed best buddy but the thug who escaped when the was the money given to other guys as townhouse set for the jailers, but in the street the cops took the one who looked like the ugly guy for the ghost and they confronted to ask his haste other hand of ugly city guys but when they burned, they could have caches and killed the Owner of the restaurant. It dint make sense, the police" but you can just pick up any guy's looking ugly in the street and arrest him for the thought if he could be burned, he will be more ugly button or he took of the face of the ugly Ghost to be the killer or murderer

and still talk about his absence's for the cities reputations. Not good but bad to the audience and the people theyhave murdered also their families to have been in the hands where they could not find who does thisthing sand there is not police can catch this thug.. Gum gum (Movie sounds).how he was given themoney to him, as to when he was captured and he was once reveled the smart Man in jail, who youcould talk to him about all. He was very ugly too but a very good jailer when there is money towalkabout. You talk to him on the table but he was captured from something he don't remember, sincehe was in there for many years and he thought the money they have in the restaurant, where he couldtalk about it to the guys who will save them. But it thought that's how we can get him giving the judgethe money and it was a place where it is in the basements, buyout could recall when it's dug by jailers. It was meant to get the ghost olive as it's in the dark to use his super Ugly demon spirits in the darkfrom escaping to come back when it has found the money. Gum gum(Movie sounds) Don't mixpleasure with pain Remember to have casualty's to your reputation that, when you are running yourbusiness on the down slope, you should not consider to be bad to yourselves, your family, or yourcompany, because it lead you to break downs or closing your only company for the good, most of thebusiness owners, from running a close corporation to the corporate ladder of investments corporation, where you could only be seen in the shareholders meetings, you should now hot evaluate and haveaccess to your own money, but don't look at withdrawing your incomes where you are down, or yourcompany is liquidated. When you running in the bad operation or business operation and you still thebank, have ways to can recover your company's reputation, respond to other investments as part ofyour assets that if you have old machinery that you dispose to other companies that needs it. Sell it tohave the money coming in back into the organization. The only important task to have and retrieveyour investments is to look at what toucan sell for other gains, or sell the company to the banks andyour share maybe they can retain more wealth from other companies. Which is great to

know how totalk to your Auditors positive with open smiles for your company to be sustainable to avoid breakdowns in to the share Markets. Your company and family should be the pleasure and not accountabletopee yourselves broke or insolvent, which is the only scary part of the companies breakdown andavoid to see your company losing business and create time to stick to the plan which you would like toenjoy to be in the growing investments of your company. You running a company you would like togrow, you would live and consider your employees to depart of your growing and developing society, when you choose to work with people, which have families, which have the qualities to run and stillknow how be part of the management, and the growing ladder in the shareholders. When you havingskilled staff you would consider to have received appropriate training in the organization, people thathave the qualities to be on the position and to have the stafftraining programs open to the individualsto have still know how to receive promotions in their organization and departments. But fromemploying staff for your company, starting in the packaging, in the driving and sales, management sandCEO, in the company, you would like to be the one chosen to run the company, but how are you goingto be on the position you would like yourselves growing in to and with the companies needs as part ofthe company's assets, have the qualities to be the managements, and still think positive about thecompanies developments the companies growing investments, and know how to be with your staff andtalk well when its needed to be the Manager in that specific environments of employments. Considering the growth and the possibilities you can attract in the long run as you are in the businessrunning positively in the invest and growing economy to see people working and generating theincome, descents wages to take back home for their own families as bread winners. Unit Eight Ghostand the crack house burns He was rushed to a hospital after he was burned and they saw the burnedbody missing when the nurses just witnessed the ugliest Action you would like to share with yourfriends. But its scary thought, "nurse" I thought themas just been delivered is gone dead already but

tolook like he's the spirit of the dead Man and ugly, but he survived the fire and he still can turn robegiven another surgery to keep his face covered, you could actually see his tongue when he mouth is notopen, But it was terrible to work on something they thought he might have passed away. But in returnthe doctor said that he is in the world or Ashes to be burned and still want to return but he is a ghost. But from the name he was given when he worked in the restaurant he still calls himself with it. "Hewoke up as we explain to the police in the hospital that the Ugly man escaped the surgery. Buyoutcould actually tell when he is placed on the machines and they responded positive. Not good to see theman Walking with scars and scar yin the city. Yeah in front of the president "Freddy the cooker" openthe freaking door for me now. He said. We were all scared and we moved. But it was scattered and wesaw his intestine, Ugly Burns to walk in public. Don't limit your incomes When you are runningbusiness enterprises you want and able to have your money in to your own pockets, these simplyimpress the aim of running the business under your own recognitions. You want to see your companyperforms really well in the stock markets, you would like to be on top of your own investments, youwant to be and seen as the most trust worthy to be investing with corporate individuals and othermultimillion share companies you can count. What would like to have in the future when you are notrunning a company, butt know how is your company performing in to have great and decent reputationto get your company to other investments level of exposure for better in come and the new generationdevelopments agencies that have met, your contribution to educate the society about how to run a greatand empowering business adventures that can lead to your reputation for abetter salaries and incomesfor the workers creating employments opportunities for others. When you have the experiences relatedto your investments, first thing that come into mind is how have you performing for the past financialyear. What have you performed in the past years you started running your company, what are the thingsyou need to have your business financial sustainable, you are looking deep in to the a financial

recordsthat you can produce and still feel proud about the performance and your business as the owner or theprivate individuality. The company you are running how, is the Markets for your production level, andhow to say it when you are in the business that you could talk to your investors, all that informationneeded the knowledge and great understandings to your money, wealth, as part of your income orinvestments, how are you gain creditability about the culture of your investments, and t lead to thepositive direction regarding and still seeing money coming In the business for future and otherpurposes. What qualities you need to have as business owner or as a private individual, you shouldknow how to differentiate between your own private space, relating you the your success, you aregoing to have or lose family in the business if your performance turn to be bad or liquidated, but if stillto be a bad partner, but not even at home, but in the business world you can also have the qualities toinvest more for your production level, you are able to promote your company's performances to otherleaders in the corporate, to still know how be shareholders, have qualities you can sell to the WorldTrade Market for great business individuals. Have your business investing to its reputation, not only tobe the owner and the shareholders, you can have the qualities to keep your employees trained well inthe facilities, have knowledge, when they only the experience's you can still invites them roaneducational center to develop them as also still know how to give them qualifications, not only themanagements, but the community staff for trained and skilled people. Time spent worth million wordsRemember when you need money to your investments, you should have gained the money from thetime you could invest, or in the future. The important message to all the investments method to avoidbread downs even when you have gained the money you invested. You are welcomed to increase theinvestments from looking into other sides where you are able to save the money you can have in thefuture, and same with investing for share sat a bigger company you desired to work for or own it. Butyou can be the shareholder for a miller distribution or you can own the logistic

comp anywhere you aregiven the subs to deliver their stock form where you can have as agents to the retailer's door. But howare you going to do that Ina bad investments, by looking into other open doors of opportunities togrown in to the financial markets of investments you can start by savings little as $250 a month and in5 years to 10 years you will have the investments increased to a satisfactory level, you might Have theinvestments interest or rate of 16 percentages to have into your income, its life changing chance to lookon to other doors of growing into an investments like to buy shares at coke or Pepsi company, you'dchoose. You can grow more that to spent the money you gained as descent income to grow by investingall of it into major companies. You could know that investments needs determination, but have arecords of companies like solid shares where you could also have money to invest monthly from aslittle to buying the whole company. Or you can be part of the meeting with shareholders and grow asyou wish. But if you have the chance to know how to make your money by investing as little as it is, togrow from nothing to something, by increasing you income into a share market toucan at least receivethe reliable money as a monthly remuneration from buying, from having $40 000.00 into your balanceas it is from buying the shares, you start by buying immediately you received it, to avoid losing tirospending it for something. You send the exchequers or communicate before you could be in the meetingbut that least is great you know you will have more money to grow for and buy other distribution oryou willie entitled to withdraw from the share board if you are not satisfied with the monthly incomeyou retained. But you could enter into the investments criteria, know how much you could save for asmuch as you can have latrine a future, but the most interesting part is when you approach themanagement with money you can have before you could take a lead or investments. You can even growmore by not depending on the minor incomes. How to start First the investments need someone whocan have the money to save for the future gain; you should not look at it a pension but to see it as greatincome for business. Pension is not great when you don't have

money, apart from your investmentswith other companies. You can start by looking for a job and start saving, but it's the only door you canmake money, looking at a perspective point of view you are welcomed to start from a business you runand grow as it is by investing with major investment companies, you are liable from gaining as moresits invested, be like a great banker who has money to his own use. You cannot receive money youdon't own or have in you banking accounts or legal saving for your future family or business incomecoming reliably into you house, with your beautiful wife. An investment needs someone who can investto your own retirements, to have a comfortable state of income not illegal drugs money. You start frominvesting with corporate you will know how to count it wisely, but to be more clever about all themoney you can invest and retain in the future for a great business adventures you would endure andstill know how grow for the better income, which will determine you healthy investments with banks, and you will have a good name from buying a loan, from your cars insurance sand the house plan youcan have which will contribute to other door to grow well. From banking your money wisely youbecome a great persona you will be able to have and enjoy the qualities of your investments with yourfamily, and you buy and be able to drive the most cars you can afford, and buy or purchase the houseyou would like to have for your family, or you are a business man you can still buy property that youcan own, intellectually a Flat where people of great income can invest and you canals buy a land youcan build offices or shops for business owners they have invested into for operations of goodcustomers. There more you arable to invest to your business you grow and still know how to attractthereat market of investors, where you will be the one who can recall from where you starts fromsaving as little as $200 and more you have reached stage to avoid poverty or from keeping emptypromises, where it will not be good when you lose family, like your spouse or just not interesting tohang around with people that are not well with their investments or they just don't have the money yetto adventure the great about investment sand to retain to grow as you wished. Unit

Nine The city uglyGhost in Police cage Once the cooker was arrested, there was one soldier who works on the ghosttechnology that was discovered to cache the ghost and they give them the jail, but you could only catchit in the day light. But you have to keep it in the Conner to get it in and you close fast before it couldleap. Once you have it you put in the truck for transportation. It was done once and it escaped before inthe road where it took the jailers and through them to the driver constantly, but once it approach thedark or the dawn it becomes powerful with the Demon. But it can be killed when you have Jesus cross. It wanted to kill them all in the transportation bus, but the cooker as given his own space to have him inthe locker. But separately only thief's and thugs to be in the penitentiary, he once escaped from thetruck and he was given another look before he accepted the money, but it can be that the man in themusk is The Freddy Ghost in the darkest and pecan only control it to become it, it but when is thedarkest, he can't even say things like human, he becomes the Animal Ghost trapped in the Darkestdemon world. Freddy is captured and he was the only one we could talk about, until to have him in thecage straight o jail, but he will escape" police" he will leave as the same a he did with the previouscommanders, he thought that he will scape to the last as the same way, bu tum you thought its turningdark and he will also escaped the cage, (scary movie sounds..) but you could tell by the cop and histeam, they stayed away for a while till its dawn, and they all we away to their homes, abnormal to whatthey do, knowing off "the ghost", they will never see me again and I will return after nothing its said. Gum gum the Jail is not the place to live but they left the ghost alone in the Dark and they have thetechnology to capture the only scary ghost, but as it was the mid night, retried to escaped the cage andit built to get the ghost seen when is escaping, after through the mid night he disappeared and theythought he will never return, but after they saw the morning sun, he was still captured and he, said howwill you live me in here and don kill me." Freddy with crack voice "We thought that you are a friendlyghost but after you accepted the enveloped, but it was a set and we

thought the we live the guy whotold you about the money in the restaurant and you left, but escaped the jailhouse, how? "The cop "It'sdifficult to escape this walls and they are made from still that is used back world war 1 and other wedon't talk about, are you a magician, "no" "Freddy ghost" he was losing his sight" and the technologyguy said, look we could see the them Signs of this Man is working but to get to trace the ghost youneed the equipment "computer guy", in the mid night to see him ghost night hunting googlies and theday light. Consider outsourcing or buying a company First howdy you buy a company, you have themoney you have investments for all your life, starting from a little remuneration you spent on yourboos, toucan cut it to spent from $2000 on alcohol and save to make it at least $1800 dollars, you canbe saving. Regardless you are An Artist or maybe you thought you spending too much and youappreciate the concern to your own future investments. Will you recognized having more into youraccounts when you need to withdraw from the money as appropriate to your descent investments;"Yes" it's a great idea to have and be in control of your investments, but remember that you willing toimpress your family to be a great Father, to a great parents with food in the house, with great Furnitureand other related materials you can own and to be yours, fairyland intellectually stable, to have andreconsider disposing it for your descent income. You can own a share for an art Company, you can ownconsiderable income from major companies that are registered and performing well in the Stockexchange market, from where you were vulnerable, you remembered that by saving your money forinvesting, you will gain interest into your investments, you will be entitled to invest with othercompanies, now and in the future. You can enjoy the freedom to your own wealth, and still to investmore for other values, over sea, back at home to have the credibility to grow your business reputationand also assisting other to realize the value about investments in the markets of investments and also toconsider purchasing as the other places you can consider and reconsider about the business as a whole, the only very important ideas to all, it o have a great

production level for a Profitable Market. Grow into the business tenders How do you know that you are available to be the one considering the Tendersin your area and in your city and the country as a whole, money is open to all the ideas, to all theinvestors and to all the living society to use it wisely in their homes in their families, not to think aboutlosing money, but to know how you can retain more money as part of your growing income in to yourinvestment's and to grow you potentials needs regardless you have been in a bad stable of business, oryou'd like to be part of the investments contributing in tithe developed and civilized society and thegovernments. You would like to be part of your growing economy in your developing countries, besomeone that governments can still know how to contribute as part of the society and developingeconomy to see its people becoming well and enriched with good education, receiving the great aboutthe possibilities that have been engaged in to the budget speech, and to be proving all the said its veryprovable and Important to the economy, to the growing countries and still to consider all differentangles of investments. Buying and selling of your company's shares will enable you to have thefreedom to your own society from inviting prospects and share a hint of excitements and teach how tocan have the companies' view allocated for your investments as individuals. Buying shares will haveyou incorporated with your shareholders, to have the money to buy a share of about a Dollar or Twoworth of a Value. When you have investments you allocated form the investors a part of yourcompanies growing contributions and value to your company, you need to calculate it to your share ofpercentages outcomes, a share price does not have value, but the currency itself as medium ofexchange, that's how we create the freedom to our investments. You can buy share for the corporateover sea, but how do you allocate the investments before you can speak to the right Market? First youbuy the ideas to have you contribution for the desired company you would like to work for, it can partof your daily investments, monthly, yearly which will be after every even financial years, don considerracism but have the courage of owning a little to the companies, as its politics ass whole

to own aMajor distributions companies like Chrysler and other motor distributions and growing Markets. Frombuying from other Markets you will have and be entitled to create from gaining the intellectual incomeother reliable sources, not only to focus on your dreams and passionate ideas, to also look on other andshare the same view of operation, and still other incomes for more exposure, related experience's, andrelated Markets, related to the need and growth for recognition, for great production, and investing onbuying other creditors to help you company grow. Know your Market or invest into communities Howare you going to recognize your only market of investments? Howard you going to know the market ifyou don't have a target markets? But first you not going to have a company you running without anygiven approach to have a great market and still know how see your company's behavior growingpositively in your area. What product you would like to distribute if you don't have a target markets. And first how are you going to know the market if you don't production in your company and theproduction will make you a competitor in the growing economy. What would you like to sell or resellas part of your business ideas to put in to place for a simple partnership business you can run with yourfamilies and friends, but what qualities contributes to have people that you can choose to be part ofyour company's needs, will you be the one chosen for your chose to have your name in the businessmeetings contributing to be part of the growing and positive selling ideas. But before how will youinvesting to the business if you don't have the money to run and start your companies investments togrow into the positive world or and still attract innovative investors, still know how to talk to positivecompanies about the contributions of the markets you are willing to invest into. What is important tohave the recognition from the community, is to have a direct and recognizable markets from thegovernments, from the development agencies and to your cooperation, as the leader, as the presidentand also the member of the your community to discover and not to compete with peoples government, but to have the courage to change the world development into a better

places. When you invite peopleto your developments you create the need for recognitions, the need to have great reputation, the needto know how to talk to your customers, the need Mohave a place of safety, through the strength of JesusChrist, the need Mohave value of consideration, from establishing the relation from nothing tosomething. When you are in the business you want to know who is going to buy your products, and tobe in business you should its evil, because you have to be where there are customers, then the big ideasabout who are customers, "They are your clients" considerable to be the people buying behind thecounter. They can be people that are close to you; people that can know how to talk about thedevelopment you are creating the city, and also Mohave and create leadership to the city, to the peopleof God, to the Politicians, to us as the people living in the great developments. Places where we like togrow, to see the future as beautiful, to have children that receive the great facilities, in the cities, tohave accessible resources of life and to enjoy the smell fresh of the cities and to our own developmentsfor wealth and Investing into communities is a great skill to work with your people, to employ them, tohave them participating into a community developments agency that contribute Into changing theirdreams into reliable integrity for their talents and other creativity in the Art Developments andregistered companies awareness'. The development swill increase the spirit for the communitydevelopments, for changing the behavior to a positive direction; don't be in a stable place where yourtalent or dream is discouraged. But have the influence to change your income to positive direction, when you have the power to can recognize your behavior, you are willing to have and change the othersas appropriate. Unit Tenth The Lady in Jesus Cross The lady who knows about the Cooker it's the onewho saw him close and he then realized that, there could be something about him to. But the only thingthat could save the city is to take him out, but catch him." But how will you know if its him, "thepolice" well I remembered that there was man here and he was kept with us and we thought that therewas someone who could walk through walls,

but how will we keep him if the darkest area is only fordeadly ghost's. But he will escape and kill everyone in the penitentiary and turn real alone on the lightor the morning sunshine and escape. But it happened in a dream from the lady once; she was givenacross from her Grandparents and the bible for her safety to be at home. She once seen cooker in therestaurant where he used to be and know he saw him in the news about his behavior and hisuncontrollable to be with people that could talk with him, once you could know and see him, he willrealize that there's something said to keep him away and he was human because he thought like realMan who lives, but we will say that even ghost are smart but not Ghost to realize the realm about lifeand to God. Only Man-made from the grown by the Only God himself he will embrace the wealth andlive among his people with Love and great laughter to keep him safe, in the days and in the nights ofgreat civilians. When you approach the great about time and quality and investments, you are enjoyingmore of your family and you should make sure to have money you retain for you spending to behealthy than to keep you uncomfortable, when you lose money in your family you can have ways toinvest and to know how to talk about all your budgets, but first should be looked down to the familybefore you could know how to seethe exposure to wealth and great Experience to know how to cansave more or your money in to an investments that you trust to change all your trouble or breakdownsto great exposure to wealth and great family. This book is meant to educated our readers about theinvestments monies that can be retained in the future, by starting now to Google and entrust thereatabout saving your future from bad income to a greater contributions from investments companies thathave the property and surety to you interest for every penny invest with them, first you would like toknow if you can save $500 dollars a month, and including the percentage that they provide to the valueor the future prices, it can leave you with the total amount of $100 000.00 every five years, regards totheir percentages. But first you should know how to compare and calculate the appropriated value youcan reach and invest more to avoid break downs and make

sure that you can have the money in thefuture without the company failing to give the notice to their customers or their investors. If you arewell with the funds you can receive while you still alive, it important to know the estimation calculatedto the full potential for all your salaries you can obtained when it healthy and great to have more moneycoming in the family for great to the future and to the family investments which will give you thefreedom to buy more for the house and other family matters toucan accomplish to be positive. Regardless from failing to pay the full house money and all the money you owned which theinvestments retained can cover it and to the models of your desire car. Defeated by the Police for Thefinal end when the Freddy turns in to a real ghost he knew about these that happened in the restaurantbut that turned in the Darkest world in the dreams, but happen to be in the penitentiary, he accepted thebill and we was told that if he was given the envelope, he will leave them and escape. From the jailwalls as he is ghost in the dark and the Man in the light. But he managed as his Freddy the Ghost andthe ugly cooker. But never lives his side of killing, that how it kept his that ugly and after hews told thatthe money he had given to the Judge he is not a real judge but a tricked somebody but not cop, if hewas a cop he will be dead from the time he was given the envelope, if there was a lady there who sawallot happens to keep the two guys talking, but it was not the only place that, this man could beExistence in real life but you could see him when he sin hunt for killing. But seeing him is when youknow how he is killed by shooting at him like the police protection Gun or pistol, the lady was in thehouse and she had a gun with here all the time as part of a woman make up. She pulled called a Nikongun and Freddy Left. "Well" the lady was overwhelmed to see that this ghost is afraid of guns and thatwhen she recalled that you can kill a ghost, but by having bullets in your trigger. Twill save you fromthe ghost and same with the Ghost hunters. All just the guy in the restaurant said is total bogus, thewoman" but I thought I could ask him if he screamed my name and he could tell that he said somethingabout his son, "the lady" who drove by with the latest Station wagon

thought I knew the place I itwhere spooky, she ones stopped AND SAME RUNNING, and she continued to drive her car fast aftershe just witnessed the musk Man but it was the guys that works with the police,"he said" lies I knowI'm not the only one who thought that, there is something missing in this house?, "the Man" are younot Freddy the guy who use to work here?" the station W.. Lady" no I'm just the regular guy who buysat this restaurant, that woman just left said I'm ghost. No I just thought you are one, one what, are youinsulting me" freely Freddy behind Musk" no you thought the woman is looking for something here?Nothing the wagon Lady" you driving a nice and you thought I would know there must be woodinsides, but I liked the interior, before I could escape the jail and there was nothing to talk about, beforeit was returned to be the car to Know, awkward. I don't drive Volvo V9o engine, I walked to the landwhere I escaped, but what what..." the Musk ghost" sash it's burning and the money is burning too inthe restaurant" gum gum, (Movie sounds). The gas exploded "boom shh" Not To mislead the great boutthe Authors and the education, but create and to implement the be professional skilled Writers and toalso influence the life behind the scene of Murder cases just been cleared from bribery and to have thecourage to keep the talent of the street to keep our future generation into great and educated people toseen and also to love among our people of great honor and peace to all the open society of humans inthe world or great dreams. Pimp fighting Snoop and the gang is robbing him The pimp own the cagefight and other trucking deals he run for his staff, what staff,"the cop lady" I meant nothing but only mystuff, or you mean moving trucks, "yes I can say mistress" snoop. "Ones the idea taking place forrobber to smuggle drugs in jail, they were not alone to get the staff in handout. Mastering, connecting itwith other software like importing or exporting a final tract. Most to the guy they thought that thedigital world is not the real world but only victuals for engineering. Writing, Producing and Makinggreat sounds When you produce great sound you like form working up on your bed at home, butfeeling great to have your composition ready for recording,

depends which model or type of a set youuse like guitar when you wright a song, it can complicated or simple numeric song, or tone, like "yo" inthe back ground does it require you to be alone on the song a writing the chorus, does it require a lot ofpeople Artist singing in the composition of recorded tracks, in a form of album, in form or single ordemo Album you like. But before you to know your songs from writing them on the note book of songswhere you will be able to sing them in the studio when required to do so, as possible from writing is notdifficult when sinning In a choir where you are able to have the time to practice the tunes or melodyand also still singing or producing the lead singer, and still refer to the Artists, or person who wrote thesongs, like musical Professor or choristers' and instruments conductor. Speaking or Marketing yourartists for music deals and the official Website First we thought it was a Joke to have your own labelthat makes good music, in our homes, we hear good music in the radio. When the community radiospresent the most talents, the great and new upcoming Artist to her their dream come true through radiowaves. How do you become an Artist without a proven deal, some recoding companies work well withDeal Arts, they give all the available space or quality and professional recording facility's, having awritten contract making you r music and producing the very best of hip hop music, RIB and stillknowing how to collaborate with other good artist, for making a hip hop song you are required tohaving someone singing in between to have a total pies of Art work, to put all the work together, mostof guys, or Artist they have the total range from completing a 10maximum and more from adding othertracks and to knowing the recording label better for the best Artist, from selling with Pop Artist, Soulsingers and other related genre like Fusion, but its only through quality investments to have musicalsplaying in keyboarder. Studio managements, Meeting Music Deal and Reading Contracts In the firstplace, when you are able to see artist on the meeting board room discussing you Take out and otherrecording arrangements with realizable dealers for a great open source markets, that reach globalorganizations, like

EMU and Sony music Associations. When it's the appropriated time to speakthrough with great agents, but from recognizing real not fake contracts, how do you even have a time toread it through, howdy you know you are dealing with registered clients, or real world productions but, not thugs, see if it's the idea to take the contract home and read it without any pressures and return itaccording to your estimations concluded from the discussion as its recorded in the arrangementscontracts from receiving the deal, and the comfort zones, like meeting and featuring other highlyrecognized artists, from a starting all your recordings to an open deal and great studio sounds andcomfortable, reliable music facility, but deal it is very important to invest on it than to entrust on justthe broke community without you music played in the Radio stations, or other related marketing like UTube websites, face book another marketing materials accessed. Only music for the public to know andlistens according to their favorite's music sounds at home, in their iPod's and other related musicwebsites you are available to download. Locating the most given recoding deal when you are attractingmost of the consumers, Artists who would like to records a piece of work with you. Mostly they arelikely to visit you if they would like to know how you produce the best sounds in the studios, and onlyyou would be the for more an hour to establish the great talent, from singing in the instruments whenthe rhythm musical sounds or a beat been played or chosen for type of music genre you make. Thisinformation on this book only to be seen and advised as an individual of music passion, and to knowhow to look further in the Music producing world, and learning to have your forecast not only In thebad side but to the leading individuals like meeting the right carrier and not mixing bad organizationwith great music legends in the pop star acumen's, but to know that personal life does not have to beincluded drugs related problems, but to know how to be good with your passion, and great carrier patschosen for other to a new music and available music artists of the future, upcoming generations, whereit start from home and to grow well as great artistic and music producers. This book will live you onthe edge to be a reliable

outsourced music producer, and great Music consultant and from reachinggreat Artists and meeting related music industry meeting boards and reaching sealed contracts for moreexcitements of recordings and music entertainments you like for final consumptions. You will like tohave great recognition to investing with big and established recording companies, from a small mediumpoint of view, to get to a position where you are able to invest more. If you need to consider majorcourses or subjects you added for a little investments retained from your savings, this book will giveyou chance to grow in to the music industry and know how to teach others, as well through establishingyour recording disillusionment most exciting part of this elements is to give the most describable and togive our reader to understand the important knowledge to even people who have never been to anycollege, depends on the language and we have knowledge to be more understandable, most of the courtcases are not because they are judged different, but to know how to speak with the educated peopleabout your problems, but to mislead your conclusion about your lawyers, you magistrate or the police, but to know how to respect their job too. We don't guarantee to have you misjudgments, but know whatis the final conclusion to all your judgments, from doing wrong to the governments and remember thatwe are not all perfect and you might have missed a step form talking wrong to your family, buyinsulting them a little, but it doesn't have to affect everyone in the city, only therein step to rectify andcorrect from talking to the right people about how fix your family problems, it can be in the office, athome, or any place in your private conversation. But respect yourself first and others to follow. Stipulated above and in this book we have identified the need for our reader to receive properinformation and needed further consultation tithe professionals, only with something they can talkabout rather be driven to something they just thought it could be right but never appropriate robeincluded in the conversation, but from miss understanding the language and other simple facts thatneeds a little research from asking the people around you. To finished to the

most interesting ideas westarted at home, we interview people from asking if they needed the very simple languages, that theycan understand concluded in their court days but to know what's important to remember when it's theirturn to explain and from seeking other information from asking the lawyers and to have beenconsulting or asking around for more details if they could be someone on behalf to stipulate the problems or cases behind the scenes. But how do you find the wright information if happened notprepared to pay for your break-ins, at work you might have problem with your boos, ad he happened toretouching intending to receive pleasure form you, and you don't like it because you thought he couldbe gay, but touching you whenever its needed for your boss you like the most, but if he's gay and hesaid it, howdy you come with the plan to resolve the matter. If you know that he told you about hisstatus that he's one of them, or just thought that you might like other stuff from not working in his area. But touching means he's, friendly or more human to can be close to you. But described to touch youfrom other perpetual intentions, this should be reported to the lawyers that you comfortable workingwith someone who touches you to be his spouse. Periodically it's not the only problem you should facein the working environment but have their names and talk when you need to before you could takemajor steps. But it should happen if you are not responsible for other related duties regarding you tostrip for money, even to ladies at Have the information in to your own conversation, but consider thegreat about education and other related centers you might need help. But stop abusing yourself and toother family members. Stay at home when it's necessary and if you are abusive to your family spouse, please make sure that you need proper help from the professionals and be great. You need and like to beon the course to be a lawyer, subscribe to your nearest university and sturdy hard. You think you canmake it now and in the future. Learn from all your mistakes, you still have a chance to climb out andchange and be on the right side of the law. This book is meant to read and know the importance of greatlaw house from your own bed and start earning fat Exchequer

these books give thanks to MY parentsand tony Enterprises, from the time we had trying by all means to have the book deals published theBook deal for a "Business Adventures by shane". This contributed from purchasing our bookdistributed and from the Partridge. We appreciate the total comforts from producing the best-sellingbooks ever to have us working as it is been before. When you need something to talk about in thepresence of great interest you are now starting to realize the change taken from the first place yourealizing the dream come true, for the time spent trying to change your life to the fullest. How are yougoing to make a huge difference without having to determine the only excitement that has the mostimportant behavior you need to reveal fro your own good. Accepting the only :GOD" given talent, itsrelevant and that what give us peace, only we should know that if we are having a dream to change, wealso need to tell GOD and also the spirit of JESUS CHRIST that we are aware of all you giving us, which give us the chances that GOD will never kill us, he will be and protect us from all the assets andall into our families. As we are well aware about the passions and about the dreams we need to follow, when someone is considering a dream come true, starting to have the time to realize his potentialgoals. If you are having something you call it a dream come true, its the most acquirable and greatinterest that have you gaining the importance that can change your perceptions, the moments thatmake's you someone who can talk and consider the truth and the great wealth given for a dream tocome true. The book is meant to help the society from to having a realization to their dreams come true, it will give them the skills to talk openly when its the time with people who are able to give theconcepts to help them realize that, if they needs physical strength to know how to deliver the onlypotential interest or seen as dreams. From all they have been discouraged by alcohol or illegal drugsthat are not good when you are willing to change all your dreams to be true. Full fill your excitementsHaving the dream, having the passion First we thought of writing a menu script, from all I started todream about, dreaming about taking the idea to the

second step. To have the other books as with thefirst. The second, the third and the fourth book. Since that we are very good, from keeping the promiseto on self. From the time you sit back and know know what you'd likely to know from keeping youbusy and great; carrier development strategy for a great standard to improve the lives of our youngstersfrom not taking illegal drugs to have a dream. In your time you create something called a passion, youcreate something called a dream come true, how do you recall all the ambitions to make it: a dreamcome true' you'd recall and know whats been so important to have your self standing to be the manwho has a dream. A dream has many implementations you would thought. It create the only passion hesdreaming about. But how do you need time considered to have your dream put to reality, regardless youbeen discouraged from keeping it done, it's a very good question that need a great answers, which willmake you someone rich and well outmaneuvered. Keeping track of your important dream come true, will get you on the edge to be a full filler. Dream is something we all acknowledged, which simplymeans a lot to every mankind living in the developed are, urban or cities and simply means a lot tohave people and comp[any you can be able to know all you have been put your thought to great future. First realized my dream from running my own company, someone would say that, he's been having adream to make his own distributions which simply shows the interest for a young developed andgrowing society. Changing the lives of hi his ow and the people in the neighborhood. The book is greatwhen you know the out come from telling the meaning of great about passion, about fulfilling yourdestiny and to all the visions you dreaming about establishing them when to positivity. The first youwill realize that, having talent it's the same as your interest to have and build a great change, frokeeping it to reality considering reality to all you should have and call it a dream come true, but howwill determine the out comes without having something called a passion. And have the dream. Goodquestion. First I had nothing to explain I called myself someone who has a different occupation whichsimply means and turns

everything in to positive and to reality. I needed to have and be seen as a greatMan in the whole life I needed people to learn from all they should see a difference from all thediscouragements to what they believed to live and have faith, from all the struggle, hatred andunresolved anger management," but considering a change to overcome "what reality."Finding yourdreams and passion" Increasing your realization is essential to have your common thoughts to asituation where you overcome the concepts for keeping your dreams come true, keeping and increasingthe idea of man and woman coming to have a real occupation from realizing the importance of humansthat have a dream come true, for every time you come across a dream and you are gaining theambitions to have to an increasing point of changing it to reality. Dreams are true and great to know ifyou could establish it for passion. Finding simply differentiate the needs from creating the only impactthat has conclusions, finding and to realize your dreams and of potential agreements to fulfill yourdesires, having a dream is very important to realize your potential goals owning a precious and veryinteresting passions or dreams. Identifying the only dreams that have you interested to know, whereyou are eager to have to only ideas proven and having to establish the great idea positively towardsmaking a great change. If you'd find the importance to have the access contributing in finding andrealizing your dreams come true, you are well stable or well developed to keep it contained and wellsafe also achievable for everyone knowing and noticed that, the importance that leads intact with agreat change and encourage positivity that keep you all motivated and passionate strong and havingambitions. Considering a dream or passions you can or could identify, but when its the time you knowthat when you are having a dream come true you are given the concerns and pleasure from within andalso from talents that are natural and identifying the passion is the most importance that everyoneshould establish. To finding something that is relevant and true to consider the fortune that describesthe only truth when you need to have something very important, when you are trying to have somethinginto your very best considerations.

Finding the only idea to give it a hint for every time you need toconsider it and change it, that's when you are positive and making the only difference and to alsomaking a change in yourself and also to making a change in everyone pleasure of interests, it will makeyou someone who has a dream to change, someone who has the potential ideas given a chance, someone who has a time to speak to GOD and make a change that gives him freedom and healing to allhimself, or been trying to accomplish discovering the dreams to be matching you as the owner of yourown desires. For everything that you need to know and still be able to recall all your dreams to be true. When you can remember all you have achieved from the start of owning the dreams for your ownwealth. Remember at all times that you are able to become inspirational, to be more interested to buildyou most important personality. When you having to be dreaming or trying by all means to know theconfidence of changing a perceptions into a reality actions. "not just as imaginable test to completewithout trying it to make your dreams, passions, goal and the only time spent to change something tomake it a great hobby" Finding your dream and Passions You determine the dream come true, yourealize that you are talented and you become the one to know how you should take further step to be onthe edge of completing your passion. A dream come true in may different perspective and in differentmeaning. What is the most reliable meaning you could express the word "dream": you say "well" itssomething you want to see a change form starting a career to your own desires to make something thatleads and compact with passions. I the different perspective you can realize from making a step furtherto change your dreams to another level considering the difference from establishing a dream, createsthe importance to have an income based on the stipulate forecast you might thought that you couldcreate the accomplishments for you to recognize it, before or its could happen that's you realize youronly dream to be fulfilled or simply means. It's a great, success to be o y our carrier to have your dreamcome true. Success that when you could tell when you reach your potential dreams to be descent andready to be

reached accurately. From employing your very first talents reaching to great society for thefullest. Realizing the best to have all you interests to be true, you are cindered a success ti have it to apoint creativity and determination, for all the given points where you are maturing. If you recognize theimportance to have and know how you could know that you are having a potential Indeed you shouldconsider and create time for all you should be practicing for a change. To stipulate your creativitystarting from realizing your potential to be a great dream. "not only you could have one dream, but twodifferent dreams make you great and having to identify them positively, different and great. Rememberthat you might have similar dream with someone who you know and talk about, and realizing that adream that you know is to also knowing the way you can make it a dream come true. But how do youknow that having a dream to be the same and similar with in of your fiends, who is close related with. And how do you determine the dream if you cannot realize the importance and the potentialcontributions related to the idea that you entrusted to change positively for the better and better. Selfdetermination is the only keys to make it a dream come true, to be and have possibility to the onlypassion you regards your importance to self fulfillment. Knowing and finding the potential dreams toall your goals" You become the one of a dreamer come true you are realizing that you are responsiblefor all you have in a way that you become open and know how to accomplish. Responsible you can bethe person who change someones passion to become recognizable and well achievable to be seen by thepeople that are your family first. Mixing passion with other priorities, will make you realize that, "anger Managements" incorporation its important to handle your state. Everything when someone reachhis potential agreement from discovering and dream which leads someone for a great career. That'simportance does not need discouragement from people that hate you the most. But nature it to besomething you could reach for that final satisfaction. You'd believe that you well endured specificallyfor a great dream, you are increasingly having the idea to know more doors to have your

dreams cometrue. From realizing the first dream to people that would still believe about all you should be taking andmaking the great idea to be a great success. You are responsible to have all your changed to reality forthe better and to make it configurable to be and knowing all of them. Realizing the great to all you havewill make you knowingly to have a way step forward to all the open doors, which happen to beavailable and promising to make it a change to it. Listing and writing down all your open dreamswhere you will have the freedom to know, and how to change the to make it positive. When you realizecompetition to all your dreaming about, just have hope and know who is becoming bad towards thesociety and also know how to overcome the pains delivered from hatred, hanger and discouragements, towards poverty that happened to be in the cities of GOD, realizing and changing your own dreams. First how do you over estimate the changeless creating the only behavior over the challenge whereleads you to discouragements from making it possible in future. Without the knowledge and experienceto having the idea to make your own dreams possible changing into your dreams will determine themost common and that can give someone a realization to having his dreams possible. If you come torealize the potential life change contributions, where you ending up knowing the potential dreams tohave and make it true, to you and to other families, that have you proven to be open or as the part ofyour career to realize, it means that's the part of acknowledgment and it create healthy minded. Contribution from all allocated to keep your health stable and promising, realize that the change andthe outcomes that have created wealth to your growing and educated society, it will give you thepositive and well human ideas positive, from all primitive organization that have been changed to theopen economy as the only potential part or important part of the society that would reach ideas torealize that outcomes and success in every time, to have a respect for everyone's health. Life changingits the importance to realize how you are achieving your agreement or your goals, but specifications ofyour goals are proven only on the side of positive society, from all the positive

influence you having tobe seen or established, according to your open minded society" where it gives the freedom to do actpositively out of the box, from all its been difficult to realize about the goal you'd make them happen tobe changed to you, and to your organization where they are able to express them positive. Wen youwant to change your positive ideas to make them possible, you are entitled to have knowledge andother respective thoughts that contribute to changing them only and relevant behavior having themproven positive, positivity is the only main agreement concerning the behavior, to keep it into control, you should be able to communicate throughout it when you are welcomed to know the only importancewhen coming to reality. When you are breaching the time to considering that you are having a dream tochange you start to realize that you need a step ahead, for the time you spent to give a realizationconsidering age and planning from leaving your material of bad people who always discourage the onlygiven talent, you may call it a dream to change. Give all you need to have completed from the start ofevery career you are entitled. Considering the most important dream you need to reach, but to concludeand never have to realize the bad situations that will keep you out of every plan or any idea you mightneed to accomplish fro an every time you pursue a chance to deliver the best outcomes to the people, oryou might get to a stable situations that makes you comfortable when you are ready to reach all yourgoal. Finding your own inspirations comes into perspectives to consider the positive influence fromchanging to be a great Artist, a great Man and someone who ii able to dream and change hisperceptions. How to know the most importance and the only agreement to conclude the behavior fromconsidering to have a dream come true. If possible behaviors concerning the ides to be the onlydreamers, which will enable to determlne Llie potential dreams and well fair to be stable and to talkmore freely to all your needs to make, you should have the time speculated from giving all you need tothe people of GOD. The importance confirmation regarding to all its been received from keeping themost given talents and to also nature it in the great

given environment for this specifications. When youare able and liable to have differences in your given space and time, you will be giving your self aquality time and to yours as to be having the most helpful endurance to keep it fit from" not focusingonly on the negative memories or side, but also keeping the idea of reaching and fulfilling the mostgiven talents reaching your dreams for the good and great outcomes. The passion comes first and thenthe other is consideration from all your passion to make then a dream come true, passion does not haveto over your change or consideration to have and be able to accomplish your change or consideringtohave and be able to accomplish your goals in particular. But when you have the idea to know andchange the method ta leads to and open exposure, not only one idea can make you believe that you arehaving the passion to make a dream come true. Knowing all you practice will make you a very healthyman or human sin particular, when will make you a city people to conclude that you are very educatedto pick a knowledgeable book that will educate you to become part of the great open society and thatare accurate or eager to see the success that leads to an open development for people. Where thatexposure which just learned to make it a great prosper for one people, for the family with great honor. You become one of the community in order, to can make someone very rich and change his or her life. How could you tell the importance that is very determining or maturing when you approach an opendream where it will make you someone, "great in the near future" which simply describe the very bestof human society and human behavior to have the courage when yo speak with people who arecivilized to know if someone is very educatedto have and change his perceptions to be the same withsomeone identical, for a great change to people, where its not incorporated to work and haveinformation turned with the people or society that, does not have a dream. To see the perfection tohaving a dreams come true for all you been hoping to make it a change for the better to be seenaccomplishing and making a dream come true. Having the encouragement to be and make possibilitiesfor a Man that is great successor for someone who can

have the knowledge for people to be successful. To having the trust for the only dream when you needed tutor for success, remember that you couldacknowledged many different people who can change your possibilities of success, but some certainenrollment from receiving the knowledge, how can you tell that you are having the right path, whenyou need a dream changer or a guidance that have value and trust, to it when you consistence to theappropriate exposure or knowledge and having he right doors that contributes to the only given dreamsin the peoples homes. But not only receiving bad reputation or some insults from your family, or yourbad friends or bad organizations. A change of the only dreams that would give you a hint to get it to apoint of positive contribution, depends with the community or people you live with when you haveproven to be someone receiving the outcomes of positive realization where would make you a greatgraduated acumen leading the only achievable and positive dreams. The only importance that create amental importance it connect from looking or focusing only to a changing it to positivity. Safety fromreaching your goals is the potential for most ideas to get you realize that, you must have been maturedor reaching a stage of increasing your unacknowledged, which would prove your organization or skillsthat keep your well informed and developed. The only things you keep in common times, its the lifeyou'd like to achieve when you need, and also the possible positive steps will make you a rich-mansome day. All the things you need to accommodate for every efforts, you are trying all your best to bepositive for all your dreams to be true. When you see the change that needs all your focus andspecifications, are things that needs your comfort zone and great exposure to know; you should bedealing with your potential dreams that you need to know about it. When you are able to have acomplete mind set to be having a consideration to all your potential goals. Its not good to bediscouraged to be having bad memories from all you are realizing from bad communities, from all theups and downs from reaching your only true goals, to deliver the best memories which will encourageyour potential skill to be on the positive side of great

communions to be living a great life, to be havinga dream come true. When you are interested tom be changing your dreams to reality, you making apositive ideas work for your time. Its not encouraging to talk to people who will just make you bad. When you are reaching the time and thought, speaking means you are not settled to can give a little toall you should know, knowing is positive to give a hint and to give more to all you should be describingand talking To talk means a lot that you are able to consider different ways that will make you whoshould be. First your determine the knowledge to be or having the dream for your self and finding thepath to be engaged with the open society to having to trust that Man who can change your life for yourcarrier to be on the edge, similar with the people of your age, people of your identical dreams peoplewho are open and healthy to can speak their mouth wide open with encouragements of hope greatknowledge" not just open ideas that does not not have value to keeping the dream come true. When youfind out about the dreams that doesn't have open mouth or value before you could establish and make achange to have them success. You will have the discouragement and other negativity for them to beunhealthy and very annoying to can have an embarrassments, few all your down fall."what do youhave?, in your thoughts its very important to know how to take care of them when its the time to provethat you are talented to be having the importance for a great change. For a subjected dreams that isgiven and encouraged from other family members, should be given the only role shown from alldifferent angels. When you overcome the importance to have the idea to overcome the challenge giveninto reaching the comfortable behavior when you are a dreamer. And the most important realizationwhich will keep you a great dreamer, will have you to be someone who can and able to change otherperceptions of becoming the leader and a mind changer to a positive and growing economy where itsgraceful and acquirable through consistencies for everything in detailed control, you remember that youare groomed and well organized to be having dreams, seeing also to have a passion from consulting toprofessionals

who can assist you to have a great establishments when you need a dream and passionchange. When you need time from considering the behavior concerning your potential dreams, sometimes you should to seek guidance or help and considering the burden you need to ease off yourshoulders. To be most influential ides that can lead someone knowing the best and great outcomerealizing the most or consulting the right people. Your should realize when someone needs greatexposure and great guidance to help them realize that difference from seeking the knowledge for acareer and goals accomplishments, is better and very important from not losing a dream, com true. Loosing a passion without identifying the possible outcomes is not good to know how you should fail, but gaining exposure and having to realization from a dream change and great people who can give youthe only concepts to see you succeeding in to a great future. Everyone speculated to be dreamer forevery possible angles of a success, its possible and liable for that exposure to turn into terms andperspectives realizing the change and the goals in particularization you need the guidance for all yourdreams you should have seen the control that have the common and great understanding to knowing theonly importance. Its the most and relevant to deal with great exposure comparing from having a dreamor just not dreaming at all. When you can have guidance of knowing how to change from identifying adreams; And goals for the ability to have and be positive. If to realize the potential agreements fromdeveloping your dream and change it to make positive, if you could realize the most important task youneed to accomplish from making a change and giving your only courage to make it a dream come true. Knowing the curiosity to become a dreamer, know the courage that can make you one of the talentedand passionate companion in the open and healthy society, a changing of ideas are very relevant to canhave them into counseling from different perspectives, in part to having an understanding to be havinga dream come to reality, specifying the only change and the realizing from specification, will consult toyour method of many different and given doors of opportunities to the right owners who

who arewilling to change. When you approach the stage to know all your are able to make it a change start tohave a realizable to be having a break to own and to realize how its important to have a hobby andknow its important to have and realizing dream and to know that you are changing the passion to bepositive. Before you are willing accurately to know the importance of taking care of your dream, itsgreat when you are realizing a change and trying by all means to give and show control of your verydesiring dreams for a better change. When you are very positive to change your reality for a greatconsideration, there is nothing you could be tricked when you are seeking or still trying to occupy theincome when will make it very descent to can have, if you happened to be realizing about all yourdreams to be true, you are having the passion to keep all, your ambitions to be great, realizing is ch partof every man's behaviors, especially in the family, where its about three you can count and more torealize. Fixing your problems will also relate you to your carries development strengthen to have adream to be very great and come true, which is the major concerts that everyone. All who has theimportance to be having a dream come true, must be having the accomplishment to make it greatsuccess. When you starting to accomplish the presence of having a dream come true. You are the veryfirst person to know how to have it into perspectives. Making a dream to be true only to yourself andthe other people, you are not missing a step or loosing value from realizing your potential goals. Accomplishing the very best and the talented concepts that are designed to help you have a direction togaining, to have a dream, it is very important it a focus or direction to all the open doors and try by allmeans to avoid disappointments and other negative aspects of talent, you are great to talk and teach allyour people or civilized society how to dream and change the old primitive standards of living in to acity or a place where people live fairly or with freedom to survive. A hobby comes in many differentways to realize the potential dreams, for every hobby you should accomplishing something, you are notthe only one to be discouraged of feeling unwanted or just unacceptable to live freely

with people youwould talk to when you are not certain, but have the right knowledge to approach or be approached. You know ow it is to have or to know when you are realizing a potential dreams and passions for allyour should be maturing for, talking about them positively for the first time or many times, when yoube a realization, you should speak positive with great human and people tat can respond and nature, tomaking you passionate and ambitious human being. For every time you are able to have a dreamconcerning your potential interest for, every method your focusing on to yourself encouragement to bepositive about the dreams, you like to accomplish, from the very best times you'd change consideredliving within your perceptions of not giving up to all the interest of dreaming. When you are ready for agiven dreams is the most time and also to show the talent that you change to make a great hobby orcareer. For everyone to dream you need to change first, you may recall all your potential knowledge tomake and a differences and also to know how to be a dreamer and to know how easy it can be able tochange it for the better chances of keeping the idea; outcomes and challenges to be true to yourself, toeveryone and also to GOD. In particular to have a challenge is to know how to accomplish a differenceand to have a difference tats when you are willing to make it possible or acquirable and very easy toreach all you ma access for every efforts is taken to be a dreamer and also having a potential idea to canchange it and make one of the best dreams and talents possible to be very accessible or available to betrue. When you approach the dream change for the right purpose in your live, first you should bewilling to have and encourage to the person you would like to know to be able to give your accuratestandards to have it realization between the two of you on the table, where you are able to communicatefrom considering your research-lab and your realized that, you might be falling behind and you see allyour friends and family living a nice lives, and driving great cars and living their lives to the fullest. But when seeing something to can have, you should notice the idea to say it when you needed someguidance to be able to take it further. Remember

to avoid a lot about getting in touch with people whichAR not good spiritually when coming to an interrogation, no helper or someone that have you in aplace where you cannot even say a word, some instances consulting the right doors doesn't have badreputation or bad accusations from discouraging something very important and precious when you arearound. You change it when you can, when we started to have a conversation about this book, to canhave it and complete, we realized that we were very confident to own a dream for everyone to know, how much is best and looking in all the different faces or great dreams to come. Changing it was not asyou'd do when you realize the beauty behind all when you are realizing about taking another path. Butthe only chance, used to be on this material book novel considers time when trying to accomplish it tobe a very complete set of dreams. And to perfect also the story which important to know. Before wealso helped a lot of people to be having a carries similar to other fiends in the are, we lived. We used tobe with friends which are educated and they also needed the same guidance we have in the book wherewe didn't not change or feel lazy to just keep it down, we knew that to be open and tell people about allits troubling our dreams of thought and also needed to heal for as much as we could express all fromdoing everything to be very impressive and to also be having the idea of a creative young talents andalso to nature the dreams to the open sources of human nature. Talking about your dreams that simplymeans that you are willing to pursue them and make a great change to yourself as a passionateindividuals, and you are well developed to see a change and to also know how to accommodate theconversation and also realized your society development according to people you would like to share ortalk about your potential dreams for a better successful and healthy. This is the only way to expressyour most talents to be having therm to realize the importance of changing them to the right possiblethoughts; and also seeking the exposure where it will lea us to the right direction of living among ourhealthy and well positive people for more to gain and to have positive actions taken into place. Whenyou identify that you can have

something to say in common understanding about the only differencethat arises when you need a great exposure from knowing how to deal and work on your talentspassions and dream come true. Never have to look back when you are passionate and natural person, passion to nature and take care or your important or all of potential dreams. When you are seeingyourself to be a dreamer or someone who is able to change his personality to make his way through, positivity or encouragement. This method is giving you and everyone the courage to share and deliver avery own perception given specifically to encourage and to know the positive answers to the onlypeople you'd change. Encouragement and to realize the right paths to be knowing an idea that you areable to can share it with all the people you can trust and to tell them about all your potential dreams, that knowledge is very important to be having something to can talk about when you need assistanceand it will enable you to have a skill that is proven to can have all your ideas or dreams given intoattention for everything that you are able to discuss positively. When you are discouraged fromchanging your dreams to the fullest," not to be negative from the course of illness that will keep youway from dreaming to the fullest"; not to be negative from the course of illness that will keep yousways from dreaming or something which will make you not" perfect" the word which describe thehuman nature or handy capped, nothing is not great, but something put together to make a greatpositive impact to be realizing and to know how to be a dreamer. You area entitled to identify on thebook that you can be having a dream come true, but it can only work when have been told that you canbe having similar dreams with someone you envy or like into your visions. In particular from having achange of dreams make me to be someone who can be available when needed time and considerationconcluded to all its been keeping us busy running around in the cities trying by all means to talk andalso connect to our families, to our sons and daughters for the open and quality purposes that weneeded to have for our families to know and also nature other people of the same implications to keepthe standard of great community to be having

and knowing how to dream. Increasing your destinationor just simply implicating the value for a person or someone who can have a dream to accomplish inthe presence, you are having a passion to fulfill it to the positive direction. You are someone who canalso identify a positive dream that is important to be dreaming a very healthful life. Seeking for aknowledge to extend your capabilities for a dream change and positive recognition when its possible, be easy to can have and let it loose or not to make it a difficult for your dreams to success. To give theaccurate importance when you deal with the only dream you need to make, happened or you have theidea to make it real and possible when you are available to make it. Happen if you are someone whoshould accomplish a status mind set from keeping all you should change and make it very possible andpositive when you need to at a proven possible times. Remember that always stay true to yourself andto also know how to identify the only dreams you are willing to change and make them possible. Thefuture needs people of common and great understanding and great common attitude to be having andknowing how to talk about their dreams and know how to talk positive with other people or rightsources of difference experiences to have access to all they needed from reaching a dream come true. The importance or stipulate the ideas to have your dreams come true, when you are having the potential thought and realizing that you can make it possible to have the importance to realizing your observations regaining your only interest. You are welcome to have the idea that is common to other people and other members of the organizations regarding to positivity and to know the outcomes. If you are realizing the ambitions that has your potential agreement. This is able to inform you and addressees your behavior, from considering. Your dreams to be true, first you are able to make a differentiations, before you could realize from the first time you know about changing the potential dreams to all your goals, its the time hen you are able to appreciate and to have concern for everything that you are liable concluded about fulfilling the potential agreement for the exposure proven to be positive. Regarding your incomes and regarding

everything you have taken and have made easy and achievable for your incomes given time you spent trying to accommodate all your dreams and passions. The difference that will leave you with trying to make all your dreams possible and to know how can it become something you can recall to make it possible and having the strength to be positive and great influential about keeping, knowing and maturing the most given talents, dreams and all passions to be possible to be acquirable, to be positive to all given exposure and to all given method to change and make possible and be a "possible changer" for every time and great quality efforts to keep the most and the potential agreement to your proven and very positive desires to be true Becoming the person owning a dream for your self, you are entitled to give it a hint and a step forward to get it flourished. You are not entitled to give any false ideas to "GOD" when you are blessed, you must know how to express it, when its appropriate. Having to be dreaming or choosing a dream you cannot forget to have and be, from now and the near future, its important to know how to take care of it, its soon as it arrives at an early stages and its easy to know and still know how to grow be having a nurtured dream come true. To informed for a dream come true, simply identify the only occupations relating to your success for every efforts simplified. This is the only important talents that are arising and they have you getting to accomplish them. When you need to know how does it come to a point of completion if nothing comprises to the only and potential agreements you should have at the end of the day. For every dream, comes with passionate and involvement related to your ambitions and other related out comes or interest to complement to a hobby, and maturing a dream come true is very important. Knowing the endurance when you are on the edge of accomplishment to reality for a dream, that needed the most interest to have it to know how to nature the right and need dream. Maturing or Maturing simply means to live according from, taking g the major steps completed to uplift your own desires to a fulfillment of having the right decisions to complete the only agreement. The information you would like to carry and deliver to

the people where you own an endurance as to be giving the right actions when you are suppose to deliver the dream. Its very important to have a dream, some have the actual concepts to be owning the dreams. First you should consider life changing decisions concluding to too-many different perspectives of maturing, choosing the right dream or path and accomplishing the only total discipline to have knowledge for maturing your passion. If you are very welcomed to be trying to take and keeping close to the importance of realizing the conditions from trying to establish your dreams to be positive In the direct perspective from living in peace with people you love and like to share the importance point of views. And through establishing the right implementations t all the efforts been given another chance to be proven, from realizing and considering chance to shine and keeping its been encouraging you to make it a dream come true. The least is considering measures and seeing other purposes that will make you a great person who can have and knowing how to can have his ideas or goals be proven and also having his ideas or goals and also from taking major implementations to keep your favorite plan put to practice looking into the book and lacquering the most given information to be knowing what are dreams and goals given into little and bigger perspective from trying to have and keep the only important treasures to give you the most healing prospects, to see yourself growing bigger and knowingly the total efforts to keep you enduring and having a great passion and a great pleasure to change oneself. From keeping and knowing the most given information that will lead us to the open space of dreaming and be the future dreamer who have and know how to deal from a blank information task to be knowing from keeping the trust than knowing nothing. When you are having dream come trues for your self and you family, you should be willing to can have the ways to make it happen, the way to make it happen, the way to make it positive. Naturalizing a dream come true, simply its identified to be having a the concerts having to nature it. Giving a dream keeping the promises for all you have taken and the very best to an end where you know how to talk about

it, and also talking about a dream doesn't make you an idiot or a very bad person, but you should know how to give it a hint, to also making it possible. From all you need and all you should accomplish or accompany them dreams are very good to every one, or every person who has a dream come true. To keep the ideas of dreaming and to also nature it to make it possible for everyone to know and also have the only knowledge that results to positivity, when you are dreaming and you should accomplish the idea to make it possible and great. We are people that have feelings and people that know how to dream and make it possible for our family members to live positively without for and without the bad behavior when they need a great change. First you are able to reach a stage where you can identify the dreams, before maturing or taking care of your family's needs. If you are not concerning the difference between knowing or considering a potential dreams which are open to other society or the citizen. Not only focusing on giving up a dream when you need a great focus to realizing your only chosen dreams, you must nature it, you must be having the ideas to keep it working and proven to be nurtured or fulfilling, means a lot to someone who is able to have a change, from keeping all he had proven to be bad, for the time you can make a huge differences, from choosing not what is bad, to keep up to all it means for a man to survive. Keeping the natural importance from dealing with real potential gifts from the only spirit of GOD. To know more about keeping the only secrets to yourself and every person you are willing to change and to make differences about, keeping a talent, not only to know how to keep it and also to encourage your society and the people you live with to "master your own destiny" From starting and we have considers the most behavior that is not proper to have people and Ghost in the same living are for humans, as it course mismanagement and not great society. Considering that ghost are not good spirits as we know from conducting certain measures. When we see someone who we thought its proper person to talk to, but later we find out that when you try to be nice and exchange some information to someone who is a bad spirit, how do yourself try and overcome the

agreement to have yourself from keeping safe home. The home of a "woman" when that vision is true," the running dress" its something you can remember" her husband "well you must have been missing for two days," woman", I think you have been kept silent about other staff" its a memory forget it", it must have been to see the and respond to the business call remember" husband" I had to go to see the Man who called and it was proper to talk to someone who call himself a Movie Director and on the phone without living a his address for the Taxi cab. "husband" and it happened that I was trying to meet him private, I said I had the envelope" twice" in speaking" Woman" since I have the message and I responded but only there was someone driving in the car." Station Wagon" woman" this must be only the memories of someone who is trying to rob us" Wagon Lady" its a consignment that needs to faced, and my closest Friends who has visions from see eying a bad ghost trying to kill her and her husband "Wagon" Gum gum "movie sounds" why does it have to happen with only us but if you could realize that when you are been threaten by any consignments spirits, the least you can do is talk, not believe in them either or just ignore it" wagon L". when the ghost was captured before its been seen but living the proper, especial a state property without a notice or something been said. From committing a crime and trying to escape the criminal laws, which tells us when you are been charged or seen to be in the scene where you are considers not living to the laws of other suspects as the case is been taken into consideration. But if you thought that you must have seen a Ghost, "cops" yes I think its been the only time I would like to talk and something hunting me long time ago. "woman" well, but how do you consider to have a Ghost in your house, where you cannot talk. Talk before we could see someone missing" cops" I think this woman know where we could try to ask questions" police" I will look further to this case but if given time and I will consider to take more steps to check in," over tomorrow" the police leaves the woman in the house. Well, "tow cops" in the car, she's been talking about someone missing for a very long time since, she thought her husband was talking on the phone with one

the Directors, to take more into place about, getting to work on the movies. The "woman" on the dream she's seen something but it happened and she was trying to recall her memory when she see a spirit. "Woman" take that cross it helps you" its been in an echos" like a woman wearing a simple dress" running" ha aha"., she sees a vision and she is coming back to real life, she's been trying to talk to people bout it" how its been doing so far lately" a cop on the phone" the woman" he's back and he's fine. OK if anything you should speak, Is us know" Lieutenant" gum gum "movie sounds" when you must be considering to over see something happening in your dreams, do you have to know and thought that when there is a spirit of malicious or bogus connections only happening but not considering to see it in real life, existence do you need to be worrying about it, "no" its not proper to have visions that doesn't not relate you your success apart from sharing your bed with your married spouse or Talking with flirting friends. And consider the connection of misjudgment to be mostly happening not only to you, but the are where you could have neighbors closer to you. Seeking the right knowledge will make you someone who is trusted to can share and talk about the consignments that a retrying to fool us as society but only fight them. This exposure can lead us to be great and living in peace among our only cities. To have future you are great person to know from all its been thought by Man to have a great family and from keeping himself clean on all his bad reputation. For talking it can make his a very healthy to tell and speak to himself and to also hear from "GOD" to help and ask for his all prayers. Proven to be a very greatest person who live but not to insult by a broken parts of memories. Considering a change to fix all the work the cage is taken to a remote place where they needed to free the captured Freddy cooker the Ghost who is seen to be very ugly and not very good when he's around people we should live with in peace. We can recall from taking the belongings of the people and out not properly to be the only citizen. How did he make himself ugly. But when you get close to see his other sides during the course of the light. He's not somebody you could trust when you need to know." knowing is

making a very good side to somebody you should trust". But when you overcome a situation where you can be exalted into a city. The lost city of people who have no visions, people that does not have a goal to accomplish and the lost places where you could recall. The only things that you devoured not to be greatest person who can have the great exposure from trying to be a dreamer, having anxious desires and visions. Changing and reply to all its been said for human kind to be well and envied for a great dreamer. Do you want to be a music producer, A Music engineer and know how to master you sturdy with quality sounds, market your tracks through sell your Music Art on your website and to organize and lounge for your music sounds and with real Artists on the concert through Agents? Keep this book which will have you organized to be intelligent and still look forward to make it a dream come true. Guaranteed for all your instrumental compositions taking place, try to have the knowledge to your music and have the history through making a sounds and what would you like to attracts most, it can be in a full instrumentals or recorded technology's put together making a great music type of Art language a genre. You should know when you need practice or making or producing a selling record, it's not playing music, but making hot or hit quality sounds. It can be the type, of pop instruments like Michael Jackson moon walk, Hip hop the most is not difficult to make it, and gospel for A great band or choristers, singing in the turner vocal, or first part, and conducting RIB which means rhythm's and beats, and making the great of LL cool James music's, as seen to be RIB not evil, but to App music, as associated with Parental explicit contents, guidance, For the public point of view. Considering buying equipment's will need you to have money for buying in the music store, you consider to have a store, you need more money like capital in business investments, to starting a stable expensive music stores, not all are able to afford to buy a Jazz equipment's, little Sax instruments, but only to know how to estimate through, but to have other options if considered to be on a little investments, don't buy cracked equipment's, like software's of making real sounds, but to your quality and producing

equipment's in front of real artist or pop stars" its embarrassing", only great to have something you are able to repose's or dispose as its acquirable from the real music production websites, or just subscriptions. You considered to be the one producing the greatest t sounds, it more likely to be one of best engineering to have your own sounds and your grated distributions, for finding the right music studios designer, Architectures and marketing channels, you might have yourself selling the greatest music equipment's on your deals. You are able to plan all your production through for recordings you establish with real Artist, it can be in the studios where you are able to make new sounds and still produce the great quality standard with Artist or just local to work with. Music equipment's Sax phone Piano Guitar music producing speakers, big or small Computer Software's Micro phone Head phones Demo and real sounds Mastering Channels and studio Mixers equipment's Fruity-loops software's Reason Pro bell Software's and Equipment's Hip hob and RIB Jay studios and Mixers equipment's Deejay and mixing On concerts and great Parties or Music and production entertainments Sax phone – most used musical instruments played by Jazz band to lead the great melody, most fully famous played by the great bee gees and the legends of great musical instruments like, Toto the African mostly established Rock band from the home garage to the global markets. Piano– is the most musical instruments like to be play by music legends "Like John Legend" Pop musical Artist and to the public as it's the most attractive piano sounds on the mostly competition bases, you can learn at home first, to the music school, form reading the manual that come with the piano roll and the desk. Guitar – the string music instruments mostly played by the talent of Late "BOB Marley" the legends, and it's made from wood shaped like a wooden guitar and the strings in between producing the most acquirable Spanish sounds, acoustics for re-gay mostly liked to play by the famous lucky Dube. Music producing speakers, big or small This are the speakers you are able to provide it the studios producing the quality sounds, when you are in the music store, make sure you buy the wright musical production speaker, ask they if you don't

know how the look like, be great when you are buying the most talents you will be making. Computer Software's There are computer software's that you might like to have for your studio recordings you building in your quality investments areas, time where you are likely to call an IT guru to give the musical production software you would like to buy. Buying mean establishing the wright tool to make quality and very good sounds for the public ear. Micro phone. It's the tool to connect through the computer or recording for producing the human sounds with great vocals, to record to the musical software through for corrected collaborations put together with real vocal, rapper, hip hop and gospel signing Artist. Like when you hear a" on the Fruity loops," I broke onstage, broke a leg and the ligament" microphones that produces the fastest rapper like Twister, and Buster Rhymes, it's a true vocal from a quality Microphones, and the sounds that produces from the Manhattan Signing Artist, you might hear that there is a chorus where, there are about number for 2people sing in the back ground, when you hear "Yeah" from Usher Raymond" it's made from recoding a vocal song, you might need to know how the studios microphone in connected, only through the actual coaxial cot musical that looks like the ones you see for big concert speakers. You are welcomed to ask the music store man to show you the demo or real production studios equipment's if you might to have a quote. Head phones this is the most expensive studio equipment's you need most of the time in the producing level, first in the engineering course you approach, the Marketing your album, Producing and Marketing the engineering for the quality sounds, that when you are graduated to have a music composition degree and still be able to sell your Market's, before you could know how to interact with your music agents for more musical concerts, which will make you or keep you touring or responding positively, as to your fans will always find your records through you composition, apart from not living the Art or track on the website to download, there is no way that you could have music to downloads to your I Pods. And other related music file like Cloud for music, but also for collecting tangible assets or product in your

home PC's where you will be able to install it for accessing needed music files anywhere in the country. What you need the most for a great talented production level, you need to have acquired the most given knowledge to work and still produce the great quality music you are able to master, with Mastering equipment's from buying or investing on the actual products that you can touch and know how to connect through a from a professional mastering course or training and from receiving the actual help or real consultations from other related sources of music and studios mastering levels. It can only happen if you are not qualified to run home studios without consulting the actual secrecy most of the producer does from outsourcing the yellow pages, and give a great consultation fee as considered. But it can only happen if you are able to work on the mastering channels for pioneering a full Track and to be charged on the Full album for 10 songs if happens to be marketing you albums for more income and other sources you might happen to attract for giving and selling your talents to other music's and studio owners to give you a music contract or deal. This is a music producing money making software you need to know through practice, but it's difficult compared to reason software most of the time you can import a project or related instruments from reason, when the song is complete in a wave format, or import a song from a project of Jay hip hop or house sound and make or encrypt to saving it and change it to start for an av or recoded music Art. It can be expensive if you make it the songs that you have a trade mark of before you could the complete instruments to an artist through producing and he will register it as his own productions, but not free music you might attract. But through music Artist that can and are able to make quality real music, you listen to and like the songs when you hear it in the radio, or car Decker. For this musical software call the propel music production, you are able to make songs from importing wave files and to know how to change the project to a saving Wac format when completed. But you are able to have a manual book that comes with the software program you are able to buy, but before you could purchase, know what you looking in music or instrumental

for music composition. Have the update more frequently and you be able to access other related website you might need to download other sounds missing on the updates very time you felling outdated, but you need to consider real equipment's connection like, mastering tool or equipment's, and playing Guitars and recording it while you working on the full track you would like for people to hear. Practice makes perfect every time, but know when you need practice and have also great family time when you work hard on this production method, of course you should schedule how you make production and to also know how to interview from making appointments and receiving calls In your music office studios and entertainments. Music deejay - this is the most simple stand wanted from making ready songs, only you are able to compare from making hip hop song from scratch, you only need to know how to work both with software from importing the sounds instruments to a hip hop Jay or the other way round with importing ready wave files from the music albums projects to the a Wac file and press play, to hear how it sounds through your rhythms of musical composition. You become in the music store and ask around for a Jay software and how install it with discs, but to have the disc you need more space in your computer as it consume a lot of computer memory. For a simple wedding you might be needed from arranging the dates of leasing of renting your musical instruments, but how will they know if you not around, for a big concert you should be able to know how to accommodate the mass of fans that will accompany you If you're a Dee-jay concerts, but from differentiating a huge concert not charging like it is just like a wedding date arrangements, according to your call you received for your registered or just a starter company with great passion to have your entertainments and recording sounds to the public, you might be needed to be a deejay to a simple party that needed music and other equipment like tents or chairs. When you are a real producer you need to know about all your equipment's and how to conduct through, from writing and producing a complete song from scratch; but how do you come up with a song without the great knowledge or production skills to

become a real engineer, how do you start without college or basic knowledge that can conclude your dreams to reality. Wrote the book business Adventures, which give you the total concept to business practice to your door, I was been consulted for my other readers here in Africa's deal they were impressed to have the most interesting and give a great attractions through, rubbing shoulders, touring and enjoying the good side of life to business deals where you could establish your own ideas given any name through company registering given to be any name you come across, for your company auditors financial s and bookkeeping, through touring they have asked to have a the book for a full studio music deals or production they can have to read for their extra time, most of the people where the only college students and music producer who have spoken to see the final produce about this book now. It's great to have you store up running in place of business area, you are able to locate your music store from running a recording company in house, but little different when you selling speaker In a mall and you would like to buy the product you can have and know the quality sounds it produce's, different from selling as production or engineering music. Analogue is proven to be a manual set equipment's and is very important to know how it works, most of the Artist and Deejays prefers to have all the analogues technology and digital technology or computers software, combine working on the project like making music at home or in the studios, from mastering a son with digital equipment's, requires quality pioneering from saving a song in your fruity loops or Reasons music production software's, which all you to have the freedom from playing a digital Piano Roll through connecting it the input output cords. Digital or Automated binary machines which is the most technology that is used for industrial organizations or factory production of musical sounds from a tangible computer device or hardware compatible from having a coded software's analogue, which is shown to be for counting or just a running numbers or old computer software like Dos calculations, but the digital world included the computer software's where you are able to work on the sounds tracks with

software or virtual equipment's from This information on this book only to be seen and advised as an individual of music passion, and to know how to look further in the Music producing world, and learning to have your forecast not only In the bad side but to the leading individuals like meeting the right carrier and not mixing bad organization with great music legends in the pop star acumen's, but to know that personal life does not have to be included drugs related problems, but to know how to be good with your passion, and great carrier pats chosen for other to a new music and available music artists of the future, upcoming generations, where it start from home and to grow well as great artistic and music producers. This book will live you on the edge to be a reliable outsourced music producer, and great Music consultant and from reaching great Artists and meeting related music industry meeting boards and reaching sealed contracts for more excitements of recordings and music entertainments you like for final consumptions. You will like to have great recognition to investing with big and established recording companies, from a small medium point of view, to get to a position where you are able to invest more. If you need to consider major courses or subjects you added for a little investments retained from your savings, this book will give you a chance to grow in to the music industry and knowhow to teach others, as well through establishing your recording studious When you are finished reading and making sure that, you having the right channels to be having and knowing how to practice the most importance of keeping your dreams to, reality for a great change and to also be having a believe to know the differences when you are making the only difference owning a precious gift from "GOD", and also a passion in your exposure. The final stage to have and own a realization from conducting a perspective knowledge. Conclusions Great memory of Biggy Small, left-eye and aliyah who have reached the highest level of music peaching the music and marketing of creating in Art and a lot of music artists that have been trying by all means to be n the marketing of Art creation that have never reached the top but are still trying all means to be on the part of making, creating the

world to be smart and intelligent, form keeping the mix of Artist and sharing all their best from the industries and out of all the media and fame, Career emotions, alcohol abuse and substances which does not have to be part of any given in the like of listeners, if you are caught in places where you cannot see your music taking place from reaching your talents to other companies which have yourself working and creating the best of all time, to music listeners production and entertainments. You should acknowledge the idea of knowing the importance of talents, music in particular and also to have the positive loo out to Art and music making career. If that social impact doesn't not lead to any of your passion, but concluded to be major due dancing and other material of Art production, its important to outsource major industries that lead to any given talents of music listeners productions and all the sources of materiel in producing the best, from All given Art projects, to moneymaking deals in particular. Asking around to other artist it does not have to about social activity that involved drugs of bad media in my concern, but looking of the positive side of making the great exposure to rel music and Art investments. To reaching the top part of all in the music and investments productions of Art in particular its rare to have the negativity when trying to reach the talents needs to corporations and music companies, when you realize to be on the side where you a rechanging all you desired. When you have some musical instrument you need to share with your fans. You are someone who is precious and someone who like to be seen on the positive side of all your reaching. We have common ideas to know and how to change it, and making it interesting and positive, is when you are acquiring a deal in the first place. A computer does not have to be just the sport for productions in all places. Or a place where you would like to compose a song and have ways to sell your songs to your fans, have courage to deliver the best in a dream to change it for the better as seen in the music production and cooperation industry's for over 3 years and including all the experience as been writing and helping other to acquire their dreams, I worked with many individual trying by all means to make

the, very good with all they change to make it possible, for themselves and for their family's and for their musical career and to keeping the great artist in the music industry. Working with many artist opens the ideas of taking and delivering to their needs and expectations and also giving them the positive side of proving their music or Art to composition of their very best talent that they can share it with fans across the globe. A music career is great when you reach the deal and knowing who can speak to about the career in music openly. With other Artist its not easy to just start song and compose it without having a dream, or without having a passion and also would like to share a piece of knowledge which describe your talents, your personality, the behavior to be having dream to change, a passion to share among your desires and your family's, and fans, which describe the knowledge of talking to them through music and talent. Remember at all time that to know that reaching for a dream does not leave you empty handed when you are an Artist, first you should realize if the deal will make you rich. If the talent you have will turn into a full time career, how do you determine if you have invested more or little, if required to perform certain duties for an Artist, expect to receive some or more as your remuneration. Some registered companies have their different ways when they sign their Artists. And to compare the deal if you are taken into consideration; Artists should have freedom reaching to their musical career, as his composition in all different angles. Know when you have signed a good deal with company's that sell music and entertainment, have someone to talk to in the management department who you need to have a proposal with, and have all you can conclude and put on the table when you are concerning to be recognized or given other opportunities, for working with different company's and also with great and upcoming fame. To identify the most possible concerts when you are trying by all means to be a great Pop Star, a great Musician and also to have recognition form the Music and Entertainment industries, its possible to have market of your own brand or Artist. Trusting your music will create you to be with all collaboration community that is

able to create the best of all the work not only to focus on the just Solo exhibitions of performances, for great Artist to also sharing the common talents of music in Art and the music in Technology standards and the modern civilization of good health and good money. Having an open hand full fills the great honor and prospering the ideas of open economy and open society that delivers the most and common behavior to giving the only common desires which fulfills the hands of our listeners, we having the only music we are able to share, the music we all Love and would like to give to our best results. Commonly the idea comes with the natural behavior and in the behavior you are trying by all means to see the major impact on music and investment, proper to having you own music delivers that idea of investing and helping other sources to get rich, reaching the best of recognition in the Market of music collaboration and investments on Work as Assets and Equipment. When you achieve the best results reaching a potential goal, you must know all the importance about having to release a song or songs which make an album for ones best ideas implementations and given another level or a deal, it can be in producing new songs and know how to talk with other major collaborations which will make you to be someone who has the potential and the dreams to share with fan and people across the (The GMF) Global Market and Fame. The market describes or illustrates the Talents in the Artists of invention and the fame also the "Bling" "Bling "and the courage to shake hands with major companies in the industry and also to knowing the class that delivers the insides of human character and fashion world. To be in that stable cooperation will make you to become someone who has a dream to change, dreams to share with Fans, a dream that can make you unique or different from changing it and making it possible for your self to share it, to be on the side where you are welcomed to can talk to other musicians like collaboration with oversees or be recognized for international Market for your music, to be heard by many different people to create the culture for people, who have the same dreams to change, people that have the potential of Great Education and excellency of common behavior

and human character to nature the very best of music genre and collections for all the best of idea, from doing, making composition concepts concluded to the best of collaboration with the interest of changing the prospect of making different genre, to become An Artist, you are able to travel with all the music Band and making more best music you can share through all media organization and other Marketing resources that delivers the best and positive behavior in the hands of good Art and All aspects of music compositions and distributing the best product or As seen on TV, Material for the economy to reach the open society of great investments and community entrusted to have the knowledge and love of Musicians, Art and Modern Technology and having to understand the language of Love in music. Its depends how you have been spending your money wisely or just never noticed that you have been losing, but considered to be spending you money of things you like. Depends on your budget that, if you want to buy a Car, well you deserve it to be driving in a first Class Ford Focus or Mercedes Benz es., if you are family man or trying to be good guy who be there, whenever is possible, to be buying the most expensive car in the world. Torch bearer the latest SUV Model, but you spent a Leg or Two, when trying to own and still know how to can keep it fit in way that it won t hurt you pockets, but to keep it clean and "very look-able. In certain parameters you not only looking to spent you money wisely on the things likes House, A car, School fees for all your effort to keep your family educated and away from the thugs, and also not including that you have to buy food in the house that will cover everyone and also the differences that you consider to keep the level of your diet, a house consisted of a home where people or a family can be together and live without any disturbance and live according to how they please. The family needs great comfort in their homeland they also need to be I a good stable budget to keep the house well developed, the food and the furniture which contributed for a great family to live, and not to be bad and live without a furniture in the house, if you can furniture your house, but still know that you can afford to buy or purchase water and

electricity including other material to use in the house, if you house should be needing a major or minor improvements. It s necessary to "know how much you spent only on your maintenance and including the family at all, you might have a family of three or four, or you might start back to count, from, a Father who create and who is the head of the great at home and also the who keeps the family bible, also to repellent avoided any difficulties from running out of cash. And when it come to the woman of the master head of the family, whom considered to be mother from all the children they call her, and the others relating depends, if you have any other related families that can be I the house or like to be with the rich or great family. So that spending reflects only on your budget and still know how to handle it without anything been taken back to the store owner or just, something might happen that, you might someone and spent money fixing your and the other car, which will leave up more than you thought you could spent" for that month, which added all your expense's. "Really" you need to be strong to be in and run a great family. But sometimes it helps to still know how to can talk to your parents, if they existed or someone with great knowledge to be in family that needed a great budged forever season or anytime of the year, Gum. Gum (movie sounds) look you must running out of money and also your boss want to you keep up with the sales records that you reach every time, and also that add to your daily problems, but if you know that sometimes when you walk about that behavior, you thought you might be hiding it, but only we know as people living in the cities that when your problems are bad. It's not okay, because you should talk to someone you thought could answer you; suddenly, but if you think about praying, also it's a great idea because that you are the father that run the family. But by fighting in the family will not resolve the matter or any like other family problems, you can talk in church or with you partner on the table, to say you know what woman, "Love you" and I really do "this is the time I will let you know that, all we have together in the family, Great Prayer for Happy Family God gave us the chance to know and still have hope that SOMEDAY, IS SOMEDAY

WE WILL ACHIEVE THE GREAT ABOUT OUT DAILY BREAD MERCHANDISED THE GOOD ABOUT THE MARRIAGE and TO KNOW HOW to HANDLE ALL OUR Problems OR FAMILY MATTERS IN THE GOOD WAY, NOT TO FIGHT BUT to love your partner in a good way you would like it, "quiet often". AMEN, would like to increase our strength to talk about us and the marriage to us we own. I grew up at home that, love people as you love yourself, don't hate god but your parents and the good strength of great people living the city of god or of gold. Everyone needed god in their life, depends what thy accomplished from all the troubles in the world that keep us apart from good, but still to remember that Great God Love us all. To keep us on this earth and give us life to live and love our families and to take care of all god gave us I a good way, but to insult our families or be bad towards them. Remember to know how to take care of yourself and be clean, mentally, spiritually and people with respect you as you are, never to think like, you are not part of the living society. But think and live like the great social community that have knowledge to develop their own state of living, and still know how robe in that state for a long time. If you want glamor, you make it and still you can own it, like fame and it's really for people that love to be famous o to be known with all they have, some of them like, want to be in places where they are famous and they like to be driving in great and expensive cars, depends on their occasion and also needs attention. So mostly you don't need to be hanging around bad company if you can make more money that people that hate you, not all will you the way you present yourself towards all your success, but there is no way that you can hide wealth, it will take you out still to be known by people that you don't know, never seen before but they know you and how you living and as well as your company. Well sometimes you create your own space when you are around your great exposure of fame and also the time you needed to be In that moments, depend son what you dong there but what time, and your age doe sit allow you to be I that moment, or you must out for "GREAT DATE" to meet with your partner or maybe you just happen to be drunk in a strip club, alone and you are

a grown man. Maybe it happens that it was raining shard that you almost lost your breath, and you saw a door open with friendly ladies and thought well, this could be it when it's after the rain fall. And you saw people that could; have happen to know you but in that time. They never to be seen walking in to the bar just or places of Man and ladies entertainment. Some communion they are around the table, and I have happened to hear that, if you would like to make a great pee, you need to drink more beer, really beer is like water. You drink it and you still pee in the same port you thought well, I must be drunk robe pee like it is. I said well you should be drinking, Milk? Just plain water. Why you pee is so clean. You go home and your wife should know sir or that you are clean man and you have been drinking water, you seen the result of thirst to be true when you starting to pee like Man from a clean water. If you see something terrible about you behavior of a very bad pee if you melt something bad in you toilet after you pee you and not sure about your health, but you could go to a doctor, he will still tell you have at least eight glasses of water a day. And it's better if consulted the professional about your health, he might put you a checkup, if you needed any medication, he will be a qualified Doctor to can simply address you according to your health and needs. If you need to be checked for HIV, he will do so and also for other blood testing. He will do so. Acknowledgments This participating in the mismanagement in the ART in music, fashion and creativity industries that have the positive impact considered when artist are losing the faith and courage from making to gain, not making to loose their talents and ending up like the door mad, but with great voice to sing, with great talents to incorporate with Thanksgiving to major companies for all their efforts. To see the talents on the Artist and uplift their career as a dream to be positive for all your future interests or new and upcoming new Artist as the future and faces of tomorrow.

Printed in the United States
By Bookmasters